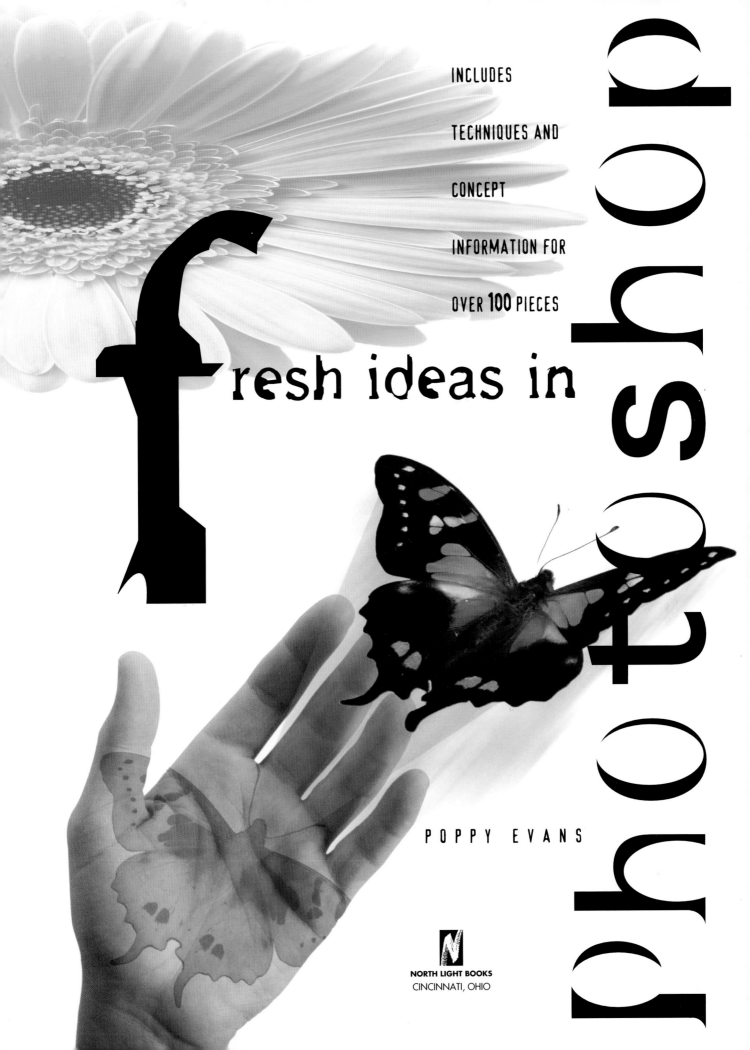

INCLUDES

TECHNIQUES AND

CONCEPT

INFORMATION FOR

OVER **100** PIECES

fresh ideas in

photoshop

POPPY EVANS

NORTH LIGHT BOOKS
CINCINNATI, OHIO

Fresh Ideas in Photoshop. Copyright © 1998 by North Light Books.
Manufactured in China. All rights reserved. No part of this book may be repro-
duced in any form or by any electronic or mechanical means including informa-
tion storage and retrieval systems without permission in writing from the pub-
lisher, except by a reviewer, who may quote brief passages in a review.
Published by North Light Books, an imprint of F&W Publications, Inc., 1507
Dana Avenue, Cincinnati, Ohio 45207. (800) 289-0963. First edition.

This hardcover edition of *Fresh Ideas in Photoshop* features a "self-jacket" that
eliminates the need for a separate dust jacket. It provides sturdy protection for
your book while it saves paper, trees and energy.

Other fine North Light Books are available from your local bookstore, art sup-
ply store or direct from the publisher.

02 01 00 99 98 5 4 3 2 1

Library of Congress Cataloging-in-Publication Data

Evans, Poppy.
 Fresh ideas in Photoshop / Poppy Evans. — 1st ed.
 p. cm.
 Includes index.
 ISBN 0-89134-842-5 (alk. paper)
 1. Computer graphics. 2. Adobe Photoshop. 3. Graphic Arts. I. Title.
T385.E9825 1998
006.6'869—dc21 97-36489
 CIP

Edited by Lynn Haller and Kate York
Production edited by Amy Jeynes
Interior design by Chad Planner and Janelle Schoonover
Cover design by Stephanie Redman
Photoshop image manipulation on cover by Michael Mitzel.

Daisy image on cover from Vivid Images
The permissions on page 144 constitute an extension of this copyright page.

Acknowledgments

I would like to thank Lynn Haller, whose advice and direction guided me in the compilation of materials and writing of this book, as well as Kate York and Amy Jeynes, who steered it through editing and production. I would also like to thank all of the designers, illustrators, photographers and artists who made this book possible by contributing their work and production tips.

About the Author

Poppy Evans is a freelance graphic designer and writer for the design industry who resides in Park Hills, Kentucky. She is the former managing editor for *HOW* magazine and former art director of *Screen Printing* and *American Music Teacher* magazines. She has authored many books for the graphic design industry and written articles which have appeared in *Print*, *HOW*, *Step-by-Step*, *Publish* and other graphic arts magazines. She currently teaches graphic design and computer publishing at the Art Academy of Cincinnati.

Contents

Introduction

The team of creative professionals involved in producing an image for print used to consist of a designer, an illustrator or photographer, and a retouching or color specialist. Each had an assigned task based on an exclusive area of expertise. The production process went something like this: The designer contacted an illustrator or photographer with an image idea, a rough sketch was produced, and a final illustration or series of photos was produced. Before the image went to press, it usually needed to be retouched and/or color-corrected.

The introduction of Adobe Photoshop in 1989 changed that. Designers who formerly hired photographers for their imaging needs started using Photoshop to tailor stock photos to their project's specifications. Rendering an illustration was possible with the aid of Photoshop's painting tools and filters. Photographers experimenting with the software used it to alter their photos in ways that put them into the realm of illustration. And illustrators who used Photoshop's type and design features found themselves venturing into areas once the exclusive realm of the art director/designer. Color correcting and retouching could easily be accomplished with Photoshop's color and brightness controls as well as its cloning and painting tools.

Photoshop has enabled creative professionals to wear many hats, venturing into disciplines they were never able to conquer before and performing tasks in-house that were formerly done by specialists—a capability which has speeded up the production process and saved users professional fees.

Beyond its time- and cost-saving advantages, Photoshop has come into its own as a creative tool. Within the commercial realm, the program is being used both to duplicate traditional mediums and to produce electronic effects that go far beyond the limitations imposed by traditional pencil, paint and collaging techniques. Photoshop is now widely used in virtually all areas of print design as well as television, multimedia and the Web. The program has even gained acceptance by fine artists who are exploring its potential as an avenue of artistic expression.

This book covers many applications of Photoshop's limitless possibilities and explores how creative professionals are pushing the limits of the program's capabilities. These examples will inspire, as well as whet the appetite of, anyone wanting to learn more about Photoshop's creative potential.

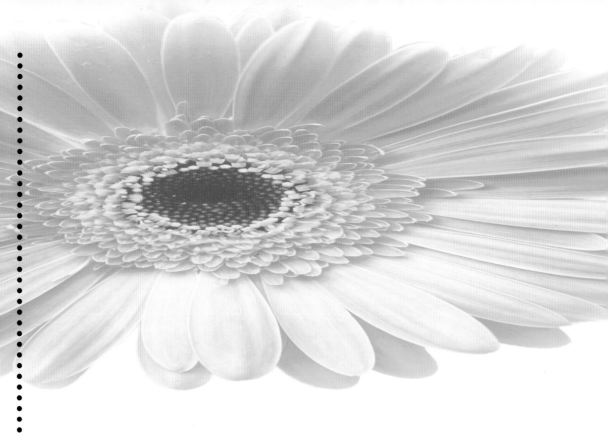

Posters & Calendars

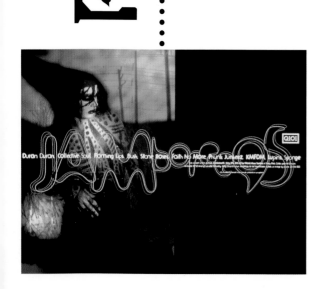

The Advertising & Design Club of Canada

Concept: The Advertising & Design Club of Canada promotes its annual design competition with a call-for-entries poster that is widely distributed throughout Canada. Toronto-based Viva Dolan Communications' principal Frank Viva chose to combine digitally enhanced vintage photography with subtle humor in his poster design which garnered awards from *Communication Arts*, *Applied Arts Quarterly* and *Studio* magazines as well as from the Advertising & Design Club of Canada.

Production: Viva scanned an old black-and-white photo and brought it into Photoshop. He isolated the image of the man by using Paths and colorized it by adjusting Hue and Saturation.

The headline was set with the Type tool. Viva converted the type using the Make Path command from the Paths palette

menu and adjusted the letters for a perspective effect. For a 3-D look, he drew sides on each letter with the Pen tool and added shading with the Airbrush tool. The rays were drawn with the Pen tool and shaded with the Airbrush tool. Viva used Layers to composite the man, the rays and the headline.

The image was brought into QuarkXPress, where type was applied. The poster was printed in four-color process plus metallic silver.

Design Firm: Viva Dolan Communications
Art Director: Frank Viva
Designer: Frank Viva
Computer Manipulation: Frank Viva
Client: The Advertising & Design Club of Canada
Programs: Adobe Photoshop, QuarkXPress

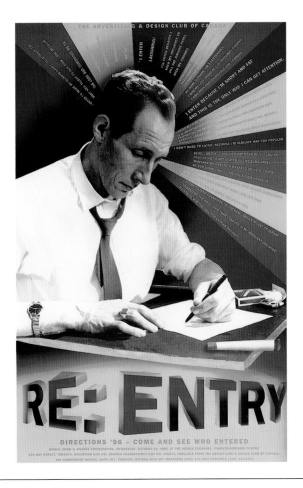

PEN Canada

Concept: PEN Canada is a nonprofit organization involved in promoting the cause of free expression. This poster, designed by Viva Dolan Communications, was conceived to foster public awareness. It's sold at group events as a fund-raiser and is posted in Canadian bookstores. The poster's gutsy combination of raw imagery and pages from a banned book by Russian author Aleksandr Solzhenitsyn has won recognition from several trade magazines as well as from the Advertising & Design Club of Canada.

Production: Viva started with a background of pages dealing with an arrest from Solzhenitsyn's internationally acclaimed novel *Sot*. He arranged and pasted the pages into a rectangular configuration and hand-painted an outline of a human head. Photographer Hill Peppard shot a color transparency of the image.

The image of type on a roll of paper is gibberish faxed to Viva and pasted onto a roll of paper towels. A black-and-white photo of this image was made and then scanned. Both images were brought into Photoshop and the Layers feature used to blend them into a single composition.

To complete the poster image, Photoshop's Brush and Airbrush tools were used to draw the gag and the eyes. The finished illustration was imported into QuarkXPress, where the headline and type were added.

Design Firm: Viva Dolan Communications
Art Director: Frank Viva
Designer: Frank Viva
Illustrator: Frank Viva
Computer Manipulation: Frank Viva
Client: PEN Canada
Programs: Adobe Photoshop, QuarkXPress

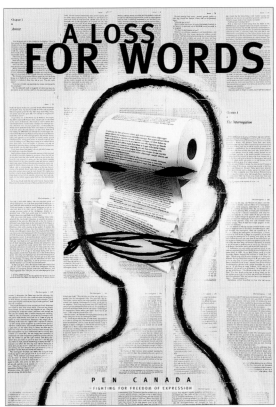

Self-Promotional Calendars

Concept: Bean Street Studios blends the talents of photographer Noel Barnhurst and illustrator/designer Kay Spatafore in the creation of imagery that combines photographic realism and sensitivity to detail with the sensuous brushwork of a painting. The effect is both evocative and surreal—a far cry from the high-tech special effects so typical of computerized imagery, yet possible only through digital means.

Although each has a separate studio, the duo has made a practice of teaming up annually to produce a self-promotional calendar. The calendar was so well received its first year that Bean Street Studios now produces it in conjunction with the calendar's printer and the color studio that produces the separations for the job. The print run for the calendar's inscription is broken down so that each of the four firms has a quantity with its name on it. The calendars have won awards from the Salt Lake City AIGA and the national design community and have appeared in *HOW* and *Print* magazines.

Production: Although Bean Street Studios' calendar images typically start with a photo, the production process is an interactive one between still photography and computer. For the 1995 and 1996 calendar images, Spatafore started by scanning one to three of Barnhurst's photos on her studio scanner. After bringing the photos into Photoshop, in some instances, she combined two or three photos using Layers.

Spatafore also embellished each of the photos with painterly effects she created in Fractal Design Painter. She imported this imagery into the Photoshop files and used the Layers feature and the Rubber Stamp tool to blend the portions of each image she wanted to incorporate into the final piece, often scanning additional photographs and

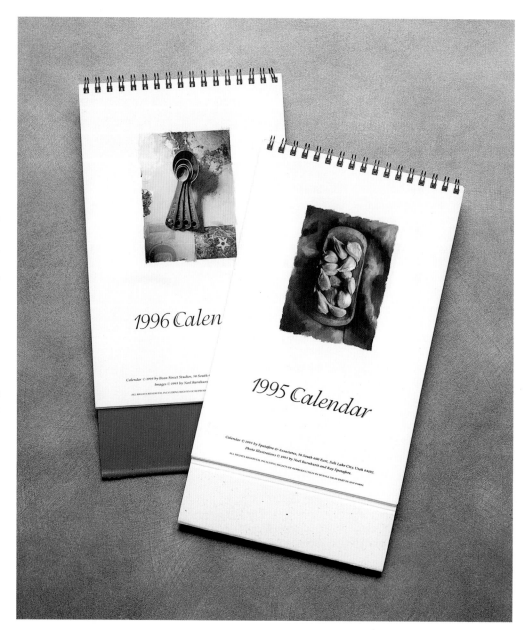

bringing them into Photoshop to achieve the desired effect. Spatafore brought the images into a QuarkXPress file to complete the calendar.

Design Firm:
Barnhurst/Spatafore
Art Directors: Noel Barnhurst, Kay Spatafore
Designer: Kay Spatafore
Illustrator: Kay Spatafore
Computer Manipulation:
Kay Spatafore
Clients: Interwest Graphic, Noel Barnhurst, Spatafore & Associates, Paragon Press
Programs: Adobe Photoshop, Fractal Design Painter, QuarkXPress

Columbus, Ohio, Independence Day Poster

Concept: To announce the Independence Day celebration in Columbus, Ohio, Rickabaugh Graphics created this glittery poster, printed in four-color process plus metallic gold. The central image combines well-known buildings with firecrackers, unified by a banner inscribed with "The Boom Is Back in Town!" Over one thousand posters were displayed all over the city.

Production: Rickabaugh Graphics principal Eric Rickabaugh and photographer Larry Hamill started with existing slides of downtown buildings from Hamill's stock. Rickabaugh scanned the slides and brought them into Photoshop, where each building was isolated with the program's Selection tools. Hamill re-sized the buildings and pasted them into the grouping. He adjusted Hue and Saturation to achieve uniform colorization. The trees were created from a single tree on another scanned slide which was duplicated and pasted into the composition.

The flag was isolated, duplicated, flipped and placed in its own layer. The skyrockets were drawn in Bryce 2, a 3-D drawing program, and brought into Photoshop, where they were combined with the flags. Hamill combined all three layers and flattened them to finish the Photoshop document.

The image was then brought into Adobe Illustrator, where the banner, background gradient, type and other graphic elements were created.

Design Firm: Rickabaugh Graphics
Art Director: Eric Rickabaugh
Designer: Eric Rickabaugh
Photographer: Larry Hamill
Computer Manipulation: Larry Hamill
Client: Huntington Banks
Programs: Adobe Photoshop, Bryce 2, Adobe Illustrator

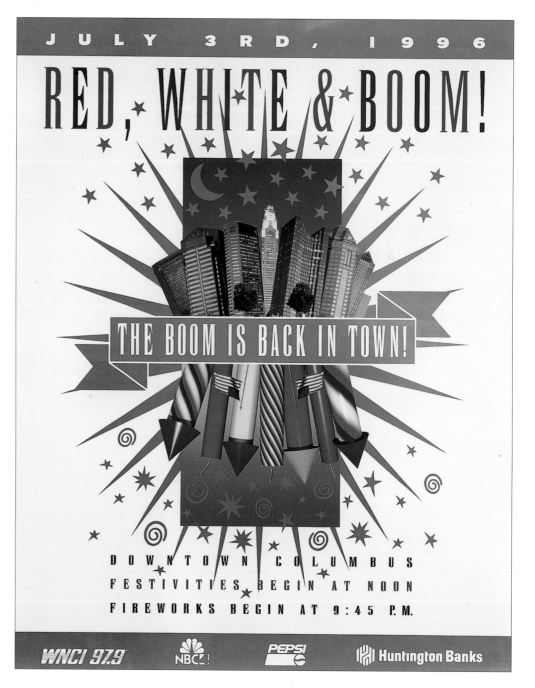

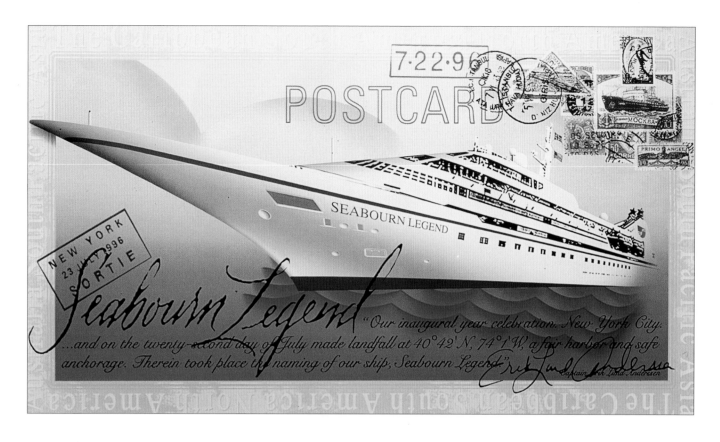

Seabourn Cruise Lines

Concept: To convey a sense of sophisticated adventure, Primo Angeli Inc. sought to re-create the look of a postcard in its poster design for Seabourn Cruise Lines. A luxury cruise ship, the *Seabourn Legend*, dominates the design with its amplified, streamlined proportions. Primo Angeli Inc. produced the illustration of the cruise liner in Photoshop and used the program to composite the other graphic elements.

Production: A client-supplied color photograph of the *Seabourn Legend* served as the working image for the poster. The photo was scanned on the design firm's studio scanner and brought into Photoshop, where the cruise liner's bow was exaggerated by choosing Distort from the program's Image Effects menu. Staff member Mark Jones also made liberal use of the program's painting

tools to redraw the ocean liner. "Very little of the finished illustration is the actual photograph," he admits. The gradient tools were used to create the stylized clouds and waves. Portholes were created in Adobe Dimensions and then imported into the Photoshop illustration of the cruise liner.

The type for the postal cancellation in the lower left corner was originally set in Adobe Illustrator and then imported into Photoshop, where a Gallery Effects filter was applied to achieve a rubber-stamped effect. Other graphic elements, such as the stamps in the upper right corner and the calligraphic lettering at the bottom, were scanned on the firm's studio scanner and brought into the Photoshop file of the cruise liner and the poster border. The poster was printed from Primo Angeli's Photoshop files.

Design Firm: Primo Angeli Inc.
Art Director: Primo Angeli
Designer: Primo Angeli
Calligrapher: Jane Dill
Computer Manipulation:
Stephanie Anderson,
Mark Jones
Client: Seabourn Cruise Lines
Programs: Adobe Photoshop, Adobe Illustrator, Adobe Dimensions

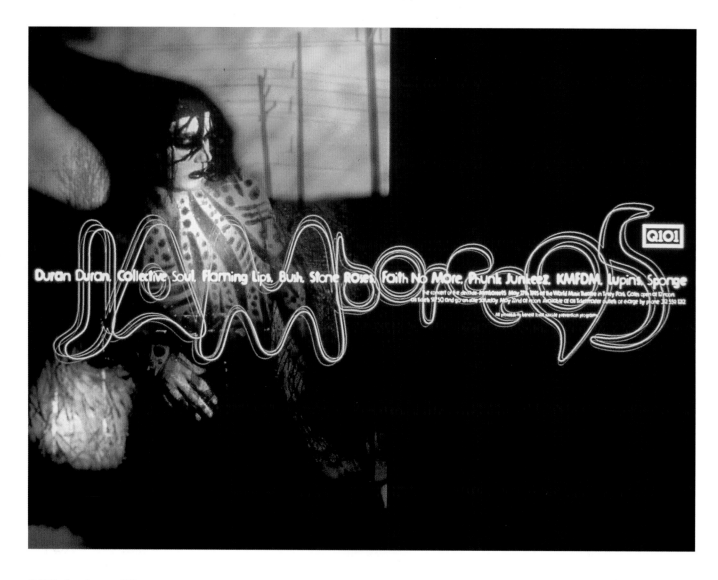

Q101 Jamboree 95

Concept: Q101, an alternative rock station in Chicago, commissioned SEGURA INC. to design a poster to capture the raw spirit of a station-sponsored concert and its music.

Production: Designer Carlos Segura and imaging specialist Eric Dinyer started with a black-and-white photo of a figure acquired from their client and a stock transparency of a landscape. Both images were digitized as high-resolution grayscale scans, and then brought into Photoshop. Dinyer used the program's selection tools to isolate the figure from its original background and used the Layers palette to combine the figure with the landscape image. Feathering and the

Gaussian Blur filter were applied to the landscape to create a hazy effect. The poster's background and the shadow of the figure were extended in Photoshop to apply a backdrop for the poster's type. Dinyer gave the image its warm colorization by converting it to CMYK and adjusting Hue and Saturation.

Segura and Dinyer created the poster's Jamboree 95 headline in Adobe Illustrator and imported the paths into Photoshop. Two duplicates were made of the headline and each was blurred with the Gaussian Blur filter. The designers then used Layers to position the type over the poster image. Segura brought the Photoshop image

into QuarkXPress, where additional type and the Q101 logo were added.

Design Firm: SEGURA INC.
Art Director: Carlos Segura
Designer: Carlos Segura
Illustration: Eric Dinyer
Computer Manipulation:
Eric Dinyer
Client: Q101 Radio
Programs: Adobe Photoshop, Adobe Illustrator, QuarkXPress

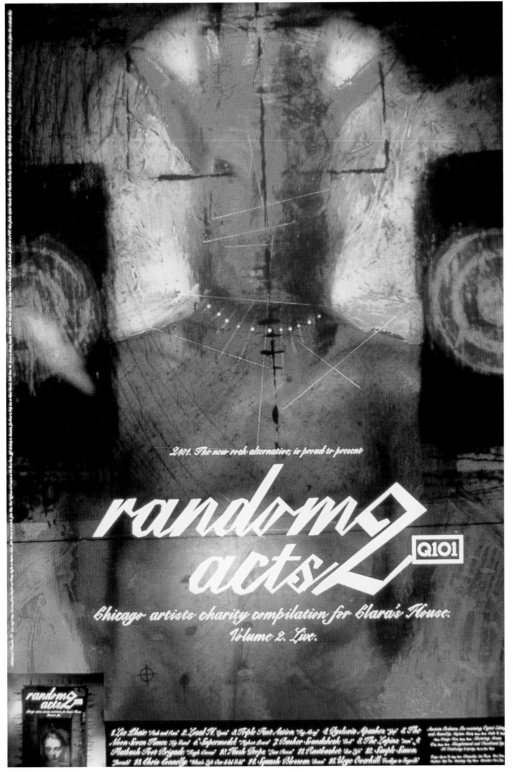

Random Acts 2

Concept: Random Acts 2 is a series of live recordings made by Chicago-area musicians. Sponsored by the area's alternative rock station, Q101, proceeds from the sale of the compact disc were donated to Clara's House, a charity based in Chicago. This poster, designed by SEGURA INC., was used to promote the CD in stores throughout the area.

Production: Carlos Segura and imaging specialist Eric Dinyer started with an original black-and-white photo of a male figure. Dinyer applied paint to the background of the photo and scanned it. The image was brought into Photoshop, where it was converted to CMYK and placed in its own layer.

Dinyer created two paintings to be brought into the composition—one of concentric circles that fall on either side of the figure, and another of a mask-like image superimposed on the head of the figure. Dinyer also scanned additional painted effects and scratches made with a knife on a dark-painted board.

All elements were combined with the Layers palette, where various degrees of translucency and blending were accomplished. Dinyer applied the Airbrush tool and Gaussian Blur filters to create glowing effects in isolated portions of the image, and adjusted Hue and Saturation to achieve the image's fiery colorization.

The completed image was brought into QuarkXPress, where the headline was set in Epaulet, a font available through Segura's [T-26] foundry.

Design Firm: SEGURA INC.
Art Director: Carlos Segura
Designer: Carlos Segura
Illustrator: Eric Dinyer
Computer Manipulation: Eric Dinyer
Client: Q101 Radio
Programs: Adobe Photoshop, QuarkXPress

"Natural Attraction" Paper Promotion

Concept: This poster, designed by Spur Design's David Plunkert, is actually a page in a paper promotion for Cross Pointe Paper Corporation's Genesis line of recycled papers. The poster is one of eight, each by a different designer or illustrator, that comprise a booklet of folded, 34" x 11" (86cm x 28cm) posters secured with a grommet. When the posters are removed, the booklet becomes a swatch book. For his page, Plunkert was asked to come up with an image that supports the phrase "natural attraction." He responded with a retro-inspired poster depicting a man and a woman, outrageously endowed with widgets, gadgets and other contraptions.

Production: Plunkert started by making a collage of the man and woman, created by pasting together selected items from clip files. He scanned the collage on his studio flatbed scanner by taping the image to the scanner lid and lifting it slightly to create the shadow behind the image.

Plunkert achieved a vintage hand-painted look by bringing the grayscale collage scan into Photoshop, where he converted it to CMYK. He used the program's Selection tools to isolate portions of the image and colored them by adjusting Hue and Saturation.

The completed Photoshop image was brought into Adobe Illustrator, where a scan of the poster's type, set with a manual typewriter, was added to complete the vintage look.

Design Firm: Spur Design
Designer: David Plunkert
Illustrator: David Plunkert
Computer Manipulation: David Plunkert
Client: Cross Pointe Paper Corporation
Programs: Adobe Photoshop, Adobe Illustrator

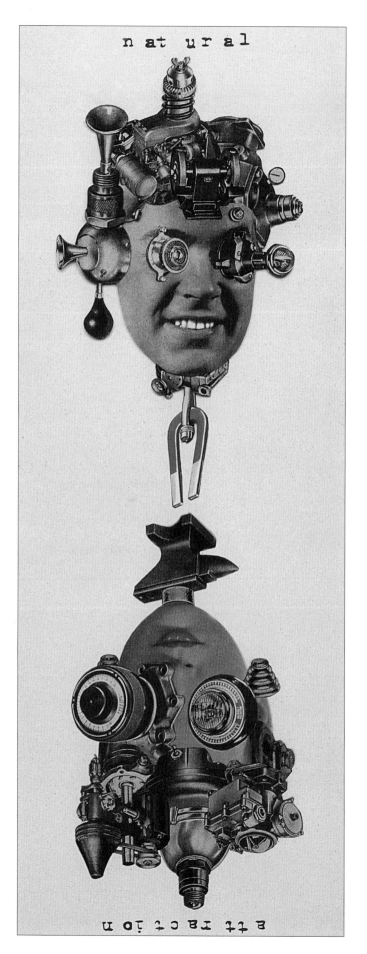

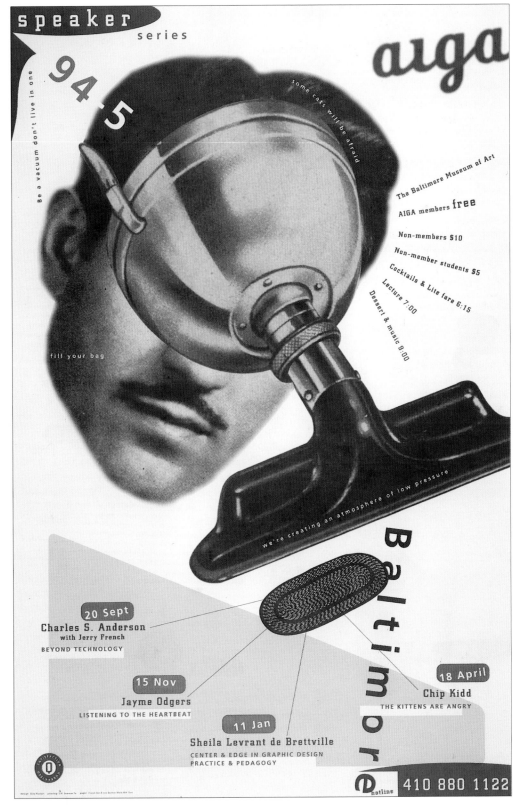

AIGA Speakers Poster

Concept: The Baltimore chapter of the Association of International Graphic Artists (AIGA) tapped local member David Plunkert of Spur Design to design this poster announcing its upcoming speakers for 1994-1995. Given free rein to come up with whatever he felt would best promote the series, Plunkert produced a composite image in Photoshop, drawing imagery from clip art files to convey the idea of sucking up inspiration and information. The poster succeeded in attracting many members to the events it promoted. It also attracted the attention of the national design community, bringing Plunkert recognition from *Communication Arts* magazine, among others.

Production: Plunkert pasted together vintage clips of a man and a vacuum cleaner to create a collage. He scanned this as a grayscale image on his studio scanner and brought it into Photoshop, where he converted it to a CMYK image. Plunkert used Photoshop's selection tools to isolate the man and applied the Gaussian Blur filter to this area. Before finalizing the image, he gave it the look of hand-applied color by adjusting Hue and Saturation.

The lowercase "aiga" in the upper right corner was hand-lettered by Plunkert. He scanned this and placed it into the poster's Adobe Illustrator file, where the Photoshop image was also placed into position. Type and other graphic elements were applied in Illustrator to complete the layout.

Design Firm: Spur Design
Designer: David Plunkert
Illustrator: David Plunkert
Computer Manipulation: David Plunkert
Photographer: David Plunkert
Client: AIGA, Baltimore, Maryland
Programs: Adobe Photoshop, Adobe Illustrator

Global Works Calendar

Concept: Global Works is a software manufacturing company that sends a promotional calendar every year to current and prospective clients. For its 1996 calendar, the company sent this eye-catching poster promoting its Thinking Machine program. For the poster's abstract imagery, Boston-based Stoltze Design used Photoshop to blend three images, generated by their client's software, into one energized hybrid.

Production: The Stoltze designers started with three images generated by Thinking Machine's Connection Machine System. Global Works gave the design firm a library of images to choose from and furnished them with color transparencies for each of the images the designers selected. Each transparency was scanned on Stoltze's studio scanner and then brought into Photoshop. The designers took two of the images and distorted them by

applying the Twirl and Radial Blur filters. These images were then blended with the cube-like image by using Layers. The central portion of the composited image was deleted with the Eraser tool to leave a white area for the calendar. For a soft edge, portions of the image surrounding the white space were selected and then feathered.

When the photo collage was complete it was brought into QuarkXPress, where type and the Global Works logo were added to complete the calendar layout.

Design Firm: Stoltze Design
Art Director: Clifford Stoltze
Designers: Clifford Stoltze, Joe Polevy
Computer Manipulation: Joe Polevy
Client: Global Works Thinking Machines
Programs: Adobe Photoshop, QuarkXPress

Self-Promotion Calendar

Concept: Copeland Hirthler design + communications reinvented the calendar with this selection of monthly cards encased in a plastic compact disc jewel case. Its cover folds back to serve as a stand-up display for each card. The Atlanta-based design firm sent this gift to clients and studio friends for the 1995 holiday season. Each card displays a graphic interpretation of a calendar month by one of the firm's thirteen designers. The opposite side of each card notes holidays and explains why each designer chose their unique approach. The calendar exhibits the firm's range of stylistic capabilities.

Production: Copeland Hirthler designers used all the major design programs in the production of the cards; however, Mark Ligameri's design for January, 1997, relied heavily on Photoshop special effects. The image that serves as the grid for the calendar started as a line drawing in Adobe Illustrator. Ligameri imported the drawing into Photoshop and applied the Lighting Effects filter to achieve highlights and shadows. To create a fade, he applied the

Gaussian Blur filter to isolated segments on both ends of the image. The Gaussian Blur filter was also applied to the entire image for an overall blurred effect. He worked in grayscale mode and converted the image into a silver and teal duotone before bringing it into an Illustrator file for the card's layout.

Although the calendar's cover card appears to be layers of images that could have been composed in Photoshop, it was produced by making crayon rubbings of textures and applying a turpentine wash to the rubbings. All of the cards that comprise the calendar were printed in teal, orange and silver.

Design Firm: Copeland Hirthler design + communications
Creative Directors: Brad Copeland, George Hirthler
Art Directors: David Butler, Raquel Miqueli
Designers: Mark Ligameri, Lea Nichols
Computer Manipulation: Various
Client: Copeland Hirthler design + communications
Programs: Adobe Photoshop, Adobe Illustrator

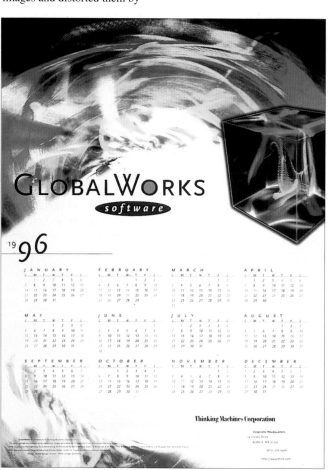

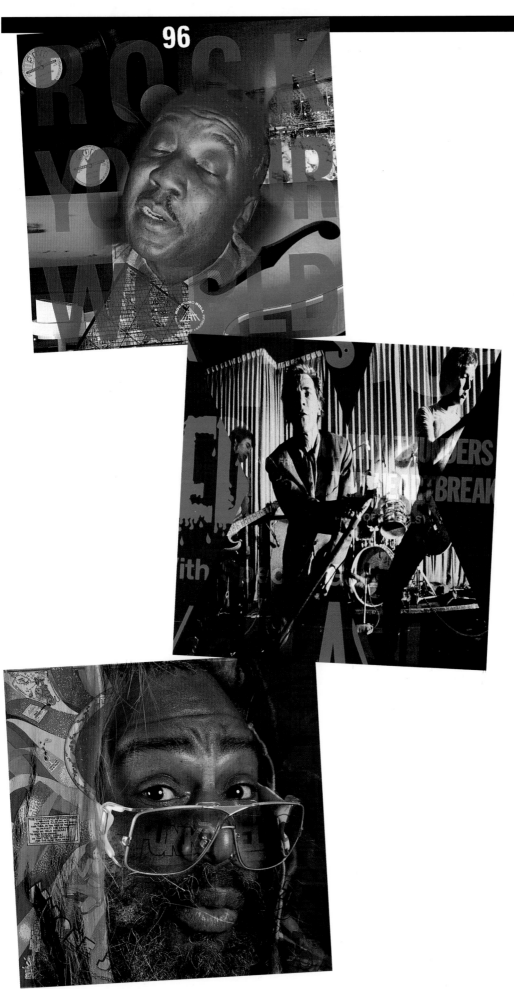

Rock and Roll Hall of Fame Calendar

Concept: Cleveland-based Nesnadny + Schwartz was honored and inspired when it was selected to design the first-ever calendar for the Rock and Roll Hall of Fame and Museum. The 1996 calendar features vintage photos of great recording artists such as Chuck Berry and Janis Joplin, not to mention George Clinton and the Sex Pistols, in photographic settings that push the edge of today's technology.

Production: Art director Mark Schwartz and designer Brian Lavy used Photoshop to combine photos of the recording artists captured in their prime with other images and graphics from the era, such as posters and newspaper clippings.

The Nesnadny + Schwartz design team scanned the photographs and other items on their studio scanner and worked with them at low resolution to compose the collages. Multiple layers were used to combine the photos using Photoshop's options and filters. The designers used a color printer to proof the results.

To achieve the kind of high quality only obtainable from professional four-color prepress equipment, the Nesnadny + Schwartz designers used their scanned images as "for position only" indicators. The final images for the calendar were scanned at the printer and assembled on a professional system. Other elements in the calendar, such as the introductory page and monthly pages, were created in QuarkXPress.

Design Firm: Nesnadny + Schwartz
Art Directors: Mark Schwartz, Joyce Nesnadny
Designers: Joyce Nesnadny, Brian Lavy, Michelle Moehler
Photographers: Various
Client: Rock and Roll Hall of Fame and Museum
Programs: Adobe Photoshop, QuarkXPress

Ludlow Garage Concert Poster

Concept: A gathering of rock bands, former employees and patrons of the Ludlow Garage, a well-known and well-remembered Cincinnati rock establishment, sparked the creation of this poster promoting a twenty-fifth reunion—a day of music, memories and nostalgia. The poster features the Ludlow Garage regulars who organized the reunion, plus a psychedelic border treatment reminiscent of 1960s rock concert posters.

Production: The group photo was shot by photographer Tony Arrasmith, who provided Mad Macs' Jeff Siereveld with a transparency. Siereveld scanned the transparency on his studio scanner and brought the image into Photoshop, where he and

art director Dan Britt made color adjustments and embellished the photo with some changes. Additions to the existing photo included inserting hands with fingers formed in a V-shaped peace greeting, superimposing a different face on one individual who was looking away when the photo was taken, and adding spray-painted graffiti to the wall in the background and a canister.

The poster was originally composed in Adobe Illustrator, but when it came time to make four-color negatives from the Illustrator files, its vector-based gradients choked the service bureau's imagesetter. Siereveld and Britt worked together to reconstruct the poster in

Photoshop by copying the Illustrator paths and pasting them into Photoshop. Because Photoshop is a raster-based program, the poster negatives could be printed without difficulty. The Illustrator file for the copy at the bottom of the poster was retained to ensure that the type would print clearly.

Design Firm: Brain Sells
Art Director: Dan Britt
Designer: Dan Britt
Computer Manipulation: Mad Macs
Photographer: Tony Arrasmith
Clients: Friends of Ludlow Garage, Cincinnati Park Board
Programs: Adobe Illustrator, Adobe Photoshop

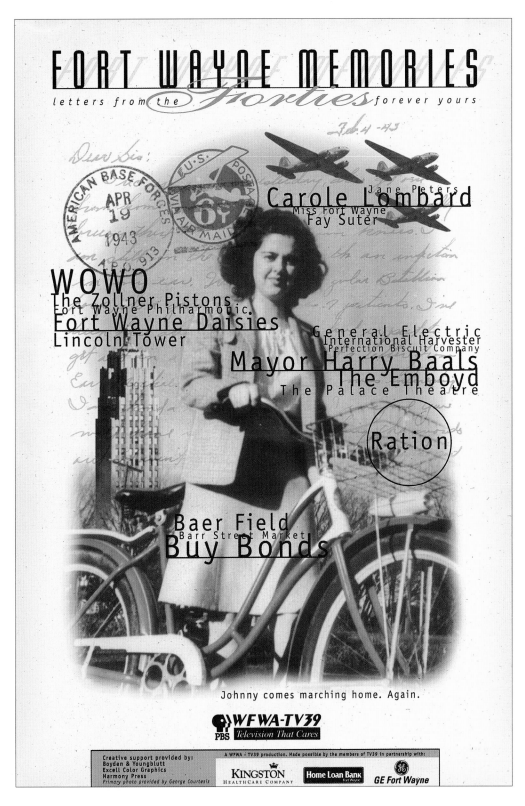

Fort Wayne Memories Poster

Concept: To promote Fort Wayne Memories, a program about life in Fort Wayne during World War II that aired on the Indiana city's PBS television station, designer Don Weaver created this collage of nostalgic images. "The show took viewers back in time through letters written by GIs during the war," he explains. The collage was used on a promotional poster as well as on the packaging for a videotape of the program. The only materials Weaver was given to work with were old letters and photos which were used in the course of the show's production. Because bicycles were commonly used during the war to conserve gas, Weaver chose a photo of a woman with a bike as the central figure for the poster. To create a local setting, he added a photo of a vintage Fort Wayne landmark, the Lincoln Tower, which was the city's tallest building at that time.

Production: The fighter planes flying in formation were actually created from a photo of a single plane. Weaver scanned the photo and brought it into Photoshop, where he used the Rubber Stamp tool to clone two copies of the plane. The photos of the woman with the bike and the Lincoln Tower were brought into Photoshop and colorized. Weaver converted them to CMYK images and colored isolated portions of each photo by adjusting the color balance within that area.

The poster was assembled in Macromedia FreeHand, where the Photoshop images were combined with type and other elements, such as a hand-written letter and postal cancellation marks from the 1940s.

Design Firm: Boyden and Youngblutt
Art Director: Andy Boyden
Designer: Don Weaver
Client: WFWA-TV
Programs: Adobe Photoshop, Macromedia FreeHand

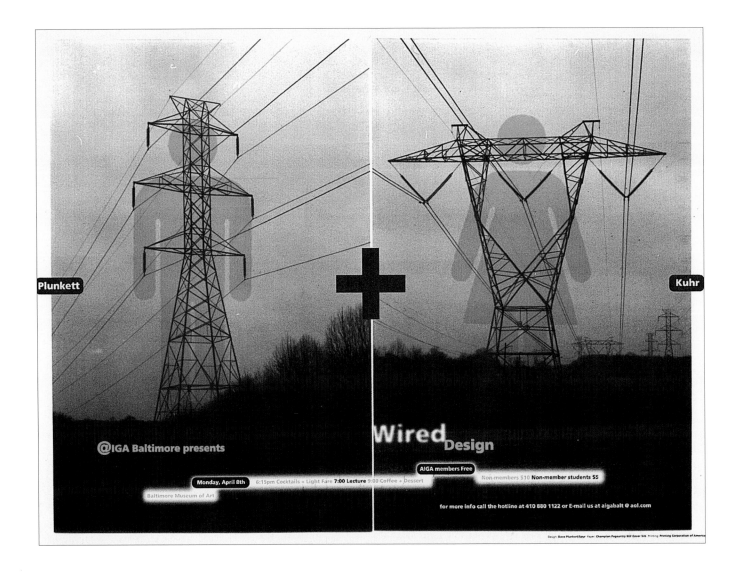

AIGA Baltimore Lecture Invitation

Concept: To promote AIGA Baltimore's "Wired Design" lecture, local designer David Plunkert of Spur Design came up with the idea of merging male and female icons with photos of high-voltage electrical wires. His concept took the form of a poster which was mailed to area designers and other creative professionals. The poster was not only successful in drawing people to the event, it has also won wide recognition in the form of several awards.

Production: Plunkert first took black-and-white photographs of the high-voltage wires he wanted to use. He scanned these, along with clip art images of the male and female icons, on his studio scanner. The images were brought into Photoshop, where each was converted into a CMYK image. Plunkert then created a separate channel for the photos and the icons before compositing them into a single image. The black portions of the images printed as the black channel, while the portion printed in fluorescent orange was assigned the magenta channel. Plunkert was able to get better clarity this way than if he had printed the poster image as a duotone.

The word "Wired" was set in Photoshop and blurred with the Gaussian Blur filter; other type and graphic elements were added in Adobe Illustrator. The two Photoshop images, one for each half of the poster, were brought into the Illustrator poster file.

Design Firm: Spur Design
Designer: David Plunkert
Illustrator: David Plunkert
Photographer: David Plunkert
Computer Manipulation: David Plunkert
Client: AIGA, Baltimore, Maryland
Programs: Adobe Photoshop, Adobe Illustrator

Riverwood International Poster

Concept: Riverwood International manufactures packaging materials from its own trees. To encourage employee support after internal restructuring and other improvements implemented after a recent merger with another corporation, Riverwood International commissioned Copeland Hirthler design + communications to create this poster celebrating the "next wave" in the corporation's future. Copies of the poster were sent with a videotape to all of Riverwood's facilities.

Production: Copeland Hirthler designer Todd Brooks started with color transparencies purchased from a stock agency of a hand, a globe, a breaking wave and water droplets. He scanned all of the images on the studio scanner and brought them into Photoshop. Brooks duplicated the globe and enlarged it and applied the Radial Blur filter to the enlarged image to achieve a swirly effect. Contrast was heightened on other images, such as the water droplets. The globe, hand, wave and water images were blended and composited into the final image with Layers, and then converted to a black-and-blue duotone.

Brooks brought the completed image into a QuarkXPress file, where the type at the bottom was added. The Next Wave logo was created in Adobe Illustrator and brought into the poster as an EPS file.

Brooks created a low-resolution comp of the poster to show to his client, and then gave it to Davidson and Company, a firm that specializes in computer imagery, to develop into a high-res version. Davidson and Company made high-res scans of the transparencies and used Photoshop to assemble them into the composited image. A low-res version of the image was used in Brooks's QuarkXPress file of the poster, and replaced with the high-res

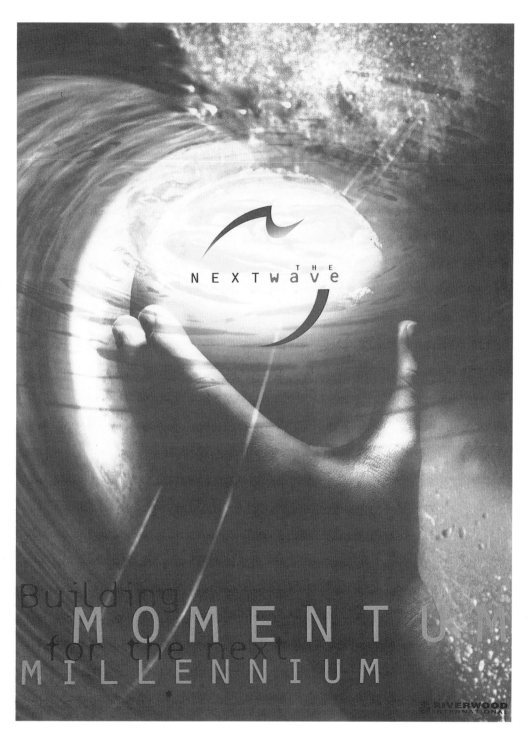

version at the printer. The poster was printed in blue, black and silver.

Design Firm: Copeland Hirthler design + communications
Art Director: Todd Brooks
Designer: Todd Brooks
Computer Manipulation: Todd Brooks, Davidson and Company
Client: Riverwood International
Programs: Adobe Photoshop, Adobe Illustrator, QuarkXPress

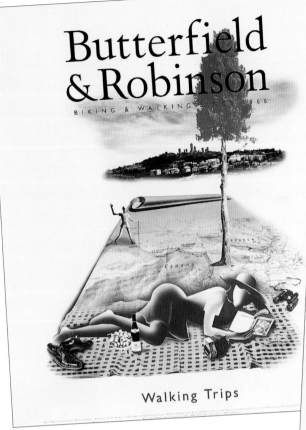

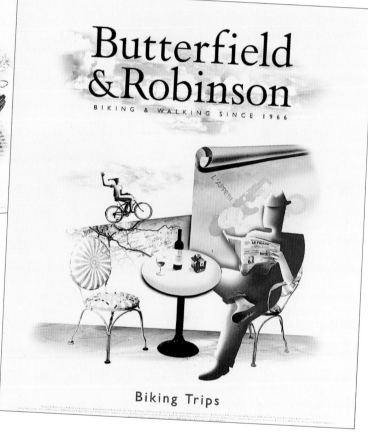

Butterfield & Robinson Tour Posters

Concept: Butterfield & Robinson is a tour company that specializes in walking and biking tours of cities and regions all over the world. To promote its tours, the company hired Viva Dolan Communications to design two posters, one each for its walking and cycling tours. The posters needed to look different, yet somehow be visually unified to present a consistent image. Viva Dolan principal Frank Viva decided to make a composite image that incorporates a realistic representation of the trappings one would typically associate with a leisurely vacation. Within each composi-

tion are figures purposely given a generic look so the viewer can easily identify with the subjects depicted in each poster. By using similar imagery and Photoshop compositing techniques, Viva was able to maintain a consistent look for both posters.

Production: Viva started with images of maps, landscapes, binoculars, cameras and other objects supplied by a variety of sources, including original photographs from his studio collection. Viva scanned these images on his studio scanner and brought them into Photoshop, where each image was isolated

from its background. Some images were feathered to vignette them, while others were saved with well-defined edges. Images were grouped into as many as five different layers, and then saved.

Viva created the human figures by using the Pen and Airbrush tools and saved these as an additional layer. He used the Layers command to composite all elements into a single composition, and then adjusted Hue and Saturation to achieve colorization that simulates a duotoned effect.

When Viva was done with each of the images, he brought

them into QuarkXPress, where the Butterfield & Robinson logo was added as well as the type. The posters were printed in four-color process plus a match color for the red type at the bottom of each poster.

Design Firm: Viva Dolan Communications
Art Director: Frank Viva
Designer: Frank Viva
Illustrator: Frank Viva
Computer Manipulation: Frank Viva
Client: Butterfield & Robinson
Programs: Adobe Photoshop, QuarkXPress

Miken Printing
Promotional Poster

Concept: This eye-catching poster was created to promote the capabilities of Miken Printing, a Buffalo, New York–based printer. The image was one of several designed by Frank Petronio which were featured in Miken's promotional calendar. The poster achieved high recognition in the Buffalo area, garnering a Gold Award from the Buffalo Art Director's Club.

Production: Petronio started with his own transparency, a soft-focus photo of a woman, and digitized it on his Scitex drum scanner. After bringing the scanned image into Photoshop, Petronio used the Hue and Saturation controls to intensify its colors. He applied the program's Blur filters so that the woman would recede into the background, allowing the type and other graphic elements essential to the poster's message to stand out in the foreground. Petronio added the letters in the lower right corner by drawing a lower-case and scripted "e," and converted them to paths. To achieve the gradated effect on the scripted "e," he made a channel of a gradated blend and then applied it to the path. Petronio also applied the Noise filter to the blend to prevent it from banding.

The image of the woman with the letters was brought into QuarkXPress where promotional copy and the word "emotion" were added. Miken printed the poster from Petronio's QuarkXPress file.

Design Firm:
Frank Petronio > commercial artist
Designer: Frank Petronio
Computer Manipulation:
Frank Petronio
Client: Miken Printing
Programs: Adobe Photoshop, QuarkXPress

DBD International, Ltd.
Self-Promotional Poster
and Calendar

Concept: DBD International's self-promotional poster and calendar is mailed quarterly to current and prospective clients. All posters in the series have an art deco look achieved by rendering them in Adobe Illustrator. DBD principal David Brier took this calendar a step further, adding rich texture and dimensionality by using Photoshop to enhance an image created in Illustrator.

Production: The man and the art deco background were first created in Illustrator as a black-and-white, continuous-tone image.

The illustration was then brought into Photoshop, where the Airbrush tool was applied to selected areas of the image. To enhance the illustration's sense of dimensionality, Brier used the Noise, Mezzotint and Emboss filters, overlapping them until he achieved the desired effect.

For rich coloration, the illustration was converted to a black, brown and gold tritone before it was brought back into Illustrator for final adjustments. Brier used Illustrator to add the remaining elements. The poster was printed from Brier's Illustrator file.

Design Firm: DBD International, Ltd.
Art Director: David Brier
Designer: David Brier
Illustrators: Michael Perna, David Brier
Computer Manipulation:
Michael Perna, David Brier
Client: DBD International, Ltd.
Programs: Adobe Photoshop, Adobe Illustrator

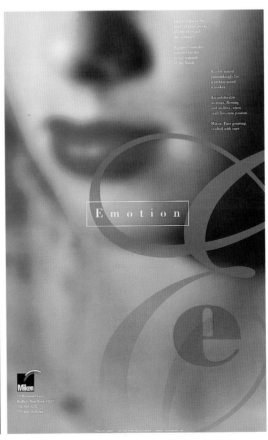

"Weakening Web" Museum Exhibit Promotion

Concept: "Our Weakening Web: The Story of Extinction" is a traveling exhibit that appears in museums across the country. To promote the exhibit when it appeared at the Cincinnati Museum of Natural History, creative director Dan Britt and designer Greg Goldsberry chose to focus on the exhibit's theme of our ecosystem's interdependency. Britt and Goldsberry came up with a spiral configuration that incorporates over fifty images of animal and plant life. Background textures that suggest water, grass, desert and mountain terrains against a backdrop of sky reinforce the image's environmental message. The image was adapted to a poster (shown here), as well as to billboards, a brochure, print ads and an animated segment for TV.

Production: Most of the images that comprise the spiral portion of the poster were taken from printed materials found at the resource library of the Cincinnati Museum of Natural History. They came from a broad range of sources which included book plates, art prints, original photos and video cells.

Computer experts Jeff and Tina Siereveld of Mad Macs did the painstaking work that was necessary to composite these images into the final poster. Each image was scanned on their studio scanner and then outlined in Photoshop before it was placed in the spiral configuration. The background images were provided as transparencies by photographer Tony Arrasmith. The Sierevelds used Photoshop's Calculate features to superimpose the image of the sky on a photo of a crumpled

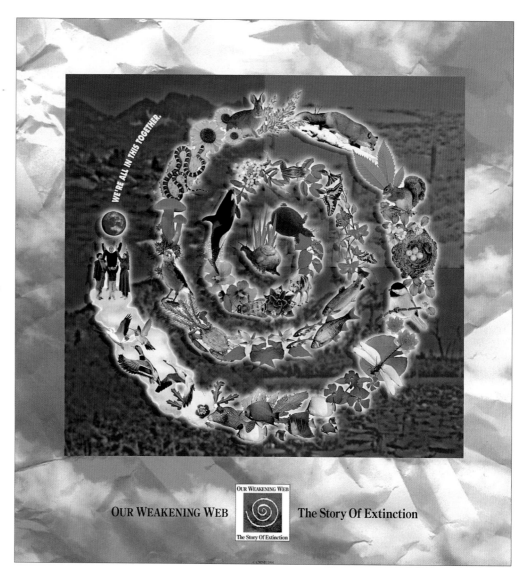

sheet of paper.

The completed Photoshop image was brought into QuarkXPress, where type and the exhibit's logo were added.

Design Firm: Mad Macs
Creative Director: Dan Britt
Designers: Greg Goldsberry, Dan Britt
Computer Manipulation: Jeff and Tina Siereveld
Photographer: Tony Arrasmith
Client: Cincinnati Museum of Natural History
Programs: Adobe Photoshop, QuarkXPress

Aureole Seventh Anniversary

Concept: To celebrate its seventh anniversary, Manhattan's Aureole Restaurant sent this limited edition print to clients and friends of the four-star restaurant to thank them for their patronage. The poster, which features a winged goddess, was letterpress printed by San Francisco–based Julie Holcomb on 100 percent cotton rag paper and blind-embossed with a scripted initial "A." It was sent in a blind-embossed portfolio which included a vellum insert printed in gold with a message of appreciation.

Production: Five images from photographer R.J. Muna were combined to make the image of the winged goddess: clouds; a costumed model posing as the goddess; dove's wings; and light and texture and gauze floating in water. High-resolution scans of the color transparencies were made and brought into Photoshop, where Muna and AERIAL principal Tracy Moon placed the five images on their own layers.

Muna photographed the dove's wings at an angle that would work for positioning on the goddess and, after isolating the wings from the rest of the dove, used Cut and Paste to superimpose them on the model. Muna and Moon used the Layers palette to blend the three background elements together and composite them with the image of the winged goddess. Opacity settings and Feathering were used to achieve a realistic blend.

The completed image was brought into a QuarkXPress file, where type was added. AERIAL furnished letterpress printer Julie Holcomb with films for the poster.

The job was printed in five colors—an unusual undertaking for a vintage printing technique, which is usually limited to one or two colors. Although the image of the goddess was saved in CMYK mode, it was printed in three-color process (CMY). For a light, airy image, AERIAL specified no negative for the black to ensure the figure's color wouldn't be muddied. For the poster's typography, two match colors (plum and copper) were added to the press run.

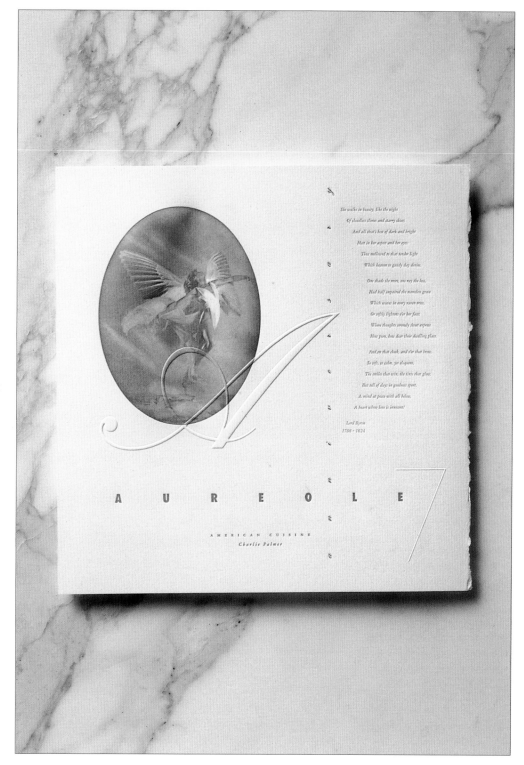

Design Firm: AERIAL
Art Director: Tracy Moon
Designer: Tracy Moon
Photographer: R.J. Muna
Computer Manipulation: Tracy Moon
Client: Charlie Palmer, Aureole Restaurant
Programs: Adobe Photoshop, QuarkXPress

Wichita State University School of Art and Design

Concept: To promote a faculty exhibition at the Wichita State University School of Art and Design, Bruce Plank was faced with the challenge of designing a poster that would represent a variety of artistic endeavors—work which would encompass all types of crafts, design and fine arts mediums. Plank felt that every piece in the exhibition had one thing in common—all were created with hands, the mind and the soul. With this in mind, he chose the saying "With Head, Heart and Hand," attributed to writer Herbert Bayer, to serve as the poster's headline and theme. The poster was tacked up around the Wichita State University campus and distributed by direct mail—it folds neatly into a $8\frac{1}{2}$" x $11\frac{3}{4}$" (22cm x 30cm) self-mailer. On the reverse side of the poster, three panels promote the School of Art and Design, while the fourth panel serves as the address panel for the mailer.

Production: Plank started with a 35mm slide of clouds, furnished by photographer Paul Bowen. He had the slide scanned on a professional drum scanner before bringing it into Photoshop to serve as the background. To create the effect of a palette superimposed on the sky, Plank first drew the outline of a palette in Adobe Illustrator, and then imported the drawing into his Photoshop document of the sky. Plank used the Layers feature to merge two layers of the sky and a layer of the palette outline filled with white. The shadow was created with the Gaussian Blur filter and Feathering features.

The heart was also drawn in Illustrator and then brought into the Photoshop composition, where several Gallery Effects filters were applied to achieve a painterly effect. Plank feathered the image to achieve translucency.

To complete the poster, a

digital photograph of a hand, shot by Don Siedhoff of Rock Island Studios, was brought into Photoshop, where a mask was created to isolate the hand. Plank also brought in a vintage etching of an eye, a clip art image which he scanned on his studio scanner.

To complete the poster, type was added to the Photoshop collage in Illustrator.

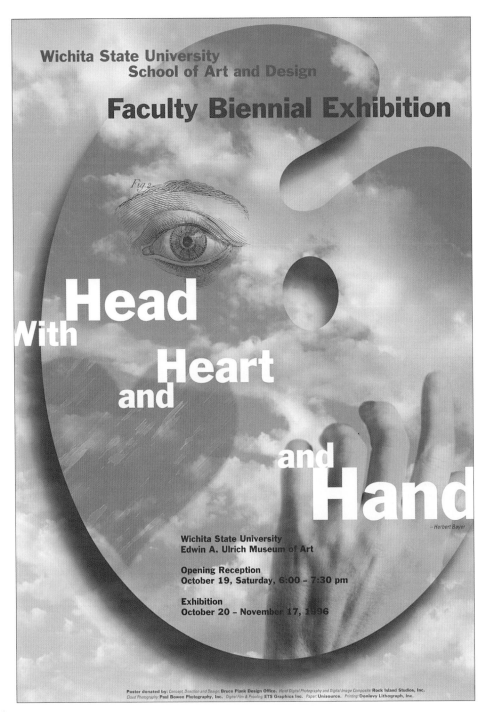

Design Firm: Bruce Plank Design Office
Art Director: Bruce Plank
Designer: Bruce Plank
Computer Manipulation: Bruce Plank, Aaron Lentz (Rock Island Studios)
Photographers: Paul Bowen, Don Siedhoff (Rock Island Studios)
Client: Wichita State University School of Art and Design
Programs: Adobe Photoshop, Adobe Illustrator

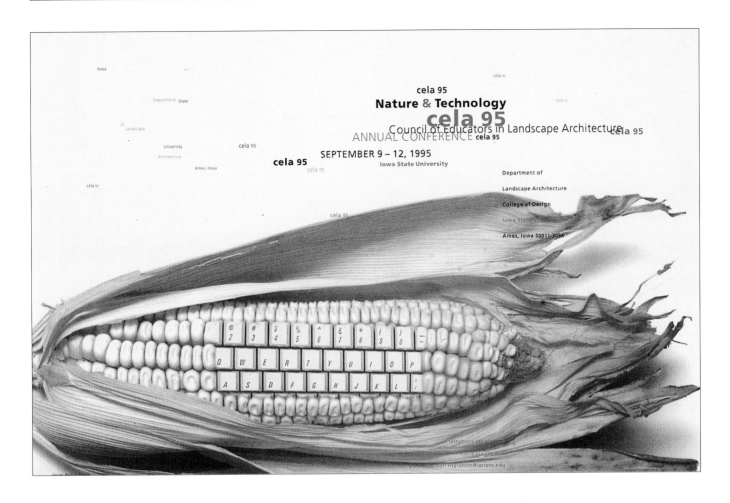

Council of Educators of Landscape Architects Conference

Concept: When the Department of Landscape Architecture of Iowa State University sponsored the 1995 annual conference of the Council of Educators of Landscape Architects, Iowa State University faculty member Paula J. Curran was asked to design a promotional poster for the event. The poster needed to include an image or graphic as its focal point which could be used as an identity for the conference—an icon that could be printed on T-shirts, name tags and other promotional items. Because the conference theme was nature and technology, Curran came up with the idea of merging corn with a computer keyboard. The corn echoed the theme of nature and also symbolically represented the conference's Iowa site. The poster has been widely recognized by the design community, receiving

awards from *Print* and *HOW* magazines, as well as the Art Directors of Iowa.
Production: Curran commissioned two black-and-white photos of the poster's visuals. Each photo was scanned on a flatbed scanner and brought into Photoshop, where the Selection tools were used to isolate each image from its background. Each image was then scaled to a size that would allow the keyboard and corn kernels to become interchangeable.

Computer specialist Steven Crabb used Photoshop's Channels feature to create a mask for the keyboard and then pasted it on the ear of corn. Infini-D was used to slightly skew and scale down the keys on the right side to conform to the size of the kernels. The Airbrush tool was used to blend edges where necessary.

The image was brought into an Adobe PageMaker file, where type was added. The poster was printed in black plus a match color.

Design Firm: Paula J. Curran
Art Director: Paula J. Curran
Designer: Paula J. Curran
Computer Manipulation:
Steven Crabb
Photographer:
Greg Scheideman
Client: Department of Landscape Architecture, Iowa State University
Programs: Adobe Photoshop, Adobe PageMaker, Infini-D

Art Directors' Association of Iowa Speakers Promotion

Concept: Mark Oldach was able to take advantage of his full name by using his initials, M.O.O., in this poster promoting his speaking engagement at the Art Directors' Association of Iowa. While one side of the poster makes an impact with the word "moo," the other side uses the silhouette of a cow to support the concept, tying in creative "tips" with aspects of the cow's anatomy. The combination poster/invitation was sent to members of the Art Directors' Association of Iowa and was extremely well received. It has won national recognition, appearing in the 1996–1997 *Applied Arts Annual* as well as other design publications.
Production: Oldach and his design team worked primarily in Adobe Illustrator to produce the graphics and type that comprise the poster. However, the silhouette of the cow with a photorealistic eye was composed in Photoshop. Designer Guido Mendez drew the silhouette in

Illustrator and then imported the paths into Photoshop. The Gaussian Blur filter was applied to achieve a hazy image.

The cow's eye was taken from a black-and-white printed image of a cow and scanned on Oldach's studio scanner. The Despeckle filter was applied to eliminate a moiré. Guido used the circular selection tool to select the eye and did a simple Cut/Paste function to superimpose it on the cow silhouette.

When the image was complete, it was brought into Illustrator, where color, type and graphics were added.

Design Firm: Mark Oldach Design, Ltd.
Art Director: Mark Oldach
Designer: Guido Mendez
Computer Manipulation: Guido Mendez
Client: Art Directors' Association of Iowa
Programs: Adobe Photoshop, Adobe Illustrator

Restaurant Kitchen Safety Poster

Concept: "Ooops! Count the slip-ups in this kitchen," states this poster designed by Mark Oldach Design, Ltd. The poster was commissioned by the Educational Foundation of the National Restaurant Association to remind restaurant employees of safety in the kitchen. Firm principal Mark Oldach didn't want to depict kitchen hazards in a literal, heavy-handed manner and risk an austere, possibly depressing poster that employees wouldn't want to have posted in their workplace. He also wanted to avoid a cartoon approach that would have detracted from the serious nature of the poster's message. He struck a balance by using colorful illustrations that communicate workplace safety in an upbeat, contemporary manner.
Production: Freelance illustrator Chris Lensch started by creating

each of the three illustrations as line art in Adobe Illustrator. These illustrations were imported into Photoshop, where color and dimensional detailing were added using the Gradient, Airbrush and Painting tools. Clipping paths were added to outline each illustration before they were imported back into Illustrator, where type was added to produce the final layout for the poster.

Design Firm: Mark Oldach Design, Ltd.
Art Director: Mark Oldach
Designer: Guido Mendez
Illustrator: Chris Lensch
Computer Manipulation: Guido Mendez, Chris Lensch
Client: Educational Foundation of the National Restaurant Association
Programs: Adobe Photoshop, Adobe Illustrator

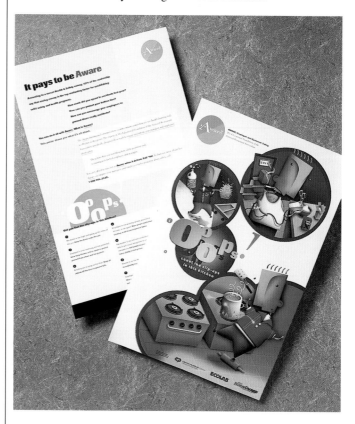

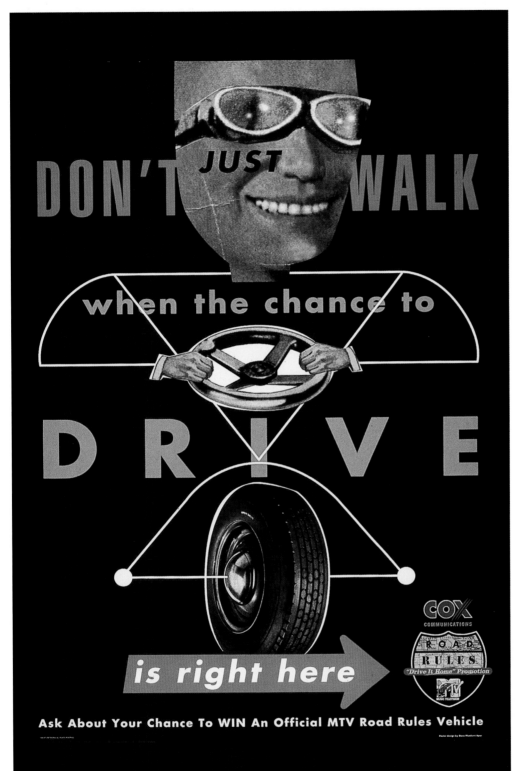

MTV *Road Rules* Contest

Concept: To promote *Road Rules*, a real-life adventure series, MTV sponsored a contest with a car as the prize. David Plunkert of Spur Design created this poster to promote the contest by using the computer to enhance and assemble clip art collage images.

Production: Plunkert started with a clipped image of a head with goggles pasted on it. He scanned this on his studio scanner and brought it into Photoshop, where he applied the Color Halftone filter to give the image a grainy look. The hands and steering wheel and the tire are also vintage clips which Plunkert scanned on his flatbed scanner. These images, and the one of the head with goggles, were color-corrected in Photoshop by adjusting Brightness and Contrast as well as Hue and Saturation controls.

Each image was saved separately as an EPS file and then brought into Adobe Illustrator, where line art was created and type and logos added to complete the poster.

Design Firm: Spur Design
Art Director: Chris Davis/MTV Networks
Designer: David Plunkert
Illustrator: David Plunkert
Computer Manipulation: David Plunkert
Photographer: David Plunkert
Client: MTV Networks
Programs: Adobe Photoshop, Adobe Illustrator

Self-Promotional Poster

Concept: To celebrate the 1995 holiday season, PandaMonium decided to send its clients two posters and a custom-packaged flip book to commemorate the Chinese New Year's "Year of the Pig." PandaMonium likes to use its holiday self-promotions to show off its design capability as well as a variety of illustration styles and digital rendering techniques.

Production: The "Hog Heaven" image of the biker pig was created by taking a photograph of a stuffed pig in motorcycle gear, scanning it into Photoshop so that images of motorcycles could be pasted onto the lenses of the pig's sunglasses. Designer Steven Lee used the masking features to composite the images.

The retro-inspired "Pandasonic" radio in the lower left corner of the poster was drawn in Adobe Illustrator and brought into Ray Dream Designer, where a texture was mapped on the radio's surface and the drawing was given an additional sense of dimensionality. The three-dimensional rendering was then brought into Photoshop, where shadows and highlights were added by selectively lightening and darkening specific areas of the radio.

Other images in the poster consist of digital renderings, photos, clip art images and original illustrations. All of the images were brought into QuarkXPress, where type was added and the final layout was produced.

Design Firm: PandaMonium Designs
Art Director: Raymond Yu
Designers: Raymond Yu, Steven H. Lee
Illustrator: Steven H. Lee
Computer Manipulation: Steven H. Lee
Client: PandaMonium
Programs: Adobe Photoshop, Adobe Illustrator, Ray Dream Designer, QuarkXPress

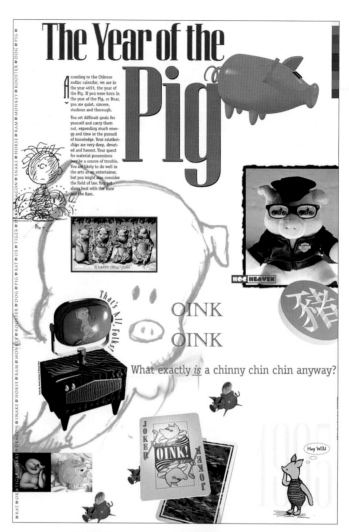

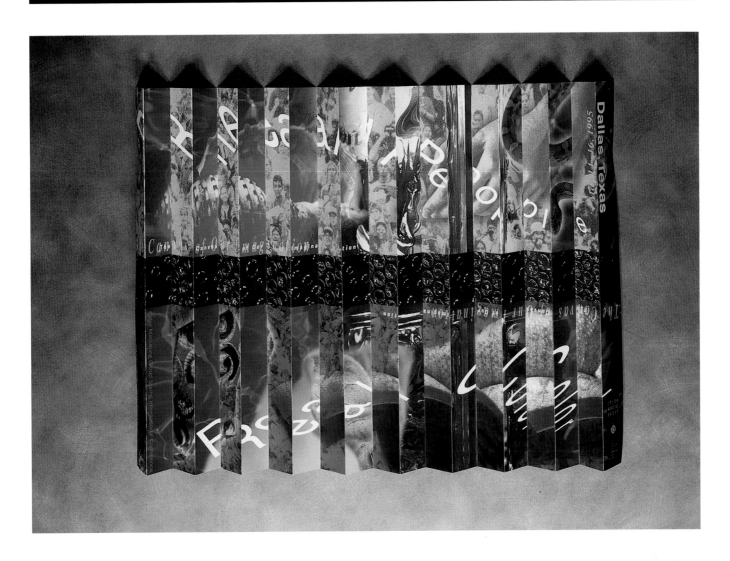

Color Marketing Group
Conference Promotion

Concept: To announce the Color Marketing Group's Spring 1995 *International Color Conference*, B-LIN created this accordion-folded poster. Designed to be viewed from many different angles, the multifaceted poster projects a sense of blending real and imagined images, an aspect that reinforces the conference's title: "Real People, Real Color, the Canvas of Our Imagination." The poster was sent in a mailing tube to members of the Color Marketing Group to announce the group's conference.

Production: B-LIN principal Brian J. Lovell and designer Cecilia Sasaki started by scanning a variety of black-and-white and color photos on the studio's scanner. The photos were taken by Lovell and

included a crowd scene, bubbles, bubble wrap, a hand, a shell, a necktie, a snake, a leaf and water. Each image was brought into Photoshop, where color photos were color enhanced and black-and-white photos were colorized by adjusting Hue and Saturation. The designers applied the Noise filter to the crowd scene, and blended some images by selecting the Opacity option under the Layers palette.

Lovell and Sasaki created two QuarkXPress files: one for the left side of each accordion fold, and one for the right side. The designers created picture boxes in the same places for each QuarkXPress file so that the Photoshop images would be placed in the same spot on

opposite sides of each accordion fold. The designers juxtaposed images that were similar in form and texture, but dissimilar in other ways. Curvy type for the poster's "Real People, Real Color" headline, created in Adobe Illustrator, was brought into the QuarkXPress file, while other type was set in QuarkXPress.

Design Firm: B-LIN
Art Director: Brian J. Lovell
Designers: Brian J. Lovell, Cecilia Sasaki
Computer Manipulation: Cecilia Sasaki
Photographer: Brian J. Lovell
Client: Color Marketing Group
Programs: Adobe Photoshop, Adobe Illustrator, QuarkXPress

Shepherd College Recruitment Poster

Concept: Shepherd College, a school offering degrees in art, photography and design, commissioned David Plunkert of Spur Design to design this recruitment poster. Plunkert chose to represent the school with a composite image that combines the college's creative curriculum with visuals unique to its West Virginia location, such as a tire to symbolize its automotive industry and wood to represent the area's lumber and furniture manufacturing. The poster was sent to regional high schools and posted on bulletin boards.

Production: Plunkert used a combination of stock images, clip art and original photographs for his composition. After scanning the images on his studio's flatbed scanner, he brought them into Photoshop, where they were outlined and isolated before being composited.

Because Plunkert was working in a version of Photoshop that predated the program's current Layers feature, he created the top portion of the image which contains the tire, pipe, wooden shape and brain as one Photoshop file, and the bottom portion as a second Photoshop file. The word "learn" was set in Photoshop, whereas the word "Art" was a found piece of art which Plunkert scanned.

When he was done with both Photoshop files Plunkert brought them into Adobe Illustrator, where he added more type and graphic elements before finishing the poster's layout.

Design Firm: Spur Design
Art Director: David Plunkert
Designer: David Plunkert
Illustrator: David Plunkert
Computer Manipulation: David Plunkert
Photographer: Geoff Graham
Client: Shepherd College
Programs: Adobe Photoshop, Adobe Illustrator

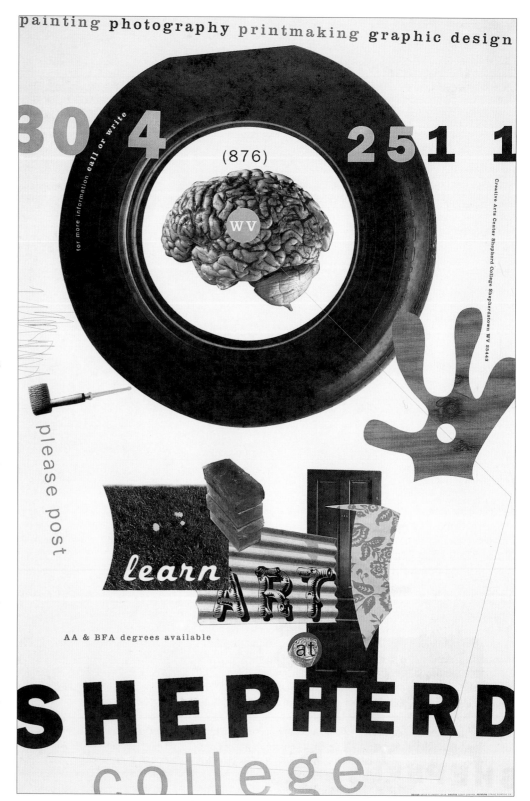

French Paper Promotion

Concept: Designer Barry Townsend took his cue from the industrial look of French Paper's Dur-O-Tone stock when he came up with this poster concept to promote the company's papers. An obviously "over-designed" and "under-engineered" truck with square wheels supplied the image he needed to get the poster's message across.

Production: Townsend started with a toy dump truck made by Caterpillar, a small-scale replica of one of its real trucks, and had a model maker replace the wheels on the truck with square ones. Photographer George Fulton shot a 4" x 5" (10cm x 13cm) transparency of the truck, which served as the central image in the poster, as well as front and side views to use as additional elements in the poster.

Townsend scanned the transparencies and brought them into Photoshop, where "French" was added to the side of the truck using the program's Type tools. Masks were created in Photoshop to isolate the trucks from their original dark grey background. The truck that serves as the poster's central image proved to be especially hard to outline because portions of the image were out of focus. Townsend ultimately feathered the edges of the truck that recede into the background to give them a soft-focus look.

To achieve a slightly rough look, the poster's type, border and other graphic elements were created in QuarkXPress and Macromedia FreeHand, scanned on Townsend's studio scanner, and then brought into the Photoshop file of the truck image.

The digital files that served as the poster's mechanical were created with a duplicate set of high-resolution scans made from Fulton's transparencies on

a drum scanner. Townsend worked with low-res scans and created a low-res version of the poster for Classic Graphics to work with in assembling the final, digital mechanical. The poster was printed from this Photoshop file in four-color process plus copper metallic ink on French Dur-O-Tone butcher wrap.

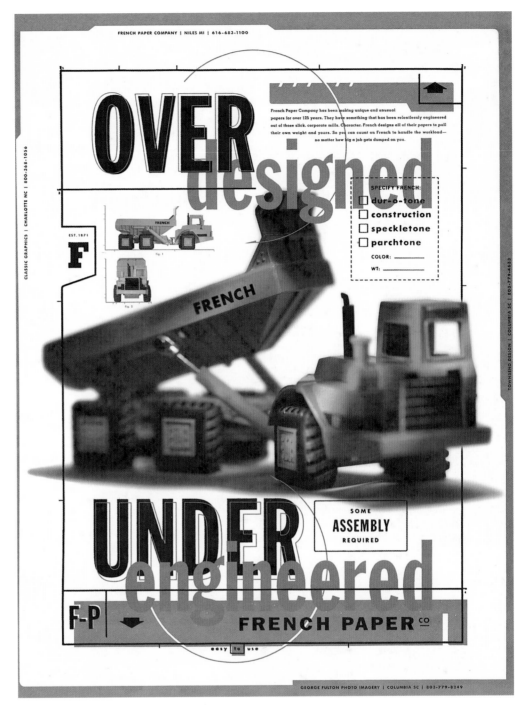

Design Firm: Townsend Design
Art Director: Barry Townsend
Designer: Barry Townsend
Photographer: George Fulton Photo Imagery
Computer Manipulation: Barry Townsend, Classic Graphics
Client: French Paper Company
Programs: Adobe Photoshop, Macromedia FreeHand, QuarkXPress

Identity & Self-Promotion

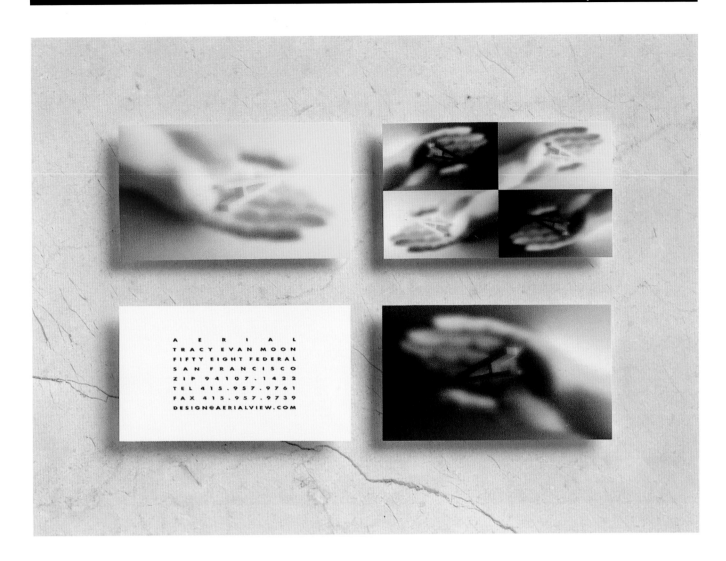

AERIAL Business Cards

Concept: AERIAL is a San Francisco–based design firm specializing in identity development. AERIAL's unusual and ever-expanding business card series demonstrates the firm's technical imaging capabilities as well as its conceptual expertise. AERIAL's business cards have been featured in *HOW* and *Print* magazines and have won an American Graphic Design Award.

Production: Firm principal Tracy Moon started with a color transparency shot by photographer R.J. Muna of a hand holding a three-dimensional letter "A." She brought a high-res scan of the image into Photoshop and used the

Gaussian Blur filter to soften it. Moon made a negative copy of the image by duplicating the original and applying Invert. Each of the two images was given two different color treatments by converting them to Grayscale, then to duotones.

The images were converted to CMYK before the files were completed so they could be ganged on a single press run. Moon created three cards—one each of the yellow and purple duotones she created and a card that showed all four duotones together. Each card was printed on the back with a QuarkXPress file carrying AERIAL's name, phone number and mailing and online addresses.

Design Firm: AERIAL
Art Director: Tracy Moon
Designer: Tracy Moon
Photographer: R.J. Muna/R.J. Muna Pictures
Computer Manipulation: R.J. Muna/R.J. Muna Pictures
Client: AERIAL
Programs: Adobe Photoshop, QuarkXPress

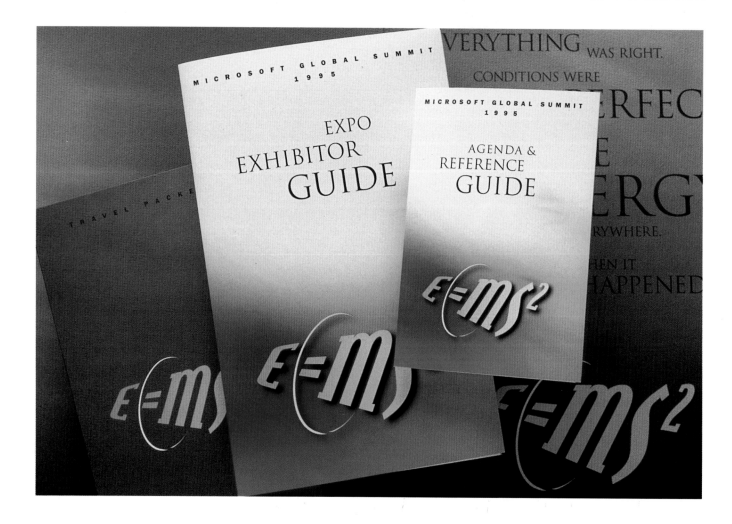

Microsoft Conference Logo

Concept: All materials for Microsoft's 1995 Global Summit carried a distinctive identity created exclusively for the conference by Seattle-based Hornall Anderson Design Works. To support the idea that the Global Summit was the perfect time for those in attendance to generate ideas, the design firm developed a logo concept for the conference based on Einstein's theory of relativity. The logo appeared on conference literature and binders and was projected onto the walls at the conference.

Production: Hornall Anderson designers started by creating a gradated background with the Texture Explorer filter in Kai's Power Tools, a Photoshop plug-in. The gradation was further enhanced by adjusting Hue and Saturation and Brightness.

The E=MS2 logo was initially drawn in Macromedia FreeHand (based on a hand-rendering) and brought into Photoshop. Hornall Anderson designers also drew the ring in FreeHand and imported that into the composition. A drop shadow was added to the logo and ring by making a duplicate of the paths, filling them with black, and applying the Gaussian Blur and Offset filters. The logo was filled with a gradated yellow, while the ring was filled with white. Hornall Anderson designers used Photoshop's Layers to blend all three elements, feathering the ring so that it fades behind the E=MS2.

The completed logo and its background were brought into FreeHand files for the covers of conference literature.

Designer Firm: Hornall Anderson Design Works
Art Director: Jack Anderson
Designers: Jack Anderson, John Anicker, Mary Chin Hutchison
Computer Manipulation: John Anicker
Client: Microsoft Corporation
Programs: Adobe Photoshop, Macromedia FreeHand, Kai's Power Tools

MTV Networks Identity

Concept: SEGURA INC.'s MTV Networks identity is based on the premise that a variety of looks suited the network better than a single logo. The Chicago-based design firm came up with four images to be used on labels and on the back of letterhead. Carlos Segura also came up with an alternative approach for MTV's identity materials—a letterpress-printed organic look. Both concepts are currently under consideration by MTV.

Production: Segura set the MTV Networks logo in Droplet, one of his [T-26] foundry's fonts, in Adobe Illustrator. The Illustrator paths for the logo were imported into Photoshop. Segura and designer Tony Klassen made multiple copies of the logo at various sizes. Several versions were created by using the Gaussian Blur filter at various levels. Drop shadows and three-dimensional effects were achieved by using the Offset filter. Each logo treatment was assigned to its own layer, where different color effects were applied by adjusting Hue and Saturation. Different levels of transparency and color blending were achieved by adjusting opacity and choosing the Multiply option. Halo effects were created by selecting Feather. The images were brought back into Illustrator, where reverse type was added.

Design Firm: SEGURA INC.
Art Director: Carlos Segura
Designer: Carlos Segura
Illustrators: Tony Klassen, Carlos Segura
Computer Manipulation: Tony Klassen, Carlos Segura
Client: MTV Networks
Programs: Adobe Photoshop, Adobe Illustrator

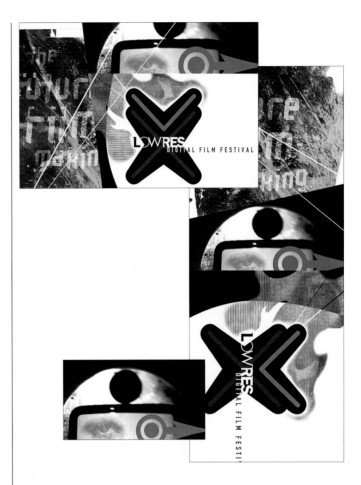

LOWRES Digital Film Festival Identity

Concept: The LOWRES Digital Film Festival is a series of annual meetings and exhibitions that feature films produced entirely on the computer. In 1996, festivals were held in Los Angeles, San Francisco, New York City and London. The festivals were promoted in trade ads, by mail and over the Internet with an identity created by SEGURA INC. The motif used on these materials was carried over into programs, signage and other on-site materials for each festival.

Production: The principal image used on the festival's materials is a composite of a TV set with an eye on the screen combined with an arrow and bullseye. Firm principal Carlos Segura and designer Colin Metcalf started by photographing an unusual handmade television set with a spherical exterior. The photo was scanned and brought into Photoshop. An eye was brought into the composition. Once the photo was cropped to show just the eye portion, Hue and Saturation were adjusted to give the photo its bluish tint. Metcalf applied the Gaussian Blur filter to give the eye a hazy, on-screen appearance. The arrow and bullseye were drawn in Adobe Illustrator and then brought into the Photoshop composition. The three elements of the composition were blended by using Layers. The image was brought into QuarkXPress.

Design Firm: SEGURA INC.
Art Director: Colin Metcalf
Designer: Colin Metcalf
Illustrator: Colin Metcalf
Photographer: Jeff Sciortino
Computer Manipulation: Colin Metcalf
Client: The LOWRES Digital Film Festival
Programs: Adobe Photoshop, Adobe Illustrator, QuarkXPress

Impact Unlimited Logo

Concept: Impact Unlimited is a firm that specializes in exhibit design and production. San Francisco–based AERIAL designed the firm's identity, including a logo which is printed in two colors on the firm's business materials. For Impact Unlimited's Web site, trade show booth and other situations requiring a stronger presence, the company wanted a full-color image that conveyed its multi-faceted approach to problem solving. AERIAL principal Tracy Moon decided to interpret this concept into a bilateral design that represents a combined effort of "right brain" and "left brain" thinking.

Production: Moon incorporated ten images into her collage, starting with two black-and-white photos of vintage light bulbs shot by photographer R.J. Muna. Muna also shot black-and-white photos of the other images that comprise the collage: a leaf, flowers, lightning and gears. Moon had high-res scans made of each of the images and brought them into Photoshop. After she had cropped each image into a rectangular format, she placed it on its own layer. Each of the images was colorized to give the impression of a duotone by adjusting Hue and Saturation. Moon used Layers to blend the arranged images into her final composition.

Design Firm: AERIAL
Art Director: Tracy Moon
Designer: Tracy Moon
Photographers: R.J. Muna, Pam Shapiro
Computer Manipulation: Tracy Moon
Client: Impact Unlimited
Programs: Adobe Photoshop

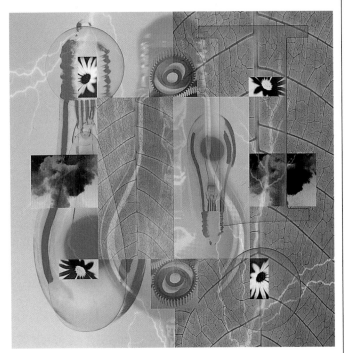

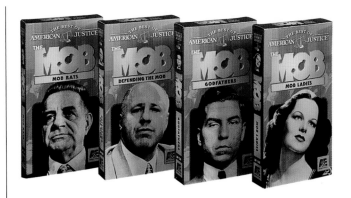

The Mob Logo

Concept: When hired by New Video Group to design the logo for its home video series, *The Mob*, Courtney & Company produced this bullet-riddled lettering, which was used on video packaging and in television ads.

Production: The Courtney & Company design team first set "The Mob" in Serif Gothic in Adobe Illustrator and converted the text to outlines. Circles which would ultimately be bullet holes were added, and roughened with Illustrator's Roughen filter.

The logo was then brought into Strata Studio Pro, where default bevels under the program's Extrude feature were used to create the three-dimensional effect. The brass surface texture was also applied in Strata Studio Pro, and lighting effects were added with the program's Point Light and Rendering features.

The work accomplished in Strata Studio Pro yielded an effect on screen which was close to the look Courtney & Company was trying to achieve, but checking the image's color balance in Photoshop showed that the image would print too green. Converting the file to CMYK in Photoshop and adjusting the curves in the cyan channel improved the color balance to yield the desired gold color.

The Photoshop file was saved as a TIFF image and brought into a QuarkXPress file for the video packaging.

Design Firm: Courtney & Company
Art Director: Robert Adams
Designers: Robert Adams, Linda Baccari
Computer Manipulation: Robert Adams, Linda Baccari
Client: New Video Group
Programs: Adobe Photoshop, QuarkXPress, Adobe Illustrator, Strata Studio Pro

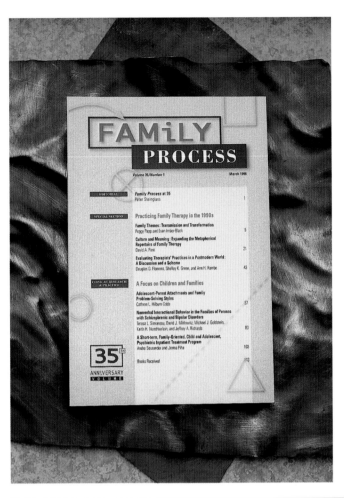

Family Process Logo

Concept: *Family Process* is an academic journal that serves family therapists, psychologists and psychiatrists and had been using the same logo since its inception in 1961. Lebowitz/ Gould/Design was hired to produce a new image for the journal.

Art director Susan Chait came up with a new logo with an "I" in the word "family" that suggests a human form. The typeface she used is Monaco, a standard font on Macintosh systems, but frequently shunned because it's not a bona fide font. "It's one of those typefaces I thought I would never use," admits Chait.

Production: The bulk of the work on the *Family Process* logo and cover was done in Photoshop, where the textured background and logo were created. The logo achieves a three-dimensional look through the creation of a drop shadow and highlights added to the word "family." Designer Amy

Hufnagel produced this effect with the Offset and Gaussian Blur filters. The four-color textured background was created with the Noise filter.

The genograms were drawn in Adobe Illustrator and then brought into Photoshop, where they were pasted into a layer above the textured background. Each genogram was then filled with the background texture using the Rubber Stamp tool. Hufnagel made a copy of the entire symbol layer and used the Offset and Gaussian Blur filters on the copy to create a drop-shadowed effect.

Feature listings were placed on the cover in QuarkXPress.

Design Firm: Lebowitz/Gould/Design
Art Director: Susan Chait
Designer: Amy Hufnagel
Computer Manipulation: Susan Chait, Amy Hufnagel
Client: *Family Process*
Programs: Adobe Photoshop, QuarkXPress, Adobe Illustrator

SEGURA INC. Logo

Concept: Carlos Segura is well-known among designers for pioneering new territory with his cutting-edge concepts. It should come as no surprise that SEGURA INC.'s identity reflects the designer's approach to his work with a logo fashioned in wire. The logo appears on the firm's business cards, labels, postcards and Web site.

Production: Segura had photographer Greg Heck take numerous color photos of the wire-formed Segura name, but ended up retrieving a color Polaroid from the trash, taken early on in the photo session, to use for his starting image. Segura had a high-resolution scan made of the photo and brought it into Photoshop. He applied the Gaussian Blur filter to selected areas of the photo to soften portions of the wire image and its shadow, and to achieve a soft

background effect. Segura adjusted Hue and Saturation to achieve the image's warm colorization.

The image was printed in four-color process on adhesive-backed label stock, and on a textured stock for the business cards. Segura set his name and address in QuarkXPress and had it printed in black on the back of his business cards. After Segura has his business cards printed and trimmed, he encases each one in a glassine envelope.

Design Firm: SEGURA INC.
Art Director: Carlos Segura
Designer: Carlos Segura
Photographer: Greg Heck
Computer Manipulation: Carlos Segura
Client: SEGURA INC.
Programs: Adobe Photoshop, QuarkXPress

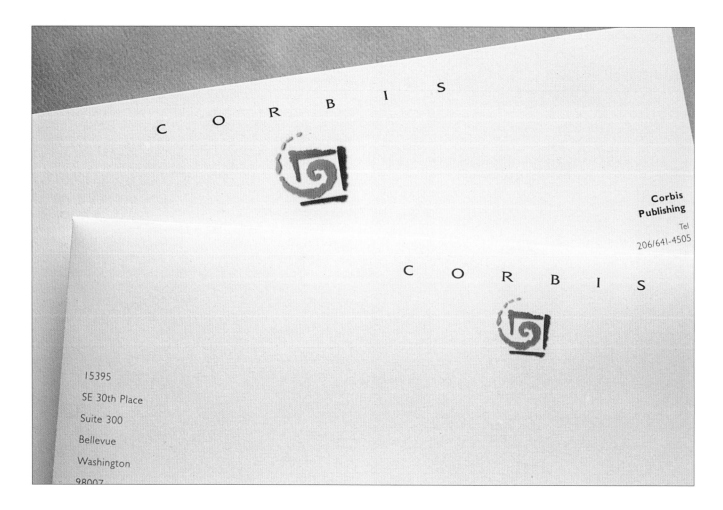

Corbis Corporation
Letterhead and Logo

Concept: Corbis is the Latin word for "woven basket or container." Because Corbis Archive is an acquirer and holder of the world's most comprehensive digital collection of fine imagery, the logo Hornall Anderson designed for the firm depicts a storehouse of information. Hornall Anderson chose to render the "C" in a swirling, motion-oriented way to suggest a steady circulation of information and easy access to it.

Production: Hornall Anderson designers started by drawing the two shapes that comprise the icon in Macromedia FreeHand. The files were imported into Photoshop, where the Gradient tool was used to fill both shapes with their gradated colors. A drop shadow was also added in Photoshop by duplicating the icon paths, filling them with black, and applying the

Gaussian Blur and Offset filters.

The completed logo was brought into QuarkXPress files for the letterhead, envelope and business cards.

Although Hornall Anderson initially produced the logo in Photoshop, they have since re-created it in FreeHand so that it can be re-sized without losing image quality. The shadow portion of the logo continues to be a Photoshop file.

Design Firm: Hornall Anderson Design Works
Art Director: Jack Anderson
Designers: Jack Anderson, John Anicker, David Bates
Client: Corbis Corporation
Programs: Adobe Photoshop, Macromedia FreeHand, QuarkXPress

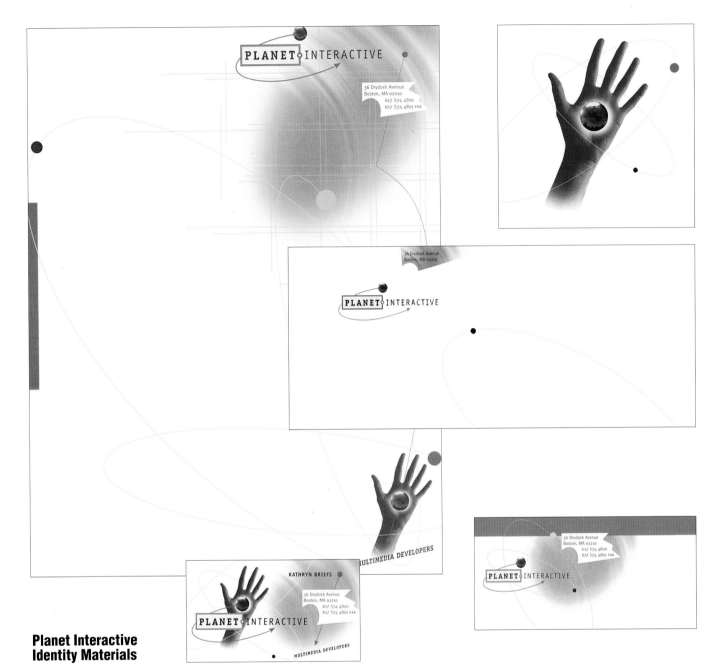

Planet Interactive
Identity Materials

Concept: For multimedia developer Planet Interactive, Stoltze Design created a collage of images and background effects that effectively communicate the movement and interactivity of multimedia. Planet Interactive uses this combination of images on the packaging of its product, as well as on its stationery and other business papers.

Production: Stoltze Design principal Clifford Stoltze started with an original black-and-white photograph of a hand, which he scanned and brought into Photoshop. The hand was isolated from its background with the program's Selection tools and given soft color by changing it into a four-color image and adjusting Hue and Saturation.

Stoltze and designer Peter Farrell created the sphere by making a circle in Adobe Illustrator. They imported the sphere into Photoshop and applied the Airbrush tool for a sense of dimensionality. The Sharpen tool was applied to the sphere to achieve a pixellated effect.

The softly ringed effect for the identity's background was made by using the Airbrush tool to apply white lines to a blue background. The Twirl and Radial Blur filters were then applied to this image and a segment cropped for the portion that appears on Planet Interactive business materials.

Farrell used the Layers command to add the sphere to the top portion of the letterhead, and to the hand at the bottom. A hazy glow was added to the palm of the hand with the Airbrush tool.

Top and bottom portions of the letterhead were saved as separate files and then brought into Illustrator documents for each of the other components of Planet Interactive's identity system. Grid lines, arrows, other graphic elements and type were added to each document in Illustrator.

Design Firm: Stoltze Design
Art Director: Clifford Stoltze
Designers: Clifford Stoltze, Peter Farrell
Computer Manipulation: Peter Farrell
Client: Planet Interactive
Programs: Adobe Photoshop, Adobe Illustrator

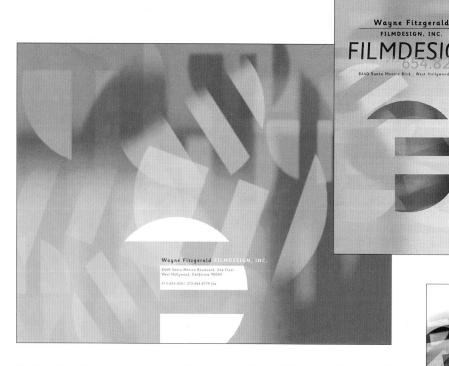

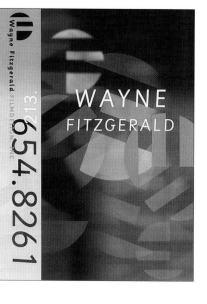

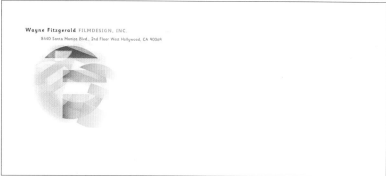

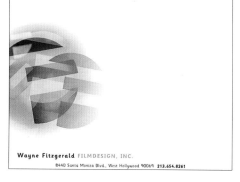

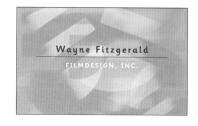

Wayne Fitzgerald Identity

Concept: When they first met with Los Angeles–based Wayne Fitzgerald Film Design about designing the firm's identity materials, REY International principals knew that their client needed a contemporary and versatile image. The look they conceived would need to work equally well on videotape packaging as it did on letterhead and business cards. The design firm was given their client's existing logo to work with—a simple mark depicting the letter "F" within a cropped circle. REY International came up with an identity system that enabled them to use the original mark on their client's business card. The design firm used Photoshop to distort the mark in a variety of creative ways for the other components of the identity program.

Production: As a unifying element, REY International designers Michael Rey and Greg Lindy decided to use violet and orange as the primary colors for the identity's color scheme.

Lindy first redrew the mark in Macromedia FreeHand to use as digital art for the variations they wanted to create. He then imported the FreeHand drawing into Photoshop, created many copies of it, and placed each copy on its own layer. Each layer was given a different treatment: various reductions and enlargements were made, and varying degrees of the Gaussian Blur filter were applied.

For the final images that appear on the letterhead, envelope and videotape packaging, Lindy merged the different layers together, adjusting the opacity of each layer to achieve the desired effect. A two-color version of the art was created for the letterhead and envelope art, while a four-color version was created for the packaging. The logo on the business card displays the original FreeHand rendering, before the variations of it were created in Photoshop.

REY International created the layouts for each component of the identity program in QuarkXPress.

Design Firm: REY International
Art Directors: Michael Rey, Greg Lindy
Designer: Greg Lindy
Computer Manipulation: Greg Lindy
Client: Wayne Fitzgerald Film Design
Programs: Adobe Photoshop, QuarkXPress, Macromedia FreeHand

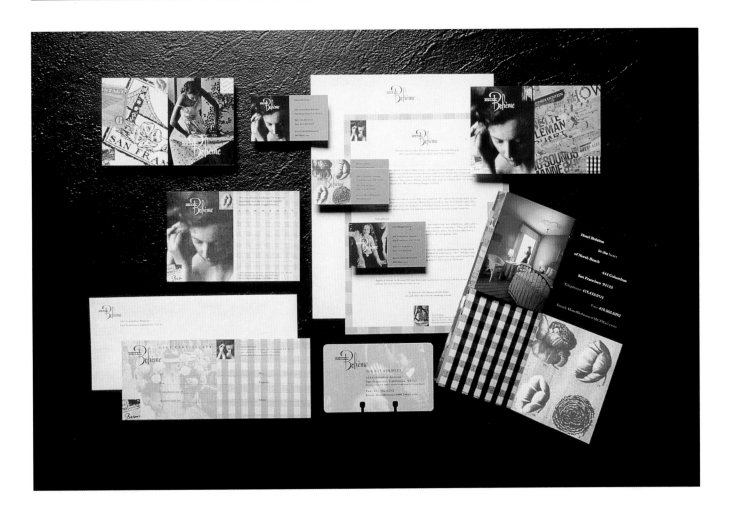

Hotel Bohéme Identity

Concept: Located in San Francisco's North Beach, Hotel Bohéme is a very special place where a bohemian fifties theme, reminiscent of a Jack Kerouac novel, sets the tone for the hotel's atmosphere and decor. The designer of the hotel's identity at San Francisco–based AERIAL used a variety of images on its business cards, brochure and postcards to capture the spirit of the period and an eclectic, bohemian lifestyle.

Production: Many images comprise the Hotel Bohéme identity scheme, all juxtaposed in a grid-like configuration based on a series of squares. High-resolution scans of transparencies and black-and-white prints were brought into Photoshop, where images were adjusted to achieve certain color effects and levels of opacity.

AERIAL principal Tracy Moon used a nostalgic gingham pattern, drawn from fabric in the hotel, to enhance and unify the identity's squared-off visuals. She brought this element into the mix of images by having a high-resolution scan made of a swatch of gingham fabric. The scan was brought into Photoshop, where it was cropped and colorized for various applications by adjusting Hue and Saturation.

One of the predominant images in Hotel Bohéme's identity scheme is a woman's portrait in soft focus. The photo is a one-of-a-kind image, shot by 1950s photographer Jerry Stoll. A high-resolution scan was made of the photo and it was brought into Photoshop, where some retouching and clean-up were done with the Rubber Stamp tool. Moon applied the Gaussian Blur filter to this image as well as the Noise filter to produce a grainy effect. The

four-color image was given a warm duotone effect by adjusting Hue and Saturation.

AERIAL created the digital mechanicals for Hotel Bohéme's identity materials in QuarkXPress.

Design Firm: AERIAL
Art Director: Tracy Moon
Designer: Tracy Moon
Photographers: Jerry Stoll, R.J. Muna
Computer Manipulation: Tracy Moon
Client: Hotel Bohéme
Programs: Adobe Photoshop, QuarkXPress

NEXTLINK Identity and Stationery System

Concept: NEXTLINK is a provider of full-service telecommunications. The company is presently developing its business focus around local phone service customers and is specializing in the next wave of telecommunications services. To express the interconnecting aspect of this client's business, Hornall Anderson Design Works came up with a logo based on the letter "X," a letterform which, in addition to suggesting connections, also suggests aspects of the unknown—symbolizing the next wave in telecommunications.

Production: Hornall Anderson designers started by drawing an outline of the NEXTLINK logo in Macromedia FreeHand and imported this file into Photoshop. The gradated color was added to the NEXTLINK name and the floating letter "X" with the Airbrush tool. To finish the art, an airbrushed shadow was added just below the "X."

The finished logo was brought into QuarkXPress files for NEXTLINK's letterhead, envelope and business card. All components of the identity system were printed in four-color process.

Design Firm: Hornall Anderson Design Works
Art Director: Jack Anderson
Designers: Jack Anderson, David Bates, Mary Hermes, John Anicker, Mary Chin Hutchison
Computer Manipulation: Mary Chin Hutchison
Client: NEXTLINK Corporation
Programs: Adobe Photoshop, QuarkXPress, Macromedia FreeHand

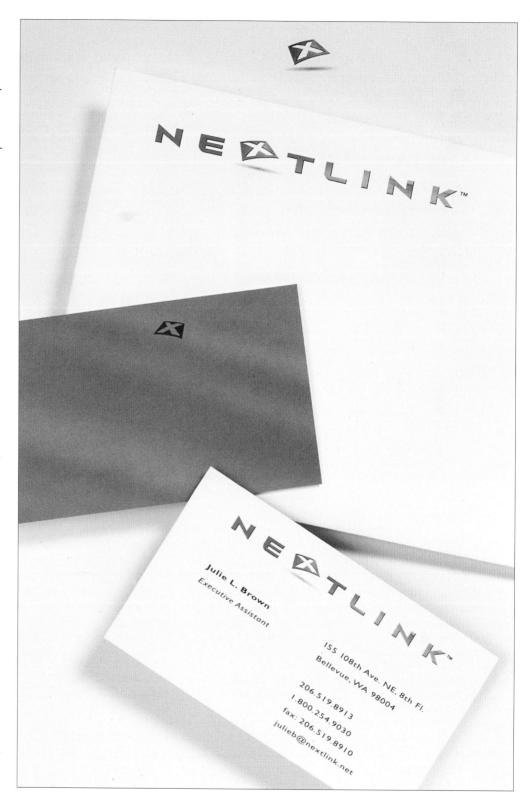

NEXTLINK Marketing Folder

Concept: In addition to the NEXTLINK identity, Hornall Anderson Design Works designed a marketing folder that lets the company tailor its promotional inserts to the specific needs of each of its prospective customers.

Production: Hornall Anderson designers started by taking the "X" from the NEXTLINK logo and bringing the Macromedia FreeHand paths into Photoshop. The designers used the program's Airbrush tool to create the gradated fill that blends yellow to blue to purple, as well as the shadows at the edges of the logo that give it its three-dimensional look.

The Photoshop file for the folder's cover was brought into a QuarkXPress file, where type was added for the blind emboss at the bottom.

Design Firm: Hornall Anderson Design Works
Art Director: Jack Anderson
Designers: Jack Anderson, Mary Hermes, Mary Chin Hutchison
Computer Manipulation: Mary Chin Hutchison
Client: NEXTLINK Corporation
Programs: Adobe Photoshop, Macromedia FreeHand, QuarkXPress

Self-Promotional Postcards

Concept: To promote his digital imaging capabilities, freelancer Frank Petronio sends regular postcard mailings to current and prospective clients. The postcards have yielded new business from those wanting to achieve an effect unattainable through more conventional media, and prompted calls from current clients who respond to a specific visual effect.

Production: Petronio's original images for the sunglasses and saw-blade postcards were transparencies Petronio shot himself. The double shadowed effect on the blade postcard was created by shooting it against a reflective piece of steel.

Petronio had these images transferred to Kodak Photo CD and then brought them into Photoshop. He used the Gaussian Blur filter to soften both photos and adjusted their colors to achieve greater contrast of hue. Petronio selectively applied the Blur and Focus tools to the sunglasses to emphasize and de-emphasize portions of the frames.

The spring image was achieved by shooting a black-and-white photo of a straight spring and scanning it. Petronio applied the Spherize filter and skewed the spring to achieve a sense of perspective. The purple orb at the base of the spring was created in Macromedia FreeHand and then brought into Photoshop. He created the background effect with the Gradient and Blend tools.

Petronio used QuarkXPress to add type to the front of the cards as well as for the production notes printed on the back.

Design Firm: Frank Petronio > commercial artist
Designer: Frank Petronio
Computer Manipulation: Frank Petronio
Client: Frank Petronio
Programs: Adobe Photoshop, Macromedia FreeHand, QuarkXPress

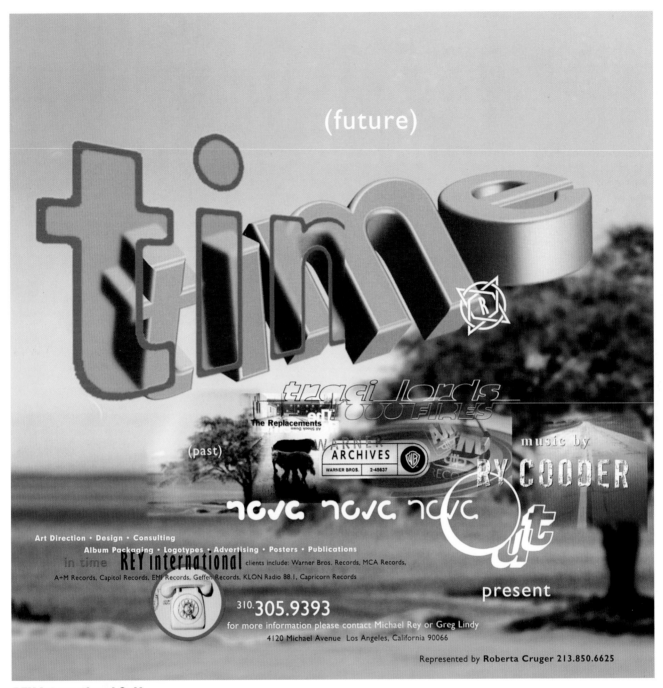

REY International Self-Promotion

Concept: REY International likes to maintain high visibility among its current and prospective clients. That's why the firm's designers created this card featuring their digital imaging capabilities.

Production: Designers Michael Rey and Greg Lindy started with a scenic image—a photo of a beach taken in Hawaii. The designers scanned the slide and brought it into Photoshop, where the photo's color was enhanced and the Gaussian Blur filter was applied. Studio scans of client logos and other images were brought into the beach scene and placed on separate layers. The opacity of the different layers was adjusted to create varying degrees of translucency on the images and blend them into the background.

The word "time" was created in Adobe Dimensions, where it was given a three-dimensional look. The Dimensions file was then imported into the Photoshop image, where it was blended with a layer showing the word in outline format.

The completed image was brought into QuarkXPress, where type, the REY International logo (the "R" symbol) and the photo of the phone were added.

Design Firm: REY International
Art Directors: Michael Rey, Greg Lindy
Designer: Greg Lindy
Computer Manipulation: Greg Lindy
Photographers: Michael Rey, Greg Lindy
Client: REY International
Programs: Adobe Photoshop, QuarkXPress, Adobe Dimensions

Equifax Binder and Diskette

Concept: Equifax is a new company specializing in software that helps businesses identify optimum relocation and retail sites. This product identity and binder, designed by Copeland Hirthler design + communications, was used to introduce the company's product to potential users. To convey the program's purpose, Copeland Hirthler came up with a visual theme based on a topographical graph that could be used on a binder and program diskettes. Although the imagery is currently being used exclusively on Equifax's product packaging system, it will eventually appear on promotional and collateral materials.

Production: The Copeland Hirthler design team developed the initial image of the graph by commissioning photographer Jerry Burns to shoot a slide of it

from the computer terminal while the Equifax program was running. The designers scanned the slide and brought it into Photoshop, where color was intensified by adjusting Hue and Saturation. The graph was blended with a background photo of flowing fabric using Layers. Feathering was applied to isolated sections of the composition.

Additional typographical layers were created using the Type tool. Words were rotated and then blurred with the Gaussian Blur filter before being blended with the graph image. Transparency was achieved by adjusting Opacity on the Layers palette.

Copeland Hirthler presented Equifax with a low-resolution comp, and when they received client approval, the comp was given to Davidson & Company,

computer imaging specialists, to develop into a high-resolution duplicate. Davidson & Company used Photoshop and high-res scans to reproduce the comped image.

When the image was complete, it was brought into a QuarkXPress layout for each item.

Design Firm: Copeland Hirthler design + communications
Creative Directors: Brad Copeland, George Hirthler
Art Director: Melanie Bass Pollard
Designers: Melanie Bass Pollard, David Woodward
Computer Manipulation: Melanie Bass Pollard, Davidson & Company
Photographer: Jerry Burns
Client: Equifax
Programs: Adobe Photoshop, QuarkXPress

Pierre-Yves Goavec Self-Promotional Brochure

Concept: Photographer Pierre-Yves Goavec's specialty is his ability to manipulate imagery on the computer. His knack for using light in unusual ways inspired the designers at Grafik Communications, Ltd. to echo Goavec's lighting effects in their design of the photographer's self-promotional brochure. They achieved this look by playing fuzzy, white type against a variety of dark-colored backgrounds. The twelve-page brochure juxtaposes this typographic treatment on each left-hand page with one of Goavec's photographs on each facing right-hand page. The teaming of Goavec's photography and Grafik Communications' brochure design resulted in a winning combination. The brochure has been featured in *HOW* magazine as well as *The Best of Brochure Design 3* from Rockport Publishers.

Production: Designers Judy Kirpich and David Collins set the brochure's type with Photoshop's Type tool and used the program's Lasso tool to select the portions they wanted to blur. To achieve different types of blur effects they applied different combinations of the Gaussian Blur, Spin and Zoom filters to their selections. Background colors were created by selecting the background of each page and using the Fill command. The typographic treatments were brought into a QuarkXPress file for the brochure.

Design Firm: Grafik Communications, Ltd.
Design Team: Judy F. Kirpich, David Collins
Photographer:
Pierre-Yves Goavec
Computer Manipulation:
David Collins
Client: Pierre-Yves Goavec
Programs: Adobe Photoshop, QuarkXPress

Editorial Illustration

Rough **Magazine Cover**

Concept: *Rough* is a monthly magazine published by the Dallas Society of Visual Communication (DSVC). Design firms and advertising agencies take turns designing the publication, yielding a fresh look for each issue that reflects each firm's design sensibility. Dallas-based Brainstorm Inc. had the opportunity to design the January 1994 issue of *Rough*. To welcome the new year, the firm decided to depict DSVC's president as the Baby New Year on *Rough*'s cover by using Photoshop to merge his head with an infant's body.

Production: The Brainstorm Inc. designers started with a black-and-white photo of DSVC president Ed Zahra and one of a baby—an existing photo supplied to them by local photographer Phil Hollenbeck. Both were professionally scanned on a drum scanner and brought into Photoshop. Zahra's head was outlined and isolated from its background using the Selection tools. Because the designers were using a version of Photoshop that pre-dated the program's Layers feature, Zahra's head was placed on the baby's body with the Cut and Paste commands.

Brainstorm Inc. designer Chuck Johnson drew the cover image's background shape with its spiral configurations in Adobe Illustrator. The illustration was brought into Photoshop and made into a mask, which was applied to the baby image. The background is the existing background of the baby photo.

The Photoshop image was brought into Illustrator, where the *Rough* logo and additional type were added. The cover was printed in black and white on tan stock.

Design Firm: Brainstorm Inc.
Art Directors: Chuck Johnson, Ken Koester
Designer: Chuck Johnson
Illustrators: Chuck Johnson, Rob Smith
Computer Manipulation: Rob Smith
Photographer: Phil Hollenbeck
Client: Dallas Society of Visual Communication
Programs: Adobe Photoshop, Adobe Illustrator

But first, a disclaimer of anything resembling objectivity.
Across the patient spectrum, the emphasis in "chemotherapy" falls on the first two syllables. In the weeks and months of its application, chemotherapy can take over a good woman's life. It can make a strong man wish to be somewhere, anywhere else.

With my dad, the strong man known as Brownie, chemotherapy's symptoms gathered in the vicinity of dry heaves and the inability to find a little forgetfulness in the dark. Bald for 50 years, retired from the Missouri-Pacific for 15, the old man manifested the chemicals' influence in bilious coughing spread over nights spent out on the driveway. He had bought himself a new pickup a short while before the cancer verdict came, a green-gold-and-white Chevy bearing a sound system that his grandchildren might appreciate. In Hoisington, Kansas, in Brownie's last days, it happened this way. The chemicals would accumulate, and the insomnia and the waking nightmares would begin, and he would leave my mother's side, and he would back his truck from the garage toward the street, out of her hearing, to a distance where he might listen and, as was his way, bother no one. There, 20 yards from his bedroom of 40 years, he would tap his hush-puppy foot to the cassettes in the truck's player. I sent him random titles at first, and then he began to make requests. Emmy. Maybe another one from Emmylou, old son. In the dawns before he died, among his strange and sleepless dreams, my dad heard the singing of an angel. The last time I saw him he told me so. For reasons perhaps apart from those of other men of my generation, **I love Emmylou Harris.**

SING, SOLITARY ANGEL.

Emmylou Harris in *American Cowboy*

Concept: Acme Design Company, based in Wichita, Kansas, designs *American Cowboy* magazine's feature section. For the magazine's January/February 1997 issue, which featured an article on Emmylou Harris, Acme principal John Baxter was given a less-than-spectacular publicity shot of the recording artist to work with as his primary visual. Rather than playing down the rather pedestrian photo by running it on a small scale, Baxter decided to give Harris the star billing she deserved by embellishing the photo in Photoshop and scaling it to fit a full page in his layout.

Production: Baxter scanned the black-and-white photo on his studio scanner and brought it into Photoshop, where it was converted to RGB color. He split the image into different channels and then adjusted each one independently by using the program's Brightness and Contrast controls. Each channel was further manipulated by applying the Pixellate and Crystallize filters. The channels were then merged and the image file converted to CMYK.

To create headline type to match the photo, Baxter scanned the headline for the article, composed from clipped type taken from an old wood-type specimen book. The headline was brought into Photoshop, where the Crystallize filter was applied.

The Harris photo and headline type were saved as TIFF files and brought into the layout for the article, which was created in Adobe PageMaker.

Design Firm: Acme Design Company
Art Director: John Baxter
Designer: John Baxter
Computer Manipulation: John Baxter
Client: *American Cowboy*
Programs: Adobe Photoshop, Adobe PageMaker

Computerworld
Illustration

Concept: In its April 22, 1996 edition, *Computerworld* ran a feature on how New York City was becoming the cyber capital of the world. To illustrate the story, the magazine hired John Baxter of Acme Design Company to come up with a new rendition of New York City's Radio City Music Hall. By changing the neon marquee on an existing photo, the illustration proclaims that "Tin Pan Alley" has become "Silicon Alley." The illustration also incorporates the article's title: "Web Start-ups Throng New York."

Production: Working with a stock image of the exterior of Radio City Music Hall at night, Baxter put Photoshop's image editing capabilities to the test. For a high-resolution image, he first had the transparency from the stock agency scanned professionally on a drum scanner.

Baxter then used the Rubber Stamp tool to clear the marquees of their original type. He set the new type for the marquees in Macromedia FreeHand and used features in LetraStudio to add a three-dimensional look to the type. Baxter also used LetraStudio to angle the type so it would have the proper sense of perspective when applied to the architecture of the building marquees.

Baxter then imported the type into his Photoshop document of Radio City Music Hall and placed each typographic element on its own layer to achieve proper placement. To create a neon halo and shadow effect, he applied the Gaussian Blur filter to the lettering on each marquee.

The completed illustration was supplied to *Computerworld* as a CMYK TIFF file.

Design Firm: Acme Design Company
Art Director: Tom Monahan (*Computerworld* design director)
Designer: Janell Genovese (*Computerworld* senior graphic designer)
Computer Manipulation: John Baxter
Photographer: Picture Perfect/Nawrocki
Client: *Computerworld*
Programs: Adobe Photoshop, Macromedia FreeHand, LetraStudio

Contrails Travel Magazine Cover

Concept: *Contrails*, a quarterly magazine published by Learjet, goes to CEOs who are in a position to purchase corporate aircraft. For its premiere issue, Learjet hired Greteman Group to design a cover that would convey the speed and increasing frequency of transcontinental travel in today's business world. Firm principal Sonia Greteman chose to communicate this message by creating a composite image that combines a globe and a Learjet with symbols of time and travel.

Production: Greteman Group designer Craig Tomson started with digital images of a globe and watch face furnished from Photo CD clip files. He brought the images into Photoshop and isolated each image from its background with the Selection tools. The image of the jet was brought into Photoshop by scanning a color photo supplied by Learjet. Changes were made to each image's colors by adjusting Hue and Saturation.

Tomson blended these images into a composite image by using Photoshop's Layers feature. A drawing of a gauge, created in Macromedia FreeHand, was also blended into the composition using Layers. Type was added to the background with the Type tool.

Greteman Group brought the completed image into FreeHand, where type and the *Contrails* logo were added. The studio design team also used FreeHand to create the other pages that comprised this issue of *Contrails*.

Design Firm: Greteman Group
Art Director: Sonia Greteman
Designers: Sonia Greteman, Craig Tomson, James Strange
Illustrators: Sonia Greteman, Craig Tomson, James Strange
Computer Manipulation: Craig Tomson
Client: Learjet, Inc.
Programs: Adobe Photoshop, Macromedia FreeHand

Primo Angeli Book Cover

Concept: *Making People Respond* is the second in a series of case history books featuring the work of Primo Angeli Inc. The book is a collaboration between Primo Angeli, Esprit creative director Roberto Carra and Esprit editor Daniel Imhoff that includes environmental graphic design, posters, packaging and brand design projects from the San Francisco–based design firm.

The original illustration that serves as the book's cover image was created with traditional media. Digital enhancements turned it into a dynamic new image for the firm—one that has been so successful that Primo Angeli Inc. uses it on the home page for its Web site (see page 119).

Production: An existing illustration of a peach, owned by Primo Angeli Inc., was scanned on the firm's studio scanner and brought into Photoshop. Staff member Mark Jones applied the Noise filter to add textural interest to the peach.

Jones originally drew the peach's leaves in Adobe Illustrator and then brought the leaf renderings into Adobe Dimensions, where they were mapped onto three-dimensional frames. Jones also used Dimensions to make "Primo Angeli Inc." conform to the shape of a sphere, and created the gold ring in Dimensions.

The leaves, ring and type were brought into Photoshop, where Jones used the program's Layers and Channels to build the illustration. Highlights and shadowing were applied with the Airbrush tool, while a custom brush was made to apply the highlight to the ring.

Design Firm: Primo Angeli Inc.
Creative Director: Roberto Carra
Designer: Primo Angeli
Illustrator: Mark Jones
Computer Manipulation: Mark Jones
Client: Primo Angeli Inc.
Programs: Adobe Photoshop, Adobe Illustrator, Adobe Dimensions

The Visit Cover

Concept: *The Visit*, a macabre play by German writer Friedrich Dürrenmatt, tells the story of a visit from an elderly millionairess who uses her money to tempt the residents of an economically depressed town into committing murder. The cover, created by Spur Design's David Plunkert, depicts the millionairess as an assemblage of strange parts with sinister implications.

Production: Plunkert started by assembling the image of the woman as a collage of clipped pieces. He scanned it as a grayscale image, then brought it into Photoshop, where it was outlined with the Selection tools. Plunkert also created the red background in Photoshop and gave it a grainy effect by applying the Noise filter.

The book's title and byline were set in QuarkXPress, printed, clipped and pasted to form the cover configuration. Plunkert scanned the type and brought it into Photoshop, where it was pasted into the cover image.

The image was brought into QuarkXPress, where the type and other elements were added.

Design Firm: Spur Design
Art Director: John Gall, Grove Atlantic
Designer: David Plunkert
Illustrator: David Plunkert
Computer Manipulation: David Plunkert
Client: Grove Atlantic
Programs: Adobe Photoshop, QuarkXPress

Bay Networks' Technical Journal

Concept: Bay Networks' quarterly journal, *Headings*, goes to current and prospective clients as well as users and distributors of Bay Networks products. The journal promotes and provides information about Bay Networks' networking systems. Boston-based Stoltze Design is responsible for the layout of this substantial, tabloid-sized publication. Given very few photos to work with and three match colors plus black, principal Clifford Stoltze and his staff rely on Photoshop to create special visual effects that give the journal a contemporary touch and enliven each issue.

Production: For the cover of the Summer 1996 issue of *Headings*, Stoltze and his design team started with a tree, a full-color stock image on CD-ROM, as its focal point. The image was brought into Photoshop, converted to grayscale, feathered, inverted and deleted to white to create a vignetted edge.

The computer monitor, a black-and-white photo shot by a Stoltze staff member, was scanned and brought into Photoshop, where paths were created for the monitor and its screen. The screen path was used to select a portion of the tree image, which was copied and pasted in place as a second layer over the screen. The screen path was then exported to Adobe Illustrator, where the "X" icon was scaled and positioned, then brought back into Photoshop to be placed directly over the monitor screen's second layer.

With the image fully composed, each of the three layers was made into a separate Photoshop document. The tree layer was a grayscale TIFF file, the monitor layer was a grayscale EPS with a clipping path on its contour and a hole for the screen, and the screen layer was an orange and black duotone EPS. The three layers

were positioned in QuarkXPress picture boxes and colorized with match colors.

Stoltze Design often uses stock or copyright-free images on CD-ROM and distorts them in Photoshop to create an interesting visual for *Headings'* feature articles. In this instance, a full-color image of light filters was converted to grayscale and given a sense of movement with the Motion Blur filter. The edges of the image were isolated with the Lasso tool and feathered to achieve the translucent duplicate image on either side. Each of the rectangular images was converted to a duotone before being composited.

All images used in *Headings* are saved in Photoshop as TIFF or EPS files to be brought into the QuarkXPress layout for the journal.

Design Firm: Stoltze Design
Art Director: Clifford Stoltze, Kyong Choe
Designers: Kyong Choe, Eric Norman, Wing Ngan
Illustrator: Eric Norman
Computer Manipulation: Wing Ngan
Client: Bay Networks
Programs: Adobe Photoshop, Adobe Illustrator, QuarkXPress

NOVEMBER 11, 1996

COMPUTERWORLD

inner *visions*

THE FUTURE OF COMPUTING
through the eyes of those creating it:

ARNO PENZIAS

JARON LANIER

CHARLES HANDY

JOHN SEELY BROWN

DON TAPSCOTT

PLUS

GENERATION X-TRAORDINARY

Innervisions—Computerworld Magazine Supplement

Concept: *Innervisions* was an issue supplement in *Computerworld* magazine that focused on the future of computing. Stoltze Design was hired to design the cover and interior pages for this special supplement. Firm principal Clifford Stoltze decided to create a cover image that suggested someone looking through a haze, focusing on the unknown.

Production: The individual on the cover is a studio neighbor of Stoltze Design. Stoltze took a black-and-white photo of the man with his hands in the appropriate position and scanned it. The photo was brought into Photoshop and the image made hazy with the Gaussian and Radial Blur filters, then converted to a red and cyan duotone except for the eye.

Whirligig, an Emigre dingbat font, was used to create the spiraled effect around the eye. Stoltze designers set the Whirligig dingbat in Photoshop and then created a quick mask of the character's outline. The mask was used to isolate the eye from the rest of the image and give it high definition.

The completed Photoshop image was brought into QuarkXPress, where type and the *Computerworld* logo were added to make the cover mechanical. The digitally-inspired typeface used for the *Innervisions* heading is appropriately named Cyberotica and is available through Thirstype.

Design Firm: Stoltze Design
Art Director: Clifford Stoltze
Designers: Clifford Stoltze, Wing Ngan
Photographer: Craig MacCormack
Computer Manipulation: Joe Polery, Wing Ngan
Client: *Computerworld* magazine
Programs: Adobe Photoshop, QuarkXPress

Packaging

CBS/FOX Video Collections

Concept: For the 1996–1997 Christmas holiday season, CBS/FOX chose to release video collections of holiday-themed television programs from the 1950s and 1960s to be sold in retail stores. The video packaging designers at Parham Santana Inc. were given black-and-white photos from their client of the stars of each television series. The designers decided that colorizing the photos with a hand-tinted look would give them vintage appeal and provide enough color to establish strong shelf presence. Parham Santana hired freelancer Adam Osterfeld to do the colorizing in Photoshop.

Production: High-resolution scans were made of each of the four photos used for the packaging. Osterfeld brought the scans into Photoshop and changed each from grayscale mode to CMYK color. From there, each photo was given a warm cast by adjusting the program's Hue and Saturation controls. Osterfeld colored broad areas on each photo by using the Selection tools to isolate sections, and adjusting Hue and Saturation. Additional color was applied with the Airbrush tool in areas requiring more detail.

In the meantime, Parham Santana was working on other items for the packaging, including the video titles which were created in Adobe Illustrator. The design firm completed the packaging by bringing the video titles and the Photoshop images into QuarkXPress, where additional type and logos were added to complete each package's mechanical.

Design Firm: Parham Santana Inc.
Art Directors: Rick Tesoro, Lori Reinig
Designer: Paula Kelly
Computer Manipulation: Adam Osterfeld
Photographers: Various
Client: CBS/FOX
Programs: Adobe Photoshop, Adobe Illustrator, QuarkXPress

PC.IABP

Concept: PC.IABP is a software product that lets the medical community monitor IABP Parameters—a balloon device that is used to monitor heart activity. AERIAL's package design for this product uses muted colors and a backdrop of imagery, softened with a duotone treatment created in Photoshop. The cityscape and country scene were chosen to represent the idea that patients using the device could be monitored from any locale.

Production: AERIAL's designers started by commissioning color transparencies of individuals seated at monitors.

Professional scans were made of the images and then brought into Photoshop, where each was converted to a grayscale image. From there, the designers made each photo into a duotone, using black plus a metallic match color. The landscape images were taken from a CD-ROM of stock imagery and were handled in a similar manner.

The images were brought into a QuarkXPress document, where type and graphic elements created in Adobe Illustrator were added. The packaging was printed in three match colors, including metallic violet, plus black.

Design Firm: AERIAL
Art Director: Tracy Moon
Designer: Tracy Moon
Photographers: R.J. Muna, Pam Shapiro
Computer Manipulation: Clay Kilgore
Client: Datascope Corporation
Programs: Adobe Photoshop, Adobe Illustrator, QuarkXPress

Ferris & Roberts Teas

Concept: San Francisco–based design firm Primo Angeli Inc. went far beyond designing packaging for this line of imported English teas. The firm's role in the project included naming the product and brand development, as well as producing a design concept that would work for the tea's packaging—coordinated labels that could be hand-applied to a black, stock item bag with a see-through window. Primo Angeli Inc. felt the line of herbal teas needed an image that suggested an English heritage. To enhance the feeling of an English import, the label design incorporates a logo bearing a crown. Each label for the three varieties of Ferris & Roberts teas features an illustration of the tea's fruit flavor. A rich palette of browns and reds and traditional typography complete the look.

Production: Illustrations depicting each of the fruit flavors were created by freelance illustrator Liz Wheaton using traditional media. Primo Angeli designers Jenny Baker and Mark Jones used the firm's studio scanner to bring the illustrations into Photoshop. Photoshop was used to mask off the illustrations and create the background effects used for each of the labels.

The Photoshop illustrations were then brought into Adobe Illustrator, where type was applied. All three labels were printed from the Illustrator files as a single press run.

Design Firm: Primo Angeli Inc.
Art Directors: Primo Angeli, Ron Hoffman
Designers: Jenny Baker, Mark Jones
Illustrator: Liz Wheaton
Computer Manipulation: Jenny Baker, Mark Jones
Client: Gourm-E-Co. Imports
Programs: Adobe Photoshop, Adobe Illustrator

Black Box Compact Disc Packaging and Poster

Concept: To commemorate its thirteenth year in business, WaxTrax! packaged a collection of favorite releases from the recording company's alternative rock groups under the name of *Black Box*. In addition to a design for the *Black Box* compact disc, the promotional campaign included a poster giveaway as part of the purchase. All were designed by SEGURA INC. Firm principal Carlos Segura worked with imaging specialist Eric Dinyer to achieve raw, unnerving imagery in keeping with the CD's collection of gutsy music.

Production: Dinyer started with a black-and-white photo of a male model with his hands held up. He painted some elements of the image, including crosses on the hands, marks on the chest and the background, directly onto the photo before scanning it on his studio's flatbed scanner and bringing it into Photoshop. Dinyer applied the Pinch filter to shrink the figure's head, and then placed this image on a layer.

The black box was constructed by Dinyer and painted with its moon-and-star configuration. Dinyer made a black-and-white photo of the box, scanned it and brought it into Photoshop. He outlined the box from its background using the Selection tools and placed it on a layer to combine with other elements.

To create the top portion of the image, Dinyer made a painting with the moon-and-star patterned shape at the top. This painting would serve as the imagery at the top of the figure's head, and a backdrop behind the neck and hands. He combined it with the black box and the figure using the Layers palette, and then added lines between the figure's hands using the Brush tool. Dinyer colored the image by converting it to CMYK and adjusting Hue and Saturation.

Segura brought Dinyer's

image into QuarkXPress, where type was applied at the bottom of the poster. The *Black Box* headline was set in Morire, a font available through [T-26], Segura's type foundry.

Design Firm: SEGURA INC.
Art Director: Carlos Segura
Designer: Carlos Segura
Illustrator: Eric Dinyer
Computer Manipulation: Eric Dinyer
Client: WaxTrax!/TVT Records
Programs: Adobe Photoshop, QuarkXPress

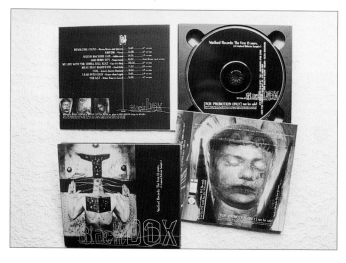

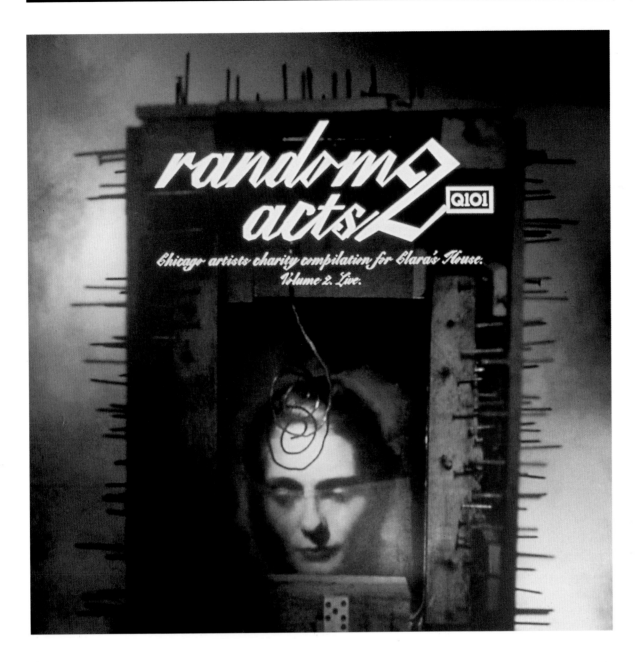

Random Acts 2 Compact Disc

Concept: As a fundraiser for Clara's House, a Chicago-based charity, radio station Q101 held a concert featuring area rock bands. The concert was recorded and segments released on a compact disc called *Random Acts 2*. Area designer Carlos Segura of SEGURA INC. designed the CD packaging for this collection of recordings. Its image of a woman framed in a box driven with nails reflects the raw spirit of the alternative music within.

Production: Segura and imaging specialist Eric Dinyer started with a color photo of a woman, scanned it and brought it into Photoshop, where it was cropped and converted to grayscale. Dinyer took a dye sublimation print of the woman and photographed it in a nail-driven box he constructed. A high-resolution scan was made of the photo and brought into Photoshop, where it was isolated from its background and saved as a layer.

Dinyer created the background behind the box by dabbing paint on paper and scanning it on his studio scanner. The painted background was brought into Photoshop and merged with the image of the woman in a box using the Layers palette. Dinyer adjusted Curves to achieve the desired degree of contrast in both images.

The completed image was brought into QuarkXPress, where type was added.

Design Firm: SEGURA INC.
Art Director: Carlos Segura
Designer: Carlos Segura
Illustrator: Eric Dinyer
Computer Manipulation: Eric Dinyer
Client: Q101 Radio
Programs: Adobe Photoshop, QuarkXPress

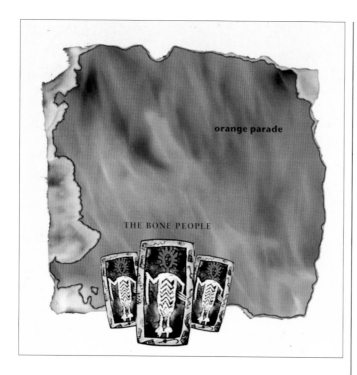

Orange Parade Compact Disc Insert

Concept: For the Bone People's album *Orange Parade*, Paula J. Curran designed a CD packaging insert that combines hieroglyphic images with burnt cloth and flames. The image well suited the jazz group's unconventional music and primitive name.

Production: Curran first took a match to a piece of silk and burned its edges. The silk was scanned on a flatbed scanner as a grayscale image and brought into Photoshop to be combined with other elements on the insert cover. The photo of flames was taken from a disk of copyright-free clip art images. Curran and Photoshop specialist Kelly Popp made a tight crop of the image and superimposed it on the image of the silk by using the Layers feature and choosing Blend If. Popp went back into the composite images and touched up areas between the burnt silk and flames with the Airbrush tool.

The hieroglyphic illustration started with a single hieroglyph scanned and brought into Photoshop, where it was copied and pasted with the editing tools to make an arrangement of three. Popp used Photoshop's Painting tools to add the orange color to the hieroglyphs' heads.

The completed image was brought into Adobe PageMaker, where type was added and the layout for the other pages in the CD insert were produced. The insert was printed in four-color process.

Design Firm: Paula J. Curran
Art Director: Paula J. Curran
Designer: Paula J. Curran
Illustration: Virginia Miska
Computer Manipulation: Kelly Popp
Client: The Bone People
Programs: Adobe Photoshop, Adobe PageMaker

A Regular Dervish Compact Disc Insert

Concept: *A Regular Dervish* is the title for this CD that combines jazz by the Bone People with poetry by Debra Marquart. The packaging insert Paula J. Curran designed for the CD includes a photo of a young girl—the subject of many of the CD's poems—and a background that depicts excerpts from the poetry on a softly flowing piece of silk. Working with a two-color budget, Curran had the insert printed in a mix of rust and black to achieve a warm, earthy look in keeping with the mood of the CD.

Production: For the insert's background, Curran screen-printed a piece of silk with excerpts from Marquart's poetry and had a black-and-white photo made of the silk. Once Curran had established her background effect, she needed a way of visually linking the soft look of the poetry on shadowed folds of fabric with the crisp definition of the CD's title. Her solution was to bridge the gap by bringing the photo into Photoshop and adding a shadowed ampersand. Curran and her production team created the ampersand with the Type tool, applied the Gaussian Blur filter to get a hazy effect and then positioned the ampersand over the studio scan of the background photo.

The completed grayscale image was converted to a duotone of black and rust-toned red, and then brought into a QuarkXPress file, where type and the high-definition photo on the insert's front panel were placed.

Design Firm: Paula J. Curran
Art Director: Paula J. Curran
Designer: Paula J. Curran
Computer Manipulation: Jason Endres, Kelly Popp
Photographers: Laurel Nakadate, Sam Wormley
Client: Debra Marquart, The Bone People
Programs: Adobe Photoshop, QuarkXPress

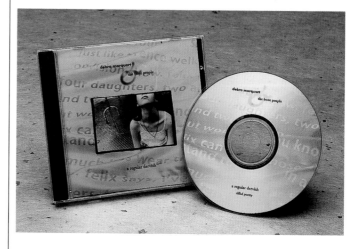

Stars and Garters
Compact Disc Insert

Concept: Compact disc packaging for Splashdown's *Stars and Garters* release required an image that reflected the rock group's alternative style. Boston-based Stoltze Design came up with a look for the CD's folded insert that successfully blends digital technology with watery imagery.

Production: Stoltze and his design team created the look of a splash by forming an arrangement of wires on their studio's flatbed scanner. The wires were scanned as a color file and then brought into Photoshop. Stoltze designers applied the Radial Blur and Motion Blur filters to the wire image to achieve a sense of movement. Color in the background image was adjusted under Hue and Saturation.

The Splashdown logo was created in Typestry, a program that can impart a variety of special effects to type. The designers used Typestry to create a three-dimensional effect for the Splashdown logo and to apply watery and chrome-like surface effects.

The Splashdown logo was imported into Photoshop and blended with the background imagery with the Layers command. The completed image was then brought into a QuarkXPress file, where type and other elements in the insert's layout were added.

Design Firm: Stoltze Design
Art Director: Clifford Stoltze
Designers: Clifford Stoltze, Wing Ngan
Calligraphy: Richard Leighton
Illustrator: Wing Ngan
Computer Manipulation: Wing Ngan, Joe Polevy
Client: Castle von Buhler Records
Programs: Adobe Photoshop, QuarkXPress, Typestry

Cybergenics' Rapid Enhancing Body Building Kit

Concept: Creating a brand identity for Cybergenics' Rapid Enhancing Body Building Kit required depicting the kind of physique the users of the product want to achieve. The identity's designers at Pisarkiewicz & Company, Inc. went a step further. The design firm brought a photo of a muscular male into Photoshop, then enhanced and repeated it to achieve a sense of progression. This subtle effect sends the message that rapid results will be achieved by using the product.

Production: Pisarkiewicz & Company started with a client-provided slide of a male physique. The designers scanned the slide on their studio scanner, brought the image into Photoshop and heightened its contrast using the Curves feature. The photo was then posterized so that the number of gray levels was reduced to four.

When the right effect was achieved with the image in the foreground, it was duplicated under the Multiply menu and blurred with the Gaussian Blur filter. Two more copies of the original photo were made, each blurred progressively more to achieve a sense of progression from hazy to sharp. Each image was created on a separate layer and then composited using the Layers command. The final image was colorized by adjusting Hue and Saturation.

The finished image was brought into two QuarkXPress files, one for the packaging and another for the accompanying training manual. Both the packaging and the brochure were printed in four-color process.

Design Firm: Pisarkiewicz & Company, Inc.
Art Director: Mary F. Pisarkiewicz
Designers: Luca Gasperi, Nathaniel Estes
Computer Manipulation: Joe Alessi
Client: Cybergenics
Programs: Adobe Photoshop, QuarkXPress

Infiniti Packaging

Concept: Infiniti is a dietary supplement that adds weight and bulk to users of the product. To impart a sense of mystery to Infiniti's mix of herbs and other vitamin-enriched ingredients, the designers at Pisarkiewicz & Company, Inc. used Photoshop to create a hazy background for the product's packaging.

Production: The Pisarkiewicz design team started in Photoshop by making an on-screen, grayscale drawing with the Brush tool. They applied the Gaussian Blur filter to this image, and then converted it to CMYK.

Since the background needed to be in two different colors, each for a different flavor, the original image was duplicated. One image was given a blue and black colorization using the Hue and Saturation controls, while the other was colorized with tints of black and brown.

The completed images were brought into QuarkXPress files for each package, where the Infiniti logo, created in Adobe Illustrator, was imported and type was added.

Design Firm: Pisarkiewicz & Company, Inc.
Art Director: Mary F. Pisarkiewicz
Designers: Luca Gasperi, Nathaniel Estes
Computer Manipulation: Luca Gasperi
Client: Cybergenics
Programs: Adobe Photoshop, Adobe Illustrator, QuarkXPress

Sweetened—No Lemon
Compact Disc Packaging

Concept: This image for Sound Patrol's *Sweetened—No Lemon* release was used widely on LP and cassette tape packaging as well as on a compact disc insert. The rock group's pro-environment following prompted SEGURA INC. to develop this image of a shadowy hand superimposed on water.

Production: Imaging specialist Tony Klassen was commissioned to produce the watery image for *Sweetened—No Lemon*. Klassen started with an original slide of water. A high-resolution scan of this image was brought into Photoshop, where Klassen applied the Pond Ripples filter, an option available under the Zigzag filter. Color was enhanced by adjusting Hue and Saturation and increasing contrast with Curves.

The silhouette of the shadowy hand was drawn in Macromedia FreeHand and brought into Photoshop. Klassen created a layer for this image and colored it black. He softened the image by specifying a 10 percent opacity as he blended the hand layer with the water image.

The completed image was brought into a QuarkXPress file for each of the packages.

Design Firm: SEGURA INC.
Art Director: Carlos Segura
Designer: Carlos Segura
Illustrator: Tony Klassen
Photographer: Tony Klassen
Computer Manipulation:
Tony Klassen
Client: Sound Patrol (Organico Records)
Programs: Adobe Photoshop, QuarkXPress, Macromedia FreeHand

OXO "Good Grips" Barbecue Kit

Concept: The OXO company has built its reputation on marketing gardening tools and kitchen utensils with easy-to-grip handles. Hornall Anderson's natural kraft box packaging design for OXO's "Good Grips" barbecue set reflects the manufacturer's no-nonsense, user-friendly approach to its products by depicting the tools in black and opaque white ink. The product packaging has been acknowledged in many competitions, including *Applied Arts Awards* magazine, *Step-By-Step Graphics Design Process Annual*, *American Corporate Identity* and *Creativity*.

Production: To best represent the product, Hornall Anderson commissioned black-and-white photographs of a grill and OXO's barbecue tools. The photo of the barbecue set stands out in sharp relief against the soft silhouette of the grill. To achieve this effect, photographer Tom Collicott shot the tools and the grill as two separate black-and-white photos and had a high-resolution scan made from the tools' image. The grill was shot to cast a natural shadow. The photo of the shadow was converted to a high-res scan and then brought into Photoshop, where Collicott applied the Gaussian Blur filter and gradat-

ed the opacity of the image.

The layered file was returned to Hornall Anderson, where designers dropped out the background tone and created a second channel with masks for each tool, feathering the edges and filling the masks with cyan. The printer used the separated cyan layer as artwork for the negative that carried opaque white ink.

The completed Photoshop image was brought into Macromedia FreeHand, where type, the OXO logo and other graphic elements were assembled into the final mechanical.

Design Firm: Hornall Anderson Design Works
Art Director: Jack Anderson
Designers: Jack Anderson, Heidi Favour, John Anicker, David Bates
Computer Manipulation: Tom Collicott, John Anicker
Photographer: Tom Collicott
Client: OXO, International
Programs: Adobe Photoshop, Macromedia FreeHand

Rhino Chasers Beer and Ale

Concept: Packaging for Rhino Chasers beer and ale successfully blends a playful approach, consistent with the product name, with a traditional look typical of the way beer has been packaged over the years. Type with a hand-rendered look and a realistic rendering of a rhinoceros serve as the basis for the brand identity. Rhino Chasers' brand identity and packaging design by Hornall Anderson Design Works has won numerous awards, among them a LULU Award from Los Angeles Advertising Women, a Packaging Design Council Gold Award and a London International Advertising Award.

Production: Hornall Anderson designers created the Rhino Chasers logo type and mechanical for each component of the packaging system in Macromedia FreeHand. However, the landscape used as a background for each package was created in Photoshop. Landscapes used for each beer and ale product include waves, mountains, snow-covered trees and a sandy beach.

For each of these images, Hornall Anderson designers worked with a stock photo, furnished as a color transparency, which was converted into a black-and-white print. High-res mezzotint scans were made of each print. The designers brought each scan into Photoshop, where Hue and Saturation were adjusted to produce a duotone effect that combines black with the color assigned to each Rhino Chasers product.

The Photoshop background images were placed as art in the FreeHand file for each package and label.

Design Firm: Hornall Anderson Design Works
Art Director: Jack Anderson
Designers: Jack Anderson, Larry Anderson, Bruce Branson-Meyer
Illustrator: Mark Summers
Computer Manipulation: Bruce Branson-Meyer
Client: Rhino Chasers
Programs: Adobe Photoshop, Macromedia FreeHand

A&M Records Compact Disc Covers

Concept: To give radio stations and the recording industry a preview of its latest releases, A&M Records sends out monthly CD "samplers" featuring its newest recordings. Los Angeles–based REY International designs the covers. Given a slogan to work with, but little else, it's up to REY International to come up with a hip, seasonally themed image that ties in with the CD's slogan.

Production: The April CD cover started with an image of a toy bunny, digitized by placing it directly on the scanning bed with a sheet of metallic paper behind it. Designer Greg Lindy brought the image into Photoshop and used the Airbrush tool to remove one of the bunny's eyes. The image was duplicated, inverted and scaled to a smaller size for the background image. Blur filters were applied to portions of both bunnies.

The May CD cover started with a scan of a slide of a yam with the word "May" carved into it. The photo was brought into Photoshop, where the image was inverted. To fill the area needed for the CD cover, Lindy used the Rubber Stamp tool to extend the background.

For June, REY International started with a scan of a slide of a beach in Hawaii. In Photoshop, the Gaussian Blur filter was applied to the image and the color adjusted. Lindy used Nova, a typeface of his own design, to set the numbers and "June." The giant "5" in the foreground was formed with Adobe Dimensions and imported into the Photoshop image.

The final images were brought into a QuarkXPress layout which included the A&M logo. Type for all three covers was set in Quark.

Design Firm:
REY International
Creative Director:
Jeri Heiden
Art Directors: Jeri Heiden,
Michael Rey, Greg Lindy
Designer: Greg Lindy
Computer Manipulation:
Greg Lindy
Photographers: Michael Rey,
Greg Lindy
Client: A&M Records
Programs: Adobe Photoshop,
Adobe Dimensions,
QuarkXPress

CAPTAIN & TENNILLE
Love Will Keep Us Together / Lonely Night (Angel Face)

SQUEEZE
Tempted / Black Coffee In Bed

CARPENTERS
We've Only Just Begun / For All We Know

STYX
Babe / Why Me

A&M Records' Oldies Series

Concept: For a CD packaging concept for a series of hits made by well-known groups of the 1970s, REY International decided to feature recording paraphernalia from the era. The firm developed a series of four nostalgic images, one for each of the recordings, and gave them a high-tech look with the help of Photoshop.

Production: REY International principal Michael Rey shot four black-and-white photos. Three feature the plastic LPs which preceded CDs and other digital recording media, while the fourth shows a turntable. Each of these photos was scanned on the firm's studio scanner so that they could be worked on in Photoshop. REY International designers also scanned the A&M logo on their studio scanner and re-drew it in Macromedia FreeHand so that the logo's outline could also be brought into Photoshop. Designer Greg Lindy used the Layers feature to superimpose several different-sized copies of the logo on Rey's nostalgic photos. In some instances the Gaussian Blur filter was applied to the logo. Feathering and Opacity controls were used to give the logo varying degrees of translucency. To enhance their nostalgic look, the CD images were given a subtle color tint. The A&M logo was assigned a different PMS color.

The image for each package was brought into a QuarkXPress file, where the type at the top and the Digital Memories logo were added.

Design Firm: REY International
Creative Director: Jeri Heiden (A&M Records)
Art Directors: Jeri Heiden, Michael Rey, Greg Lindy
Designer: Greg Lindy
Photographer: Michael Rey
Computer Manipulation: Greg Lindy
Client: A&M Records
Programs: Adobe Photoshop, QuarkXPress, Macromedia FreeHand

Quantum Product Packaging

Concept: In an effort to improve Quantum Corporation's visibility outside the manufacturing arena, Primo Angeli Inc. and Quantum's advertising agency, Golberg Moser O'Neill, developed a design program that would communicate a strong and consistent image on Quantum's promotional materials, product packaging and other retail applications, and the Internet.

Production: The image used on Quantum's product packaging started with a photo of a cardboard box taken with a

QuickTake digital camera and was brought into Adobe Illustrator, where a rendering was made. The Illustrator paths were imported into Photoshop.

Designer Philippe Becker brought digital clip images of clouds and water into Photoshop and mapped them on the different panels of the box by choosing Distort under the Image Effects menu. The image of the Earth also came from a digital clip file.

The image of the Earth in the box was given to illustrator Mathew Holmes to work from

in rendering a replica with conventional media since a traditional illustration cost less than the digital clip images.

When Holmes finished the illustration, Becker scanned it and brought it into Photoshop so the type could be added. Becker set the individual lines of type in Illustrator and brought them into Adobe Dimensions, where they were made to conform to the shape of a sphere. The type was brought into Photoshop so portions could be feathered to create a translucent effect.

The Photoshop image was

brought into Illustrator, where the Quantum logo and additional type were added.

Design Firm: Primo Angeli Inc.
Creative Director: Primo Angeli
Art Directors: Brody Hartman, Richard Scheve
Designers: Philippe Becker, Nina Dietzel
Illustrator: Mathew Holmes
Computer Manipulation: Ryan Medeiros
Client: Quantum Corporation
Programs: Adobe Photoshop, Adobe Illustrator, Adobe Dimensions

XACT 4000 Software Packaging

Concept: XACT 4000 is a program that enables engineers to design and test circuit boards on the computer—an efficient alternative to designing circuit boards on paper and then testing them through traditional methods. Primo Angeli Inc. devised this packaging concept that features a paper airplane heading for space. The visual metaphor not only successfully communicates the product's effectiveness; it has impressed colleagues in the design industry, who have recognized it with a Packaging Design Council Gold Award and an American Graphic Design Award.

Production: A Polaroid photo of a paper airplane served as the starting visual for the packaging art. After scanning the Polaroid on the firm's scanner, designer Philippe Becker brought the image into Photoshop, where it was shaded and colorized with the Selection and Brush tools. The window was added to the rendering of the paper airplane using the Drawing and Gradient features. The sky and its stars were also created with the Gradient tool.

The Photoshop image was brought into Adobe Illustrator, where type was added and the digital mechanical for the packaging was completed.

Design Firm: Primo Angeli Inc.
Art Director: Primo Angeli
Designers: Primo Angeli, Vicki Cero, Phillip Ting, Terrence Tong, Philippe Becker
Computer Manipulation: Philippe Becker, Phillip Ting, Terrence Tong
Client: XILINX
Programs: Adobe Photoshop, Adobe Illustrator

Advertising & Direct Mail

THE IDEA. The best computer generated-art. Show us samples of your best work. Design, illustration, and photography. Show us how you pushed the limits, what software and hardware you used and which configuration. Show us your most outrageous, original and inventive work. Don't show us anything less than digital dynamite.

THE FORMAT. Send your work in one of the following ways: as a printed piece, unmounted, but well protected, as color film, or as TIFF files on a 3.5" Mac-formatted disk. Any work produced in 1992-93 using any computer hardware/software combination is eligible. **THE FEES.** $25 for the first entry, $20 for each additional entry. **THE JUDGES.** Judges are chosen by the editorial staff of Confetti Magazine on the basis of their own work, their expertise in the field, and their ability to fairly evaluate entries. All judges' decisions are final. **THE DEADLINE.** All entries must be received at Confetti's editorial offices by midnight, September 7th, 1993. Send entries to 1425 East Avenue, El Grove, Illinois 60007. If you have questions, or need further assistance, call toll free 800.451.8166. Winners will be featured in a future issue of Confetti magazine.

Rate Card for *High-Tech Office*

Concept: Producing a cover image for Newsweek International's *High-Tech Office* rate card required streamlining a conference-room-table discussion from ten individuals to eight. Photographic refinements and a different background effect were accomplished using Photoshop.

Production: Tony Stone's stock image of a conference table was tailor-made for the cover design Courtney & Company Inc. envisioned. However, the image was too long for the cover's $8\frac{1}{2}$" x 11" (22cm x 28cm) vertical format. Art director Mark Courtney had the conference table transparency professionally scanned and brought it into Photoshop, where he used the Layers feature to eliminate the center portion of the table and merge the two halves together. The Rubber Stamp and Airbrush tools were applied to realistically blend the halves together and adjust the shadows cast across the table.

Courtney and designer Robert Adams used Photoshop's masking features to isolate the conference table and its seated individuals from the original background. To achieve a background effect of computer circuitry, Courtney & Company had a professional scan made of a computer circuit board and combined it with the conference-table image in Photoshop. The path that had been used to outline the conference-table image was duplicated to create a drop shadow against the circuitry background.

The image was brought into Adobe Illustrator, where type and the logo were added.

Design Firm: Courtney & Company, Inc.
Art Director: Mark Courtney
Designer: Robert Adams
Computer Manipulation: Robert Adams, Mark Courtney
Client: Newsweek International
Programs: Adobe Photoshop, Adobe Illustrator

[T-26] Font Promotion

Concept: [T-26] is a type company founded by Chicago designer Carlos Segura. To launch five of the foundry's latest fonts, Segura created this accordion-fold card featuring a visual application of each of the fonts. On the reverse side of the mailer, each panel is backed up with a representation of an entire alphabet of the typeface shown on the front panel. Segura mailed thirty thousand copies of the piece in postcard-size glassine envelopes.

Production: The images on each panel represent a rich assortment of styles and imaging techniques. Although not all of them were created entirely in Photoshop, three out of five of the images were created with the help of the program, and one was assembled in Photoshop

(the panel promoting Proton was created entirely in Adobe Illustrator).

The image on the Plasticman panel is an oil painting created by San Francisco–based designer/illustrator John Ritter. Ritter scanned the painting and modified its color and tone values in Photoshop using Hue and Saturation and Curves.

The "Superior" image was created by taking a piece of paper printed many times on a letterpress and bringing a scan of it into Photoshop. Segura adjusted colors and values using Hue and Saturation.

Designer Mark Rattin created the fourth image, "For Time in Hell," by combining a 3-D drawing made in Ray Dream Designer with images in Photoshop. After Rattin brought

the 3-D images into Photoshop, he used the Layers command to blend them.

The last panel, promoting Aquiline, features an image created by Jim Marcus. Marcus combined original black-and-white photos of a nude woman, Eskimo masks, a bird and a variety of textural photos that included wood and flowers, and brought scans of all of them into Photoshop. He added color to the black-and-white images by converting them to CMYK and adjusting Hue and Saturation. The images were blended into a composite using the Layers command.

All of the completed panels were saved as EPS files and brought into a QuarkXPress file for the piece.

Design Firm: SEGURA INC.
Art Director: Carlos Segura
Designer: Carlos Segura
Illustrators: John Ritter, Mark Rattin, Jim Marcus
Computer Manipulation: John Ritter, Mark Rattin, Jim Marcus, Carlos Segura
Client: [T-26] Type Foundry
Programs: Adobe Photoshop, QuarkXPress, Adobe Illustrator, Ray Dream Designer

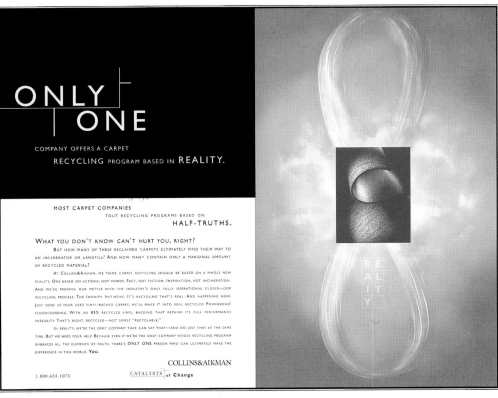

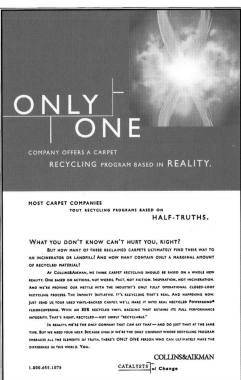

Collins & Aikman

Concept: Collins & Aikman specializes in recycling floor coverings. To unify the ads for its carpeting recycling program with a consistent visual theme, Copeland Hirthler design + communications took its lead from the idea of closing the loop in the recycling process, and represented this concept with a figure-eight configuration of looped carpet fiber. The image appears in ads that run in *Metropolitan* and other interior design trade publications, and works equally well in limited color applications as it does in four-color.

Production: Designers Lea Nichols and Raquel C. Miqueli started with a black-and-white photograph of a looped fiber, which they commissioned from photographer Jerry Burns. The photo was scanned on their studio scanner and brought into Photoshop, where Hue and Saturation were adjusted on the color image. Miqueli used the Paint Brush tool to create bright streaks along the fiber loop and

created the hot glow at the center of the figure eight with the Airbrush and Rubber Stamp tools.

On both ads, Photoshop images were brought into QuarkXPress files, where type and color backgrounds were added. For the predominantly black-and-white ad, a black-and-white photo of a rolled carpet was superimposed on the image of the looped fiber by bringing it into a QuarkXPress picture box and colorizing it with Quark's Show Colors feature.

Design Firm: Copeland Hirthler design + communications
Creative Directors: Brad Copeland, George Hirthler
Art Director: Raquel C. Miqueli
Designers: Raquel C. Miqueli, Lea Nichols
Computer Manipulation: Raquel C. Miqueli, Lea Nichols
Photographer: Jerry Burns
Client: Collins & Aikman
Programs: Adobe Photoshop, QuarkXPress

Microsoft Seminar Mailer

Concept: To advertise a series of seminars in the southeastern U.S., Microsoft sent this brochure, a five-panel self-mailer, to businesses throughout the area. The brochure was designed by Atlanta-based Copeland Hirthler design + communications, which was provided with copy and no visuals per se, except for shots of Microsoft products. The designers relied on Photoshop-enhanced imagery to suggest a theme of "endless horizons." The images add color and visual interest and provide a backdrop for the various seminar topics listed on the cover and interior of the brochure.

Production: The Copeland Hirthler design team started with stock images of sky and landscape photos. The transparencies were purchased from a stock agency and scanned on Copeland Hirthler's studio scanner. The images were brought into Photoshop, where the Gaussian Blur filter was applied to give them a soft, hazy effect. Color was adjusted using the Hue and Saturation controls.

The images were brought into QuarkXPress, where type was added and the brochure's layout was completed.

Design Firm: Copeland Hirthler design + communications
Art Director: Todd Brooks
Designer: Todd Brooks
Computer Manipulation: Todd Brooks
Client: Microsoft
Programs: Adobe Photoshop, QuarkXPress

Steppenwolf Theatre Company Subscription Mailer

Concept: Chicago's Steppenwolf Theatre Company is a highly respected ensemble theater, well known for its raw, gut-wrenching performances. To project this image in Steppenwolf's subscription mailer, Mark Oldach Design, Ltd. had to come up with dramatic and attention-grabbing visuals that projected the "in-your-face" character of the company's performances. However, the design firm was given a hodgepodge of photographic material to work from, comprising Polaroid prints, 35mm slides, black-and-white and color prints—all taken in different settings. To unify the diverse assortment of visuals and create a harmonious visual treatment, Oldach chose to bring the images into Photoshop to be enhanced and colorized in a consistent manner.

Production: The photos and slides were all scanned on Oldach's studio scanner as grayscale images. From there, the Curves feature was used to adjust contrast and brightness on each photo. Images were then colorized by adjusting Hue and Saturation. In some cases, photos were cropped and made into separate files to create different color effects for each portion. These images were reassembled in QuarkXPress.

The mailer's layout was assembled in QuarkXPress, where graphic elements and calligraphic type, created in Adobe Illustrator, were also brought in. The mailer was printed in four-color process.

Design Firm: Mark Oldach Design, Ltd.
Art Director: Mark Oldach
Designer: Guido Mendez
Computer Manipulation: Guido Mendez
Client: Steppenwolf Theatre Company
Programs: Adobe Photoshop, Adobe Illustrator, QuarkXPress

Digital Design Competition Ads

Concept: SEGURA INC.'s promotional imagery for Digital Dynamite, a computer design competition sponsored by *Confetti*, involved a different design for each in a series of three ads featured at different times within the magazine. Each ad had to be attention-grabbing design on the edge, based on computer-rendered imagery.

Production: Because SEGURA INC. produced the ads in an earlier version of Photoshop, much of the initial image creation was accomplished with professional photography. The two-page ad started with two color transparencies of abstract imagery by photographer Pedro Lobo, which were scanned professionally and brought into Photoshop. Designer Carlos Segura adjusted Hue and Saturation to achieve the red colorization.

The slingshot and globe image started with professional scans of two color transparencies. Segura had both images shot against a white backdrop and used the Eraser tool to clean up the background. The Gaussian Blur filter was applied to the slingshot, and Hue and Saturation were adjusted to give the image its red color. Segura assembled the images with a simple Cut and Paste.

The third ad in the series was created from a color transparency of a face photographed by Hans Staartjes. Segura had professional scans made of the transparency and brought it into Photoshop. After he cropped the portion of the image he wanted, Segura duplicated it and applied Invert to achieve a negative image. Hue and Saturation were adjusted on both images to get the bluish tint of a video screen. The two photos were assembled in the QuarkXPress document for the ad.

Segura produced the Digital Dynamite logo in Adobe Illustrator and produced the layout for each ad in QuarkXPress.

Design Firm: SEGURA INC.
Art Director Carlos Segura
Designer: Carlos Segura
Photography: Photonica
Computer Manipulation: Carlos Segura
Client: *Confetti* Magazine
Programs: Adobe Photoshop, Adobe Illustrator, QuarkXPress

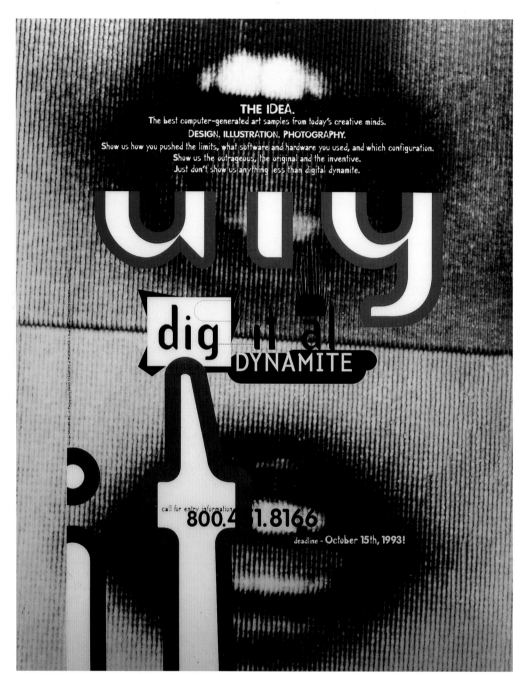

THE IDEA.
The best computer-generated art samples from today's creative minds.
DESIGN. ILLUSTRATION. PHOTOGRAPHY.
Show us how you pushed the limits, what software and hardware you used, and which configuration.
Show us the outrageous, the original and the inventive.
Just don't show us anything less than digital dynamite.

dig it al
DYNAMITE

call for entry information
800.4 1.8166
deadline - October 15th, 1993!

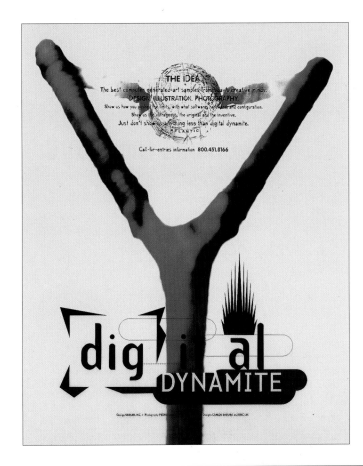

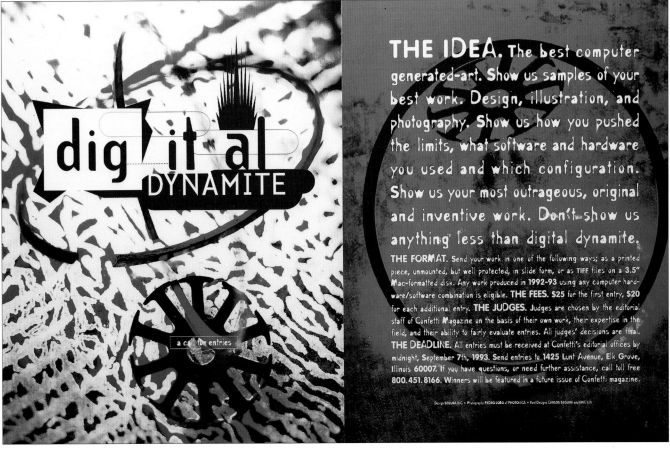

Phelps Dodge Ad

Concept: Phelps Dodge, a Fort Wayne, Indiana–based manufacturer of magnet wiring, wanted to let area residents know about its sponsorship of Science Central, a Fort Wayne science center. The company commissioned Boyden & Youngblutt to design a newspaper ad that would get the company's message across. The advertising agency came up with the idea of featuring children with their hands on an interactive device in the museum that uses static electricity to create "hair-raising" effects.

Production: Photographer Tom Galiher took a black-and-white photograph of children with their hands on the museum display. Although hair spray and gel were applied to the children's hair in an attempt to make it stand up, efforts failed, and it was decided that the hair-raising effects would have to be created on the computer.

Designer Don Weaver had a high-resolution scan made of the black-and-white photo and brought it into Photoshop. He extended the children's hair by using a combination of the Rubber Stamp, Airbrush and Eraser tools. Selective blurring at the hair ends was achieved with the Gaussian Blur filter. To create the effect of a fish-eye lens, Weaver applied the Spherize filter to the entire image.

The Photoshop image was brought into an Adobe PageMaker document for the ad, where type and logo art were assembled into the final layout.

Design Firm: Boyden & Youngblutt
Art Director: Andy Boyden
Designer: Andy Boyden
Photographer: Tom Galiher
Computer Manipulation: Don Weaver
Client: Phelps Dodge
Programs: Adobe Photoshop, Adobe PageMaker

At Phelps Dodge, we believe electricity will send the next generation into the future.

A key, a kite, and a bolt of lightning led Ben Franklin to one of the greatest scientific discoveries of all time. Today, over 200 years later, America is still discovering the wonders of electricity and science.

At Science Central, a hands-on learning center being built right here in Fort Wayne, kids have a chance to explore this amazing world around us. What makes a motor run? How do tiny drops of water bend light into a rainbow? Why does static electricity make your hair stand on end?

Phelps Dodge is a sponsor of Science Central, Indiana's first and only science center.

Teaching kids how to have fun with science is the whole idea behind Science Central. And Phelps Dodge Magnet Wire Company is proud to be a part of it.

As a corporate sponsor, we're investing time and resources in making this world-class science center a grass-roots reality. Working with other local businesses, we're providing an exhibit that shows how electricity comes into your home and, with a little help from magnet wire, allows your appliances to operate.

And that's just part of

Without magnet wire, electricity couldn't be harnessed for use in your home.

what's inside Science Central. There's also a huge turbine engine. A gravity-defying bicycle you can ride 20 feet in the air. Animated exhibits and displays. Even a workshop that lets you build your own electric motor using magnet wire from local industry.

At Phelps Dodge, we believe that scientific discovery holds the key to America's future, just as it did over 200 years ago. Because if we can help just one child to understand how something like electricity works, there's no telling what powerful discovery that one child will make next.

phelps dodge Magnet Wire Company

We're connected to you.

Advertising Supplement Cover

Concept: Stoltze Design created this special advertising supplement for *InfoWorld*, a monthly magazine for computer users. The supplement was intended as a soft-sell promotional opportunity for the magazine's major advertisers. Its cover effectively ties in the "Roamin' Empire" headline's reference to antiquity with technology-aided business management.

Production: Firm principal Clifford Stoltze and staff designer Wing Ngan started with found line art of classical architecture and sculpture. After these items were scanned and brought into Photoshop, the art was selected and colored and each assigned a different layer. These images were blended with an abstract, computerized background texture created by repeatedly applying the Sharpen tool to a black-and-white photo of a circuit board, which was then enlarged without resampling by selecting Image size.

Sharp-focus black-and-white photos of people in office environments are stock images supplied on CD-ROM. The three images were added to the composition and given a vignette effect by selecting their edges and applying the Feather command. Hue and Saturation were adjusted on two of the photos to achieve a duotone effect.

The Photoshop image was brought into QuarkXPress, where the LAN logo, the supplement's title and other type were added. The supplement cover was printed in four-color process.

Design Firm: Stoltze Design
Art Director: Clifford Stoltze
Designer: Wing Ngan
Computer Manipulation: Wing Ngan
Client: Bill Laberis Associates
Programs: Adobe Photoshop, QuarkXPress

Invitations, Announcements & Greeting Cards

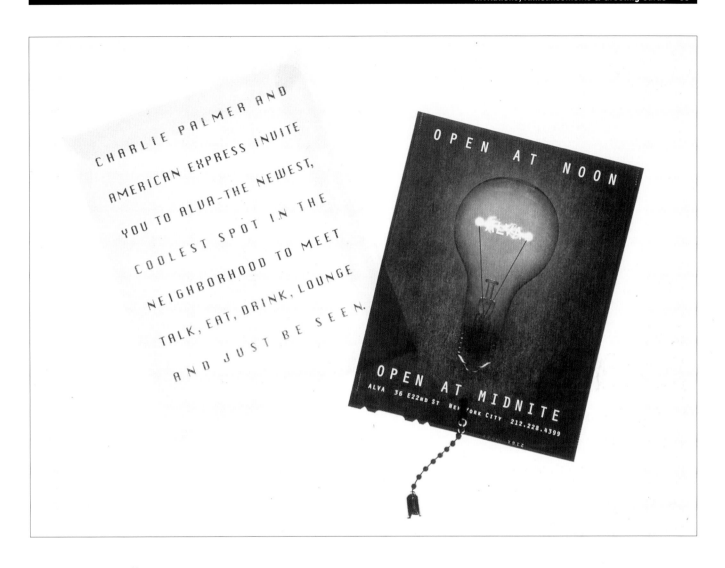

ALVA Restaurant New Hours Announcement

Concept: AERIAL designed this unusual mail promotion to announce new noon-to-midnight hours for ALVA, a restaurant in New York City's Soho district. The basis of the promotion is a transparency of a lightbulb with a brightened filament which forms the name "ALVA," Thomas Edison's middle name. A metal lamp pull was attached to the bottom of the transparency to reinforce the promotion's electrically themed message. The transparencies were generated from a Photoshop file and slipped into pre-printed glassine sleeves before being mailed to approximately 3,500 Soho residents.
Production: AERIAL principal

Tracy Moon started with a transparency shot by photographer R.J. Muna of an antique lightbulb. A high-resolution scan of the image was brought into Photoshop, where imaging specialist Clay Kilgore isolated the light bulb from its original background and used Layers to place it on a new background of scanned art paper. Kilgore set the word "ALVA" in Adobe Illustrator and then imported it into Adobe Dimensions to give the type a three-dimensional look. The Dimensions type was then imported into Photoshop, where Kilgore blended it with the lightbulb image using the Layers palette. The image was lightened using Photoshop's

Painting tools. Kilgore created a soft glow within the lightbulb by applying the Gaussian Blur filter to the background area behind the lightbulb and adjusting Curves to lighten the area.

The completed Photoshop image was brought into QuarkXPress, where type was added to the top and bottom. Transparencies were generated from the QuarkXPress file at a service bureau.

The transparencies were placed in glassine sleeves printed with ALVA's promotional message. Before mailing, each sleeve was attached to a piece of black illustration board, which was placed in a 6" x 9" envelope.

Design Firm: AERIAL
Art Director: Tracy Moon
Designer: Tracy Moon
Photographer: R.J. Muna
Computer Manipulation: Clay Kilgore
Client: Charlie Palmer/ALVA Restaurant
Programs: Adobe Photoshop, Adobe Illustrator, Adobe Dimensions, QuarkXPress

MAY THE KINDNESS AND GENEROSITY OF SPIRIT YOU'VE SENT INTO THE WORLD RETURN TO YOU IN FULL THIS HOLIDAY SEASON.

Zerogravity Holiday Card

Concept: Chicago-based Zerogravity's 1995/96 holiday greeting card reinforces the spirit of world peace and cooperation with its image of a boomerang set against a world map. Its designer, Colin Metcalf of Zerogravity Ltd., drew much of the image in a 3-D drawing program and used Photoshop to add realism and a sepia-toned effect to the final image.

Production: Metcalf started by drawing the boomerang in Ray Dream Designer. He then scanned a fifteenth-century map, photographed from a book of antique maps, on his studio scanner and also brought it into Ray Dream to serve as the boomerang's backdrop. Metcalf applied lighting and the shadow cast against the map in Ray Dream and then imported both the map and boomerang images into Photoshop.

Metcalf imported a heart motif he had drawn in Adobe Illustrator into Photoshop and used Dodge and Burn to burn it into the center of the boomerang. Spotlighting was added to the heart with the Lighting Effects filter. The image of the map was softened and given a globe-like appearance by applying the Radial Blur filter. Metcalf combined the boomerang and map images using Layers and adjusted Hue and Saturation to achieve the warm colorization.

The Photoshop composite was imported into a QuarkXPress file, where the card's message and diagonal lines were added. The card's interior reinforces its cover theme with a depiction of a heart morphing into a boomerang.

Design Firm: Zerogravity Ltd.
Art Director: Colin Metcalf
Designer: Colin Metcalf
Illustrator: Colin Metcalf
Photographer: Julie Mikos
Computer Manipulation: Colin Metcalf
Client: Zerogravity Ltd.
Programs: Adobe Photoshop, Adobe Illustrator, Ray Dream Designer, QuarkXPress

Rock and Roll Hall of Fame and Museum Opening Invitation

Concept: The ribbon-cutting ceremony for the Rock and Roll Hall of Fame and Museum was a memorable event attended by many well-known recording artists and other celebrities. Cleveland-based Nesnadny + Schwartz designed an unforgettable invitation worthy of this special event. It bears an image that combines the nostalgic spirit of the museum with a touch of self-deprecating humor.

Production: The three-paneled invitation's cover image of a mother and daughter baking cookies evokes the feeling of another era. Purchased from a stock agency, the vintage transparency dates back to the 1950s, when rock and roll first began to come into its prime.

Nesnadny + Schwartz had their printer make high-resolution scans of the stock transparency and a photograph of the Rock and Roll Hall of Fame and Museum. Both scanned images were then brought into Photoshop, where the building was outlined and composited onto the cookie tray. The Rubber Stamp tool was used to successfully blend the image of the building into the background of the oven interior.

The Photoshop image on the front of the invitation was then brought as a TIFF file into a QuarkXPress document, where it was combined with type and other photos of the museum to create the digital art for the card.

Design Firm: Nesnadny + Schwartz
Art Director: Mark Schwartz
Designers: Brian Lavy, Mark Schwartz
Photographers: Various
Client: Rock and Roll Hall of Fame and Museum
Programs: Adobe Photoshop, QuarkXPress

AERIAL Holiday Card

Concept: AERIAL's wish for the coming New Year was expressed to clients and studio friends in this holiday card—a series of accordion-folded panels with a bell attached to the end. Each panel features an image that describes a letter in the AERIAL name. When the card is viewed vertically, the name "AERIAL"—with the "L" spelled as "elf"—becomes readily apparent.

Production: Art director and firm principal Tracy Moon started with black-and-white photos and color transparencies, shot by R.J. Muna, for each panel. High-resolution scans of each image were brought into Photoshop, where Hue and Saturation were adjusted to colorize each image. The Gaussian Blur filter was applied selectively in all of the panels to soften parts of each image. The tech-

nique draws the viewer's eye to the parts of each image that remain in sharp focus, such as the eye on the doll. The letter "R" was typed using Photoshop's Type tool and rotated so it would blend with the ornament hook. Moon added a drop shadow by making a duplicate of the "R," inverting it and applying the Gaussian Blur and Offset filters.

The final panel in the series bearing AERIAL's holiday greeting is a combination of two photos: one of sculpted numerals and one of sculpted angels. Computer imaging specialist Clay Kilgore blended the two photos by adjusting the Opacity controls on Photoshop's Layers palette. Type on this panel, as well as on the other panels where it appears in reverse, was added in QuarkXPress.

The cards were printed by

making Iris prints on a 100 percent rag paper. Moon ganged multiple copies of the card on each parent sheet and trimmed and scored each card before folding it and attaching the bell. A total of 250 cards was produced.

Design Firm: AERIAL
Art Director: Tracy Moon
Designer: Tracy Moon
Photographer: R.J. Muna
Computer Manipulation:
Clay Kilgore, Tracy Moon
Client: AERIAL
Programs: Adobe Photoshop, QuarkXPress

Boelts Bros. Associates' Tenth Anniversary Invitation

Concept: The tenth anniversary of the founding of Boelts Bros. Associates provided the occasion for a party and a not-to-be-ignored invitation. The Tucson, Arizona–based design firm sent this special invitation commemorating each of the ten years with a visual that marks a noteworthy event that took place during that particular year. For instance, 1987, the year the Dow Jones dropped over five hundred points and Life Savers sold its thirty-three-billionth roll, is marked with a visual depicting a downward-rolling Life Savers logo. Boelts Bros. used the reverse side of the card to give an explanation for each visual. They reserved the tenth spot, 1996, for details on where and when the tenth anniversary party would take place. To be sure recipients would respond to the colorfully illustrated invitation, it was sent in a see-through glassine envelope.

Production: Boelts Bros. took advantage of the diversity of talent in its firm by involving many of its staff members in the production of original illustrations and photographs. The designers scanned these images and combined them with clip art and digital special effects in Photoshop to achieve the desired effect for each year. The 1989 visual, which commemorates the unveiling of the pyramid sculpture in front of the Louvre, was created with the help of the Stylize and Extrude features under the filter menu. The swirled background on the image bearing the giant Roman numeral X was created by using the Twirl filter.

The ten images were assembled into the final art for the front of the card using Macromedia FreeHand. The copy and layout on the reverse side of the card were also created in FreeHand. The card was printed in four-color process on coated card stock.

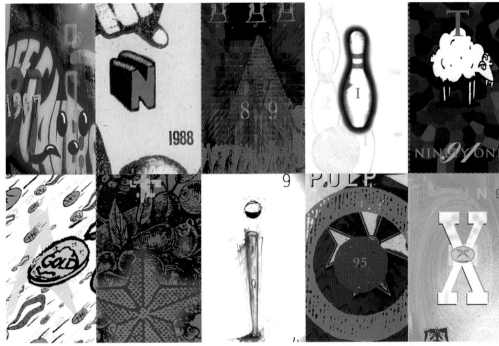

Design Firm: Boelts Bros. Associates
Art Directors: Eric Boelts, Jackson Boelts, Kerry Stratford
Designers: Eric Boelts, Jackson Boelts, Kerry Stratford
Illustrators: Eric Boelts, Jackson Boelts, Kerry Stratford, Scott Norris, Deanne Perry, Ward Andrews
Client: Boelts Bros. Associates
Programs: Adobe Photoshop, Macromedia FreeHand

Brochures

1550 Bryant Street Brochure

Concept: This brochure promotes the leasing of space within a newly renovated San Francisco landmark located at 1550 Bryant Street. Its owners contracted with Primo Angeli Inc. to design a brochure that conveyed the art deco elegance of the twelve-story building, which formerly housed Hamm's Brewery. Art director Primo Angeli and designer Philippe Becker used Photoshop to create a three-dimensional, decoesque cover that effectively communicated the image of this stately structure. The cover won a

Creativity Award and an American Graphic Design Award.

Production: Becker began the cover illustration by working with a studio scan of the 1550 Bryant Street logo in Adobe Illustrator. In Illustrator, he created a digital rendering of the logo which he then imported into Photoshop. By applying the Extrude filter and selecting the Pyramid option, Becker was able to achieve a prismatic effect.

Becker brought the Photoshop image of the building

back into Illustrator, where he added type and the drop shadow behind "1550." The brochure cover was printed from the Illustrator file in dark purple and metallic silver.

Design Firm: Primo Angeli Inc.
Art Director: Primo Angeli
Designer: Philippe Becker
Computer Manipulation:
Philippe Becker
Client: Rubin Glickman, Attorney
Programs: Adobe Photoshop, Adobe Illustrator

1994 Starbucks Annual Report

Concept: The Starbucks Corporation's 1994 annual report communicates the feeling of a good cup of coffee—rich, warm and satisfying. It's no accident that these qualities are part of the image Starbucks has built its business on. As the design firm behind the coffee retailer since 1992, Hornall Anderson Design Works has expressed this sensibility in its designs for the company's packaging, catalogs and other publications. To convey the ambiance of Starbucks' retail and food service establishments, the design firm hired photographer Michael Baciu to shoot photos at Starbucks locations all over the country. Baciu's photography and processing techniques yielded a wealth of atmospheric shots, interspersed throughout the annual report.

Production: For the annual report cover, Hornall Anderson designers wanted to capture the cozy atmosphere of the Starbucks experience, conveyed by the photos within, by creating a cover with a fuzzy, warm glow. They started by creating a black rectangle in Photoshop. The rectangle was feathered and inverted, then saved as a grayscale TIFF file to be imported into QuarkXPress.

The designers colored the image and its background in QuarkXPress, where type and the Starbucks logo were added to the cover. Before being sent to shareholders, each of the annual reports was sealed with a gummed seal, used by Starbucks on its coffee bean bags to differentiate one type of coffee from the next.

Design Firm: Hornall Anderson Design Works
Art Director: Jack Anderson
Designers: Jack Anderson, Julie Lock, Mary Chin Hutchison
Illustrator: Linda Frichtel
Photographer: Michael Baciu
Computer Manipulation: Mary Chin Hutchison
Client: Starbucks Coffee Company
Programs: Adobe Photoshop, QuarkXPress

1995 Starbucks Annual Report

Concept: The Starbucks Corporation was founded on the premise that people would enjoy drinking and purchasing premium coffee in a combined retail and food service operation. The company's venture into this blending of markets has grown into a modern success story. In 1997, Starbucks operated in over 400 locations, opening an average of three stores per week. In its 1995 annual report, Starbucks' progress since its inception in 1971 is measured by historic milestones. The report's designers at Hornall Anderson Design Works juxtaposed photos representing these events with photos of Starbucks products. They used Photoshop to compose each of these pictorial pages.

Production: Various background colors serve as backdrops for the report's black-and-white photos and are used to differentiate each of the report pages. Hornall Anderson designers added a mottled texture to each colored background with the Airbrush tool. A drop shadow was placed behind each photo by forming a rectangle in Adobe Illustrator, bringing it into Photoshop and filling it with the color used to create the airbrushed texture.

The designers also used Photoshop to add subtle color to each of the black-and-white photos. High-resolution scans were brought into the program and Hue and Saturation were adjusted on each to achieve a duotone effect that coordinates with the background color of the page on which it appears.

High-resolution scans of each product shot were also brought into Photoshop to be added to each page. The Selection tools were used to isolate each product from its background, and the Layers feature was used to position the shot on the page. Cast shadows for each product were added with the Airbrush tool, with the Gaussian Blur filter and by feathering.

The completed images were brought into a QuarkXPress file.

Design Firm: Hornall Anderson Design Works
Art Director: Jack Anderson
Designers: Jack Anderson, Julie Lock, Heidi Favour
Photographer: Alan Abromowitz
Computer Manipulation: Alan Florsheim, John Anicker, Michael Brugman
Client: Starbucks Coffee Company
Programs: Adobe Photoshop, QuarkXPress, Adobe Illustrator

TVT Records [product catalogue for 1995]

TVT Record Catalog

Concept: To promote TVT Records, the recording company uses this product catalog produced in two sizes. A 10" x 10" (25cm x 25cm) catalog goes to compact disc buyers at retail outlets, while a CD-sized version of the catalog is given to consumers. The catalog's designers at SEGURA INC. devised a cover for the 1995 catalog showing TVT recording artists on a variety of television sets. The TVs are arranged to form the letter "T."
Production: The designers started by playing videotapes of the various TVT recording artists. Screen captures were made of each of the poses they wanted to use and these were imported into Photoshop.

Meanwhile, computer imaging specialist Tony Klassen was creating the cover's red background effect by using Kai's Power Tools, a Photoshop extension, to produce a swirling pattern. Klassen selected a wedge of the image, duplicated and flipped it, and repeated this sequence to create a kaleidoscopic effect.

Klassen also created the three-dimensional drawings of the cover's TV sets in Ray Dream Designer. He arranged the TVs into their T configuration and then imported the Photoshop backdrop into Ray Dream Designer. Klassen composited the two images in Ray Dream Designer and created cast shadows against the red backdrop.

The completed Ray Dream Designer image was imported into Photoshop, where Klassen pasted the screen captures of TVT recording artists onto each TV screen.

The completed Photoshop image was brought into two QuarkXPress files, one for each of the catalogs.

Design Firm: SEGURA INC.
Art Director: Carlos Segura
Designer: Carlos Segura
Illustrator: Tony Klassen
Computer Manipulation:
Tony Klassen
Client: TVT Records
Programs: Adobe Photoshop, Ray Dream Designer, QuarkXPress, Kai's Power Tools

Hotel Bohéme
Promotional Brochure

Concept: Hotel Bohéme, located in San Francisco's North Beach, is a spot where the spirit of the 1950s reigns supreme. The hotel's atmosphere and decor reflect the look of the period, and so do its business and promotional materials. San Francisco–based AERIAL is the design firm behind the hotel's print identity. The brochure is based on the grid-like configuration of its postcards, business cards and other printed materials, but with the added twist of interior pages which are divided in half. The interactivity of the brochure's interior pages helps to convey the eclectic, bohemian spirit of the hotel. The brochure has won recognition for its design from *HOW* and *Print* magazines.

Production: The brochure's interior pages comprise four-color art, patterns and photographs as well as duotones. AERIAL principal Tracy Moon produced the duotones by working with high-resolution scans of stock transparencies and black-and-white prints which were brought into Photoshop. Moon converted the color images to grayscale and made them into duotones. She then converted all images to CMYK so that the duotone effects she created could be printed in four colors.

The cover of the brochure shows a woman's portrait in soft focus. The photo is a one-of-a-kind image, shot by 1950s photographer Jerry Stoll. A high-resolution scan was made of the photo and it was brought into Photoshop, where retouching and cleanup were done with the Rubber Stamp tool. Moon applied the Gaussian Blur filter to this image and added Noise to produce a grainy effect. The four-color image was given a warm, duotone effect by adjusting Hue and Saturation.

All images were placed into a QuarkXPress file for the brochure layout.

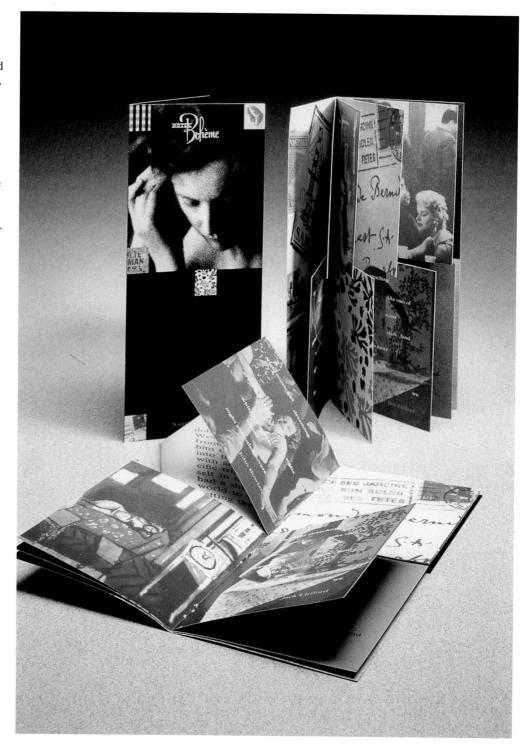

Design Firm: AERIAL
Art Director: Tracy Moon
Designer: Tracy Moon
Illustrator: John Mattos
Photographers: R.J. Muna, Jerry Stoll
Computer Manipulation: Tracy Moon
Client: Hotel Bohéme
Programs: Adobe Photoshop, QuarkXPress

DynaBase Web Management Sales Brochure

Concept: This sales brochure for EBT's DynaBase Web Management System required a high-tech look, but one that wouldn't interfere with the clarity and legibility of the highly technical information it contained. Given a budget that limited the brochure's color to three match colors, Stewart Monderer Design, Inc. came up with a background treatment that takes Web terminology and combines it with a metaphorical representation of interactivity.

Production: Principal Stewart Monderer and his design team started with an original black-and-white photo of pipes, which was scanned on Monderer's flatbed scanner. The Gaussian Blur filter was applied to the

image to give it a mysterious, hazy look. For a digital look, Web terminology was set in the typeface Clicker in Adobe Illustrator. The Illustrator file was then brought into Photoshop, where each term was made into a different path. To achieve a variety of embossed effects, the terms were feathered several times. When completed, each term path was combined with the pipe photo using the Layers command.

Two images were created using the same technique: one for the brochure's cover, and a second for the interior. Both were converted to duotones using green and black ink. The completed images were brought

into QuarkXPress, where the DynaBase logo, diagrams, photos and type were assembled into the final brochure layout.

Design Firm: Stewart Monderer Design, Inc.
Art Director: Stewart Monderer
Designer: Amy Lecusay
Computer Manipulation: Amy Lecusay
Client: EBT/Electronic Book Technologies, Inc.
Programs: Adobe Photoshop, QuarkXPress, Adobe Illustrator

Union Station Fashion Brochure

Concept: Union Station is a Washington, DC landmark located directly across the street from the Capitol building. In addition to serving Amtrak and the area's Metro service, the turn-of-the-century train station was recently renovated into a retail/fashion center. This sixteen-page brochure was used to promote Union Station retailers during German Week. It features fashions shown within the context of train travel through Germany. The brochure was distributed to attendees at a fall fashion show at the station and mailed to over twenty thousand area residents.

Production: The dream-like quality of the brochure's cover image was achieved by merging a photo of a fashion model on railroad tracks, shot by German photographer Markus Nikot, with a color transparency of a piece of metal shot by photographer Taran Z.

Grafik Communications designer Johnny Vitorovich had high-resolution scans made of both images and brought them into Photoshop. He used the Selection tools to isolate the model and railroad tracks from the background, and merged the image with the metallic background by using Layers. Both images were given their warm colorization by adjusting Hue and Saturation.

The impression of cloth binding was achieved by taking a color transparency of a piece of cloth, shot by Taran Z, and adding it to the edge of the cover with Layers. The completed image was brought into a QuarkXPress file for the brochure.

The cover is printed in four-color process, plus two hits of varnish—a glossy varnish on the highlight areas, and a dull varnish on the shadows. Vitorovich created films in Photoshop for the varnishes by making a duplicate file of the cover image. He increased the contrast level of

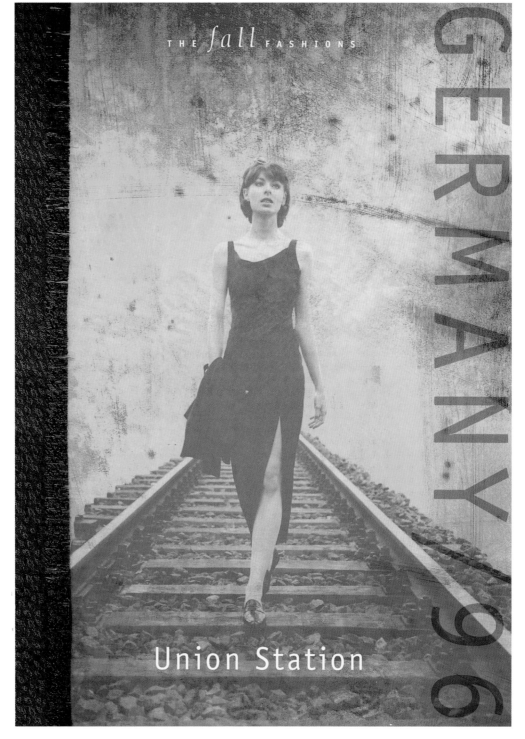

the image by adjusting Curves, and posterized the image to reduce the number of value areas. Vitorovich then selected the lightest value areas of the image with the Magic Wand tool to create a file for the gloss varnish negative. Vitorovich produced a negative for the dull varnish by making a duplicate of the highlight file and applying Invert.

Design Firm: Grafik Communications, Ltd.
Art Director: Judy F. Kirpich
Designer: Johnny Vitorovich
Photographers: Markus Nikot, Taran Z
Computer Manipulation: Johnny Vitorovich
Client: Lassalle Partners
Programs: Adobe Photoshop, QuarkXPress

Frank Russell Company
LifePoints Brochure

Concept: LifePoints is a saving and investment program specifically tailored to individuals and families. To bring out personal aspects of the LifePoints program for its promotional brochure, Hornall Anderson Design Works chose to visually represent life's financial milestones. Family photos, items from the studio's photo library, stock images and objects placed directly on the firm's scanner were all brought into Photoshop and arranged into collages that symbolize financial planning for everything from college to retirement. The brochure has achieved wide recognition, including awards from New York Festivals International and

APEX '95, and has appeared in *Print* and *Step-By-Step* design annuals.

Production: For the collage that represents education and the early stages of career and family life, Hornall Anderson used a combination of stock photos furnished as color transparencies, personal photos and studio shots. The firm hired photographer John Still to shoot a base for the montage that included the sneaker, the three-dimensional "B" and layered background effects. Still achieved the sense of dimensionality with his photo by airbrushing paint on glass and paper. Designers had a high-resolution scan made of the photo and brought it into

Photoshop to colorize it by converting it to CMYK and adjusting Hue and Saturation.

High-resolution scans were also made of the stock images, as well as other images Hornall Anderson scanned, including the pencil and personal photos. These images were brought into the Photoshop image Still created by outlining them with the Path feature and then combining them into a single composition.

Still also shot the compass on the brochure cover and layers of painted glass and paper to create the photo's blue border.

Hornall Anderson brought the Photoshop images into a QuarkXPress document for the brochure.

Design Firm: Hornall Anderson Design Works
Art Director: Jack Anderson
Designers: Jack Anderson, Lisa Cerveny, Suzanne Haddon
Illustrator: Julia LaPine
Photographer: John Still
Computer Manipulation: Jack Anderson, Lisa Cerveny, Suzanne Haddon
Client: The Frank Russell Company
Programs: Adobe Photoshop, QuarkXPress, Macromedia FreeHand

Killington Ski Resort Brochure

Concept: For its 1994–1995 winter ski season, Killington Ski Resort wanted to promote its new line of "skyships"—high-speed heated gondolas equipped with state-of-the-art sound systems. The Vermont-based ski resort contracted with PandaMonium Designs to design a promotional brochure which would feature the new gondolas and their brightly colored cabins. PandaMonium was given photos of skiers and other scenic shots from the resort; however, these visuals were of secondary importance to the gondolas, the primary focus of the brochure. Although the structural components of the gondolas were in place, the cabins were still being manufactured. PandaMonium had nothing more to work with than schematic drawings of the cabins, supplied by the Swiss manufacturer of the gondolas.

Production: Four of the new gondola cabins would be painted with designs by world-renowned artists. The responsibility for designing the exteriors of the other cabins, and depicting them realistically in the brochure, fell to PandaMonium. The firm's designers started by scanning the cabin schematics on their studio scanner and then brought them into Adobe Illustrator, where outlining and some preliminary design development were done.

The Illustrator files were then imported into Photoshop, where designer Steven Lee applied the Gradient and Airbrush tools to produce cabin renderings that are so realistic they appear to be actual photographs. Lee used the Masking features to place the gondola cabins in their black background.

The Photoshop image of the six cabins was brought into QuarkXPress, where the layout for the brochure was produced.

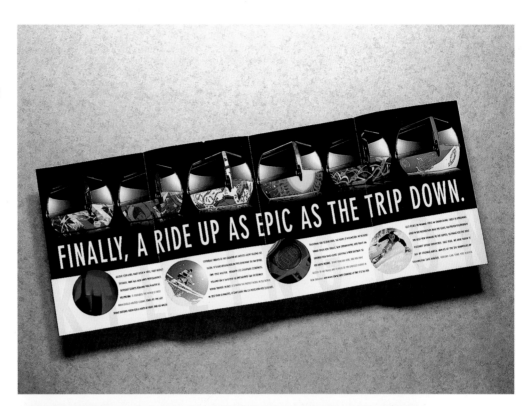

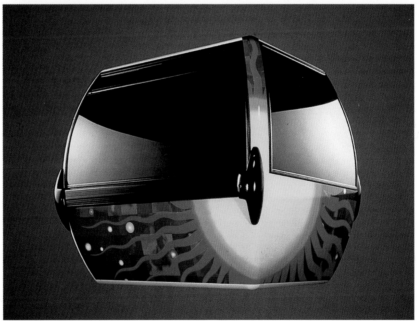

Design Firm: PandaMonium Designs
Art Director: Raymond Yu
Designers: Raymond Yu, Steven H. Lee, Deena Prestagard
Illustrator: Steven H. Lee
Computer Manipulation: Steven H. Lee
Client: Killington Ski Resort
Programs: Adobe Photoshop, Adobe Illustrator, QuarkXPress

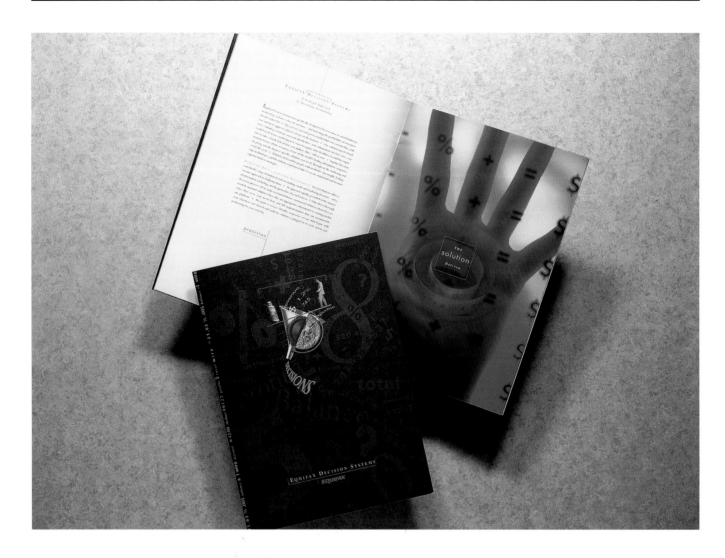

Equifax Collateral Brochure

Concept: Equifax Decisions Systems is a supplier of decision support information that helps businesses in their financial relationships with their customers. To promote their service, Equifax contracted with Copeland Hirthler design + communications to create a collateral brochure that would appeal to corporate decision makers in a broad range of businesses. The Copeland Hirthler design team chose to create a brochure that projected a conservative image, punctuated with dramatic imagery.

Production: The brochure's cover sets the tone with a montage of symbolic imagery. The design team used Photoshop to make a comp and chose images from a variety of sources,

pulling them from the firm's studio photo library, stock files and magazine clippings. Designer Melanie Bass Pollard scanned the images on the studio's scanner and used the Selection tools to outline each image and isolate it from its background. The Layers feature was used to blend them into a composite image. The Decisions title was created in Adobe Illustrator.

Images that add visual interest to the brochure's interior pages were produced as comps in a similar manner. Found images were scanned and brought into Photoshop, where the Layers feature was used to position and composite them. Photoshop's Type tool was used to set type, and hazy effects

were achieved with the Gaussian Blur filter.

When the brochure comp was approved by Equifax, Pollard commissioned photographer and photoimaging specialist Fredrik Broden to produce the final brochure images. Broden created studio shots as necessary, had high-resolution scans made of the images and composited the brochure's collage images in Photoshop.

Low-resolution versions of each Photoshop composite were given to Copeland Hirthler to bring into the QuarkXPress file for the twelve-page brochure. The printer replaced these with Broden's high-resolution versions of the Photoshop images to strip into the final films.

Design Firm: Copeland Hirthler design + communications
Creative Directors: Brad Copeland, George Hirthler
Art Director: Melanie Bass Pollard
Designers: Melanie Bass Pollard, Shawn Brasfield
Computer Manipulation: Melanie Bass Pollard, David Woodward, Davidson and Company
Photographers: Fredrik Broden, Jerry Burns, Mark Shelton
Client: Equifax Decision Systems
Programs: Adobe Photoshop, QuarkXPress, Adobe Illustrator

ProphetPoint Promotional Brochure

Concept: To promote ProphetPoint business intelligence software, Copeland Hirthler design + communications designed this brochure that combines high-tech effects with a conservative, businesslike look. The brochure's stunning imagery has brought the firm recognition in the form of several design and advertising awards. Copeland Hirthler designer Melanie Bass Pollard and her design and production team used Photoshop to achieve the rich-looking images that play such an important role in this brochure's success.

Production: For the brochure cover, Pollard made a collage of the objects she wanted to use in support of the brochure's "Business Geo-metrics" theme. She worked with low-resolution scans of images from the studio's photo library and stock images. Pollard brought the scans into Photoshop and, using Layers, positioned them into the arrangement she wanted to achieve. The Gaussian Blur filter was applied to the cover's background imagery to enable the spectrum in the foreground to stand out in sharp contrast.

Copeland Hirthler used a portion of the cover image in another part of the brochure by cropping and duplicating the desired portion and then using the Image Flip command.

Pollard created a comp for client approval and then gave it to Davidson and Company, a firm that specializes in computerized special effects, to develop into a high-resolution version. Davidson and Company made studio shots of the objects in the collage and had high-resolution scans made from them. The scans were brought into Photoshop and manipulated with the features of the program Pollard used to develop the comp image.

Davidson and Company gave Copeland Hirthler low-res versions of the cover image to bring into a QuarkXPress file for the eight-page brochure. The high-res files of the Photoshop image were given to the printer to use for the negatives.

Design Firm: Copeland Hirthler design + communications
Creative Directors: Brad Copeland, George Hirthler
Art Director: Melanie Bass Pollard
Designers: Melanie Bass Pollard, David Woodward
Computer Manipulation: Melanie Bass Pollard, David Woodward, Davidson and Company
Photographers: Fredrik Broden, Jerry Burns, Mark Shelton
Client: Equifax Decision Systems
Programs: Adobe Photoshop, QuarkXPress, Adobe Illustrator

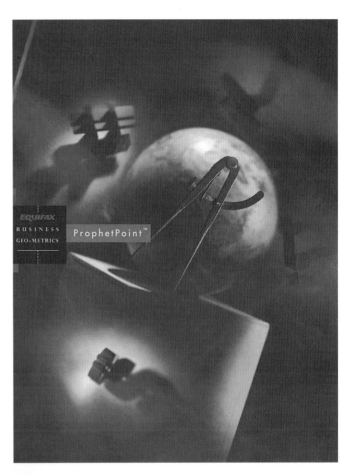

TROY Systems Brochure

Concept: This brochure was designed by Grafik Communications to promote TROY's information technologies. Targeted to corporate decision makers, the brochure's imagery needed to express a sophisticated, yet dramatic high-tech theme. The design team decided to create a hybrid image that expresses a fusion of energy, communication and information.

Production: The designers started with an image of air bubbles in water, a copyright-free photo on CD-ROM. To make the image more abstract, designer David Collins applied Airbrush, duplicated and flopped the image and positioned it on top of the original. Other stock images were added, including a brain and a spinal column. Collins converted the images to grayscale and adjusted Hue and Saturation controls to achieve the image's fireball coloring.

Black-and-white photos of IBM terminals were scanned and areas were selectively brightened and blurred before they were blended with the original image.

The title was created with the Type tool. The background was used to fill the lettering by changing its color under Hue and Saturation, then pasting it into the type channel. Collins guesses he worked with eight or nine different channels before combining them into the final image.

The images were saved as EPS files and brought into the brochure's QuarkXPress file.

Design Firm: Grafik Communications, Ltd.
Design Team: David Collins, Judy Kirpich
Photographer: John Vitorovich
Client: TROY Systems
Programs: Adobe Photoshop, Adobe Illustrator, QuarkXPress

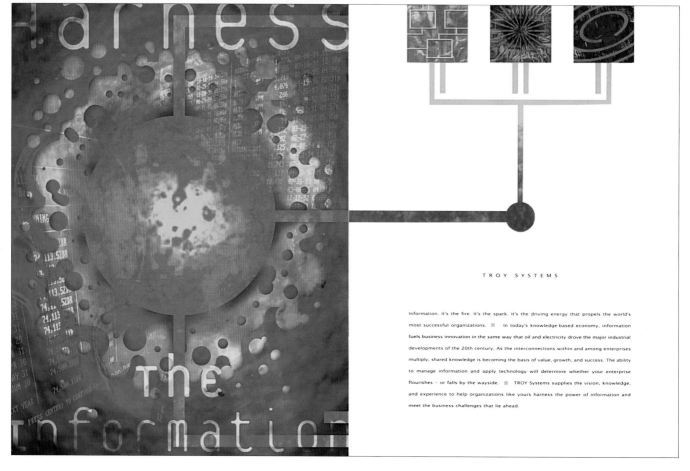

TROY SYSTEMS

Information. It's the fire. It's the spark. It's the driving energy that propels the world's most successful organizations. ▪ In today's knowledge-based economy, information fuels business innovation in the same way that oil and electricity drove the major industrial developments of the 20th century. As the interconnections within and among enterprises multiply, shared knowledge is becoming the basis of value, growth, and success. The ability to manage information and apply technology will determine whether your enterprise flourishes -- or falls by the wayside. ▪ TROY Systems supplies the vision, knowledge, and experience to help organizations like yours harness the power of information and meet the business challenges that lie ahead.

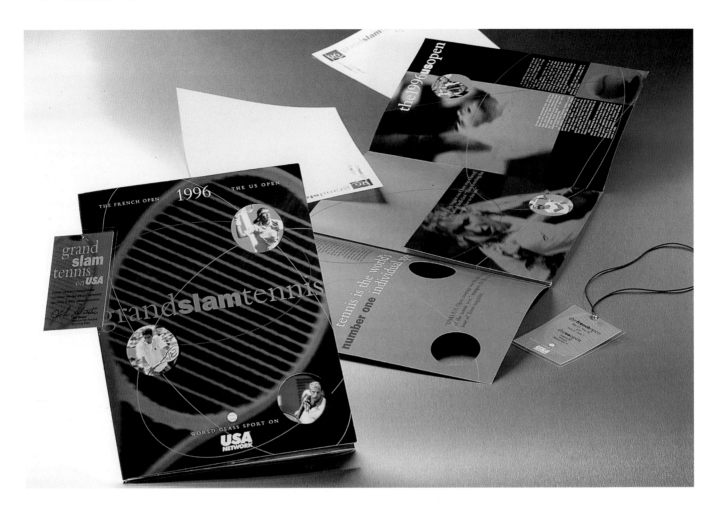

Tennis Tournament Brochure/Pocket Folder

Concept: To help acquire sponsors for its broadcast of the French and U.S. Open tennis tournaments, USA Network hired Parham Santana Inc. to design this pocket folder. The piece needed to accommodate a variety of inserts, yet make a more sophisticated presentation than a simple pocket folder. Parham Santana came up with a folder configuration that incorporates a fold-over back cover and die-cut windows on the front cover that frame action shots of tennis players on the back cover. Their "peekaboo" concept intrigues recipients into opening it to reveal more of what's inside.

Production: Parham Santana was given color photographs to work with from USA Network;

however, most of the photos were not of suitable quality to run on a large scale, as is. The designers had professional, high-resolution scans made of all of the photos that constitute the brochure and then brought them into Photoshop. To give the large photographs on the folder's interior a heightened sense of action, their backgrounds were isolated with the Selection tools, and the Motion Blur filter was applied to this area. The photos were also converted to grayscale, and a duotone effect was created by adjusting Hue and Saturation. The cover photo of the tennis racket was given a similar color treatment but was softened with the Gaussian Blur filter. Curved lines that suggest the swing of a

racket were created in Adobe Illustrator and brought into the Photoshop files for the folder's larger images.

The players depicted in the circular color photos were given more prominence by isolating the background portion of each photo and giving it a uniform color treatment. Designer Lori Ann Reinig accomplished this by using Photoshop's Selection tools to select each player. She then applied Inverse to isolate the background and adjusted Hue and Saturation to achieve the desired color effect.

When the imaging was completed, all photos and Photoshop images were brought into a QuarkXPress file, where type was added and the layout was completed.

Design Firm: Parham Santana Inc.
Art Director: John Parham
Designer: Lori Ann Reinig
Computer Manipulation: Derek Beecham
Client: USA Network
Programs: Adobe Photoshop, Adobe Illustrator, QuarkXPress

American Eagle Sales Brochure

Concept: This brochure promoting American Eagle recreational vehicles achieves broad appeal by depicting all kinds of individuals in settings that reflect diverse lifestyles and locations. The brochure's designers at Boyden & Youngblutt created this impression without staging expensive photo shoots all around the country. Instead, they used Photoshop to blend photos of the RV with scenic backgrounds and to create mood lighting and color effects.

Production: Art director Andy Boyden purchased a stock transparency of a wooded setting and had a high-res scan made of it. Photographer Larry McCay took photos of the RV with lighting effects that duplicated the effect of tree-filtered sunlight, and shot it at an angle that would enable it to realistically fit into the woods scene. High-res scans were then made of the RV transparency and brought into Photoshop. Don Weaver isolated the RV using the Pen tool and used the Layers command to combine it with the woods scene. He adjusted Curves and Hue and Saturation to make lighting on the two images even more consistent, and applied the Airbrush tool to realistically blend the RV with its setting.

Lifestyle photos of the individuals on the cover were shot by photographer Tom Galiher as

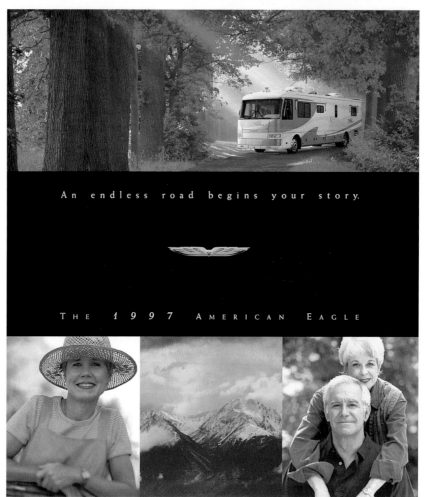

color transparencies. Weaver had professional scans made of these and brought them into Photoshop, where he created soft color effects by converting the transparencies to grayscale, then CMYK, and adjusting Hue and Saturation. The completed images were brought into QuarkXPress for the brochure.

Design Firm:
Boyden & Youngblutt
Art Director: Andy Boyden
Designer: Andy Boyden
Photographers: Tom Galiher,
Larry McCay
Computer Manipulation:
Don Weaver
Client: American Coach
Division
Programs: Adobe Photoshop,
QuarkXPress

Calypso Price Book

Concept: Calypso Imaging, Inc. is a Santa Clara, California–based service bureau that provides scanning, film processing, print and proof output and other photographic and digital imaging services. To showcase the company's capabilities in its price book, design studio AERIAL backed each page with a striking image. The images are all of a tropical theme and serve as left-hand pages facing information on each right-hand page. Each image also contains the Calypso name. AERIAL created a variety of cover treatments by incorporating each of the brochure's twenty-four images into a cover. A French-fold sleeve with an oval die-cut over the Calypso name, fashioned from different shades of Fox River Confetti, gave each price book its own unique cover.

Production: AERIAL used Photoshop to produce the price book's images. The designers used twelve original transparencies, shot by photographer R.J. Muna, and had Calypso make high-resolution scans of each. Each image was brought into Photoshop, cropped and colorized to produce a specific effect. For instance, an image of a pineapple was distorted with the Spherize filter and then given its hot red background color by selecting this area and applying Edit and Fill. Other adjustments were made to the pineapple's color by adjusting Hue and Saturation.

The Calypso logo was added to each of the images by importing an EPS file of the graphic into Photoshop. Art director and principal Tracy Moon added a drop shadow to the logo by duplicating it and applying the Offset and Gaussian Blur filters. Once a color was applied to the logo, it was placed on its own layer and blended with its background image by adjusting Opacity in the Layers options.

Type and the other elements that constitute the price book's layout were created in QuarkXPress.

Design Firm: AERIAL
Art Director: Tracy Moon
Designer: Tracy Moon
Photographer: R.J. Muna
Computer Manipulation: Clay Kilgore, Tracy Moon
Client: Calypso Imaging, Inc.
Programs: Adobe Photoshop, QuarkXPress

Promotional Brochure for D-3 Technologies

Concept: To help market a highly specialized program used by U.S. military aircraft, B-LIN designed a promotional brochure that employs the software's imagery. B-LIN's designers wanted to create a look for the brochure that combined aspects of the software's users with high-tech effects.

Production: To achieve this effect on the brochure cover, B-LIN hired John Johnson Photography to take black-and-white photos of the computer screen while the software was running. After B-LIN designers selected a suitable photo, Johnson light-painted this image and furnished B-LIN with a slide of it. The slide was scanned and brought into Photoshop, where it was enlarged and cropped.

Johnson also took a photo of a computer terminal with the software on-screen to be used for the interior of the brochure. B-LIN designers scanned this photo and brought it into Photoshop to be colorized and combined with other images that comprise the brochure interior's background imagery.

To create the impression of secret coding, type was set in a word processing program and enlarged on a photocopier. For a degenerated look, successive copies of each photocopy were made.

Other images in the composition include scanned line art of a helicopter and a silhouette of a fighter jet. These images were combined with the background type and the photo of the com-

puter terminal using Layers. Opacity was adjusted using the Layers palettes option. Images were selectively colorized by adjusting Hue and Saturation.

The Photoshop image was brought into QuarkXPress, where it was combined with type and other photos to produce the final layout.

Design Firm: B-LIN
Art Director: Brian J. Lovell
Designers: Brian J. Lovell, Cecilia Sasaki
Computer Manipulation: Cecilia Sasaki
Photographer: John Johnson Photography
Client: D-3 Technologies
Programs: Adobe Photoshop, QuarkXPress

BMG Videotape Brochure

Concept: This sales brochure for BMG videotapes goes to videotape buyers at retail outlets all over the U.S. The brochure was designed by New York City–based Parham Santana Inc., which sought to convey the glitz and glamour of Broadway by featuring the Bertelsmann Tower, a Times Square landmark and BMG's headquarters, on the brochure's front and interior front covers.

The vintage shots of recording artists on the brochure's interior pages were black-and-white video captures given to Parham Santana by their client. Because the quality of many of the photos wasn't suitable for exact reproduction, Parham Santana hired freelancer Derek Beecham to enhance them in Photoshop.

Production: The black-and-white video captures were first digitized on a professional scanner and then brought into Photoshop, where Beecham used the Selection tools to isolate each recording artist from their background. Designer Ron Anderson used the Curves feature to improve the value and contrast of each image, then added shadows with the Shadow Box tool, a Photoshop extension.

Each image was converted to a duotone before being placed into the QuarkXPress file that served as the brochure layout. Other elements brought into the QuarkXPress file included swirls and other decorative elements that were created in Adobe Illustrator.

The brochure's cover collage, which juxtaposes different pho-

tos of the Bertelsmann Tower taken by photographer Fred Charles, was also created in QuarkXPress. The inside front cover is treated in similar fashion using various crops of a photo of the building's exterior sign.

Design Firm: Parham Santana Inc.
Art Director: Jodi Rovin
Designers: John Parham, Ron Anderson
Computer Manipulation: Derek Beecham
Photographer: Fred Charles
Client: BMG Video
Programs: Adobe Photoshop, QuarkXPress, Adobe Illustrator

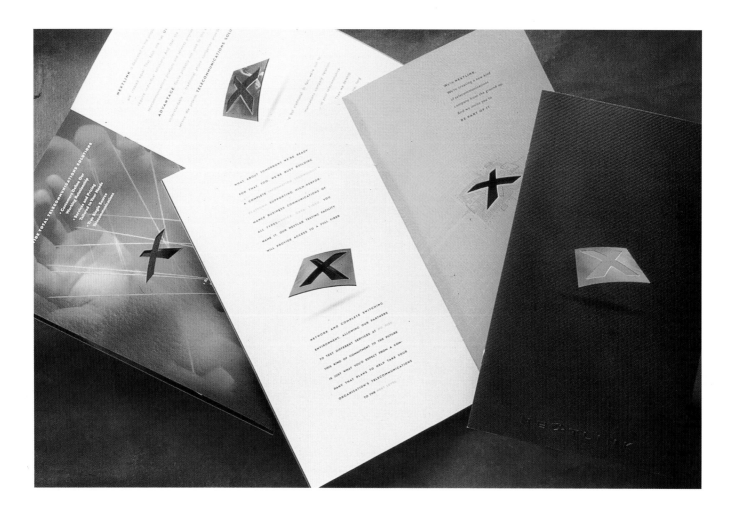

NEXTLINK Corporation Marketing Brochure

Concept: For NEXTLINK's marketing brochure, Hornall Anderson Design Works wanted to convey the speed and effectiveness of NEXTLINK's systems by combining a sense of human interactivity with a high-tech image. NEXTLINK's logo, which Hornall Anderson created, plays a prominent role in the brochure's design. The letter "X" within the logo is die-cut on the front cover and ensuing interior pages. Hornall Anderson's designers chose to interplay the logo with visuals that reinforce the brochure's theme of communication, productivity and human interactivity.

Production: The NEXTLINK "X," which Hornall Anderson created in Photoshop, appears on the brochure's cover as well as many of its pages. To finish the application of the logo on

the pages of the brochure containing text, an airbrushed shadow was added with the Airbrush tool just below the "X."

The designers also used Photoshop on an interior visual that supports the brochure's theme of interconnectivity. A black-and-white photo by photographer Tom Collicott depicting hands wrapped with strings was brought into Photoshop as a high-resolution scan and given a duotone effect by converting it to CMYK and adjusting Hue and Saturation. To create the final visual, the image was duplicated, enlarged and the opacity adjusted under the Layers palette while blending it with the original image.

Completed images were brought into a QuarkXPress file for the brochure, where photos and text were added.

Design Firm: Hornall Anderson Design Works
Art Director: Jack Anderson
Designers: Jack Anderson, Mary Hermes, Mary Chin Hutchison, David Bates
Photographer: Tom Collicott
Computer Manipulation: Mary Chin Hutchison
Client: NEXTLINK Corporation
Programs: Adobe Photoshop, Macromedia FreeHand, QuarkXPress

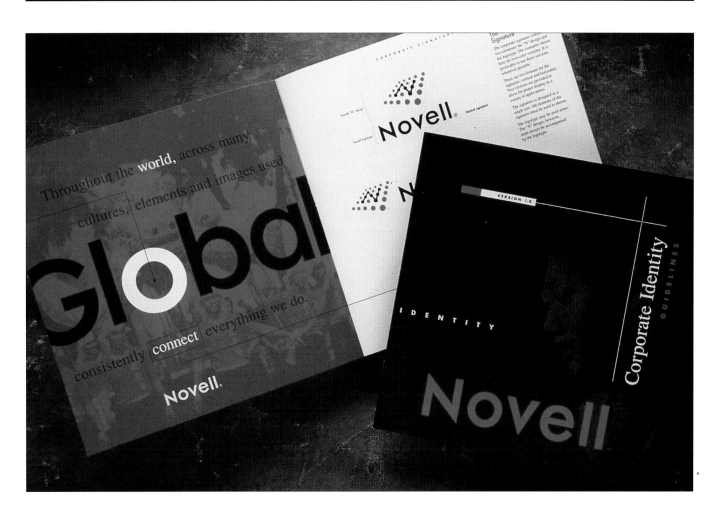

Novell Corporate Identity Guidelines Brochure

Concept: Novell, Inc. is the world's leading network software provider. The company's software products provide the distributed infrastructure, network services, advanced network access and network applications required to make networked information and computing an integral part of everyone's life. Novell hired Hornall Anderson Design Works to design a worldwide brand identity and strategy for building a unified global Novell brand across all product lines and communication vehicles.

Implementing Hornall Anderson's identity scheme required a graphic standards manual that could be used by Novell's offices in the U.S., Europe and all over the globe.

The manual ensures a consistent image for corporate literature, stationery and other applications by guiding employees in all locations on the treatment of the Novell logo and other graphic elements that constitute the Novell identity. Hornall Anderson's design for this manual needed to be user-friendly and stress the human element.

Production: To depict the worldwide impact of Novell's technology, the manual's cover shows two children looking at a globe. Interior photos show people in all walks of life, all over the world. The photos were chosen to illustrate the idea of "connecting"—a consistent theme throughout the brochure. Hornall Anderson used stock photos and had high-resolution

scans made of each transparency. All of the scans were brought into Photoshop for additional work.

The subtle image in profile on the manual cover is printed in black on a gray background. The designers applied the Mezzotint filter to give it a grainy effect. Other images within the brochure were given the Mezzotint treatment and made into duotones using Novell's corporate colors of red and black.

Images were brought into a QuarkXPress file for the sixteen-page manual. Other graphic elements such as the logos were created in Macromedia FreeHand and brought into QuarkXPress.

Design Firm: Hornall Anderson Design Works
Art Director: Jack Anderson
Designers: Jack Anderson, Bruce Branson-Meyer, Larry Anderson
Computer Manipulation: Jack Anderson, Bruce Branson-Meyer, Larry Anderson
Client: Novell, Inc.
Programs: Adobe Photoshop, Macromedia FreeHand, QuarkXPress

WaxTrax! Catalog

Concept: WaxTrax! used this catalog to promote its compact discs to buyers at retail outlets. The catalog's designers at SEGURA INC. devised a cover treatment that reflects the raw, unbridled musical style and lyrics of WaxTrax!'s alternative rock recording artists.

Production: Imaging specialist Eric Dinyer started with a black-and-white portrait of a female model, which he digitized on a flatbed scanner and brought into Photoshop. Dinyer used the Rubber Stamp tool to replace the model's hair with cloned portions of her face. He had a dye-sublimation print made of the image and applied paint to obliterate the back of the model's head and neck. Dinyer fashioned a background of abstract circles and textural effects.

Dinyer created another painting with a scratched and mottled texture, which he scanned and placed on a layer to be merged with other elements of the image.

Dinyer fashioned the "horns" out of sheets of aluminum and shot a black-and-white photo of the cones. The photo was scanned and brought into Photoshop, where the horns were isolated from their background and combined with the other elements of the image using Layers. Dinyer colored the image by converting it to CMYK and adjusting Hue and Saturation.

The completed Photoshop image was brought into a QuarkXPress file for the catalog. The cover's WaxTrax! title was set in Fury, a font offered by Segura's company, [T-26].

Design Firm: SEGURA INC.
Art Director: Carlos Segura
Designer: Carlos Segura
Illustrator: Eric Dinyer
Computer Manipulation: Eric Dinyer
Client: WaxTrax!/TVT Records
Programs: Adobe Photoshop, QuarkXPress

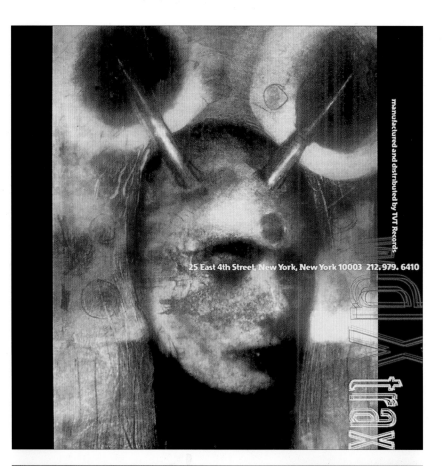

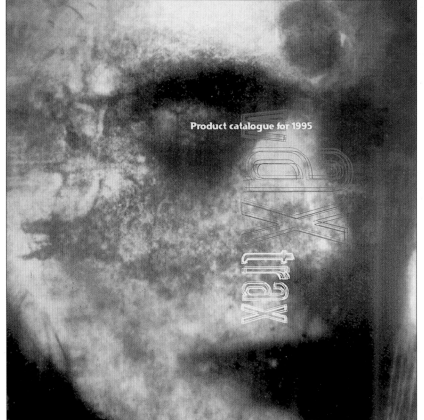

Agfa Font Catalog

Concept: Agfa's font catalog features some of Chicago's top designers' ideas on type and its importance in their work. Chicago-based SEGURA INC.'s design reflects the spirit of the city and Chicago's design sensibility in its creative use of typography as a graphic motif. The thirty-six-page catalog's covers needed to function as a self-mailer. Its intriguing exterior assured the catalog would be opened and read.

Production: Firm principal Carlos Segura and his design team started by commissioning letterpressed type from Hatch, a letterpress studio. Segura had high-res scans made of the words and letterforms and brought them into Photoshop. Using the Selection tools, Segura cropped and positioned the type. He enhanced the letterforms' colors by adjusting Hue and Saturation. The back cover, carrying the address area, features another of Hatch's letterpressed creations.

The catalog's interior illustration bears the words of a poem. Segura and designer Stephen Farrell set the type for the poem in Adobe Illustrator and created much of the illustration's imagery in Illustrator as well. The Illustrator drawings were then imported into Photoshop, where a different layer was created for each. To achieve different levels of translucency, Farrell played with Opacity controls while blending the layers.

The images were brought into a QuarkXPress file, where type and other elements created in Illustrator were added.

Design Firm: SEGURA INC.
Art Director: Carlos Segura
Designer: Carlos Segura
Illustrators: Hatch, Carlos Segura, Stephen Farrell
Computer Manipulation: Carlos Segura
Client: Agfa
Programs: Adobe Photoshop, Adobe Illustrator, QuarkXPress

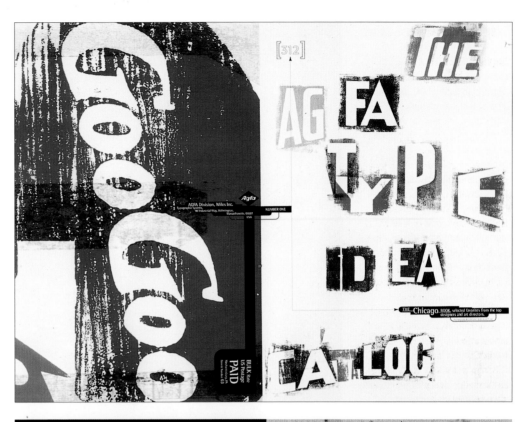

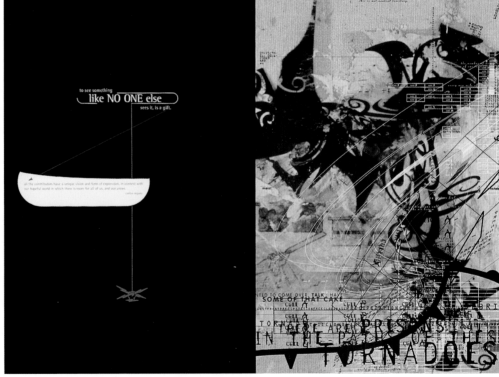

Datascope Annual Report

Concept: Datascope Corporation is a medical equipment company based in New Jersey. For the manufacturer's 1995 annual report design, the company wanted to feature photography of VasoSeal, a new product that helps with the healing process. The annual report's designers at AERIAL hired photographer R.J. Muna to make product shots of VasoSeal. Muna played with lighting and created soft-focus effects that glamorize the product. Superimposing critical text on these arresting visuals made them an even more intriguing way of visually enhancing this annual report.

Production: AERIAL chose six of Muna's product shots and had high-resolution scans made of each of the transparencies. Imaging specialist Clay Kilgore brought the images into Photoshop so that he could combine them with text. The text for each visual was set in Adobe Illustrator and superimposed on each image in Photoshop. Because Kilgore was working with a version of Photoshop that pre-dated the current version's Layers feature, he colored each character in the text by adjusting Hue and Saturation and Curves. To achieve a translucent effect, a sampling of the color behind the text was taken and white was added.

The images were brought into a QuarkXPress file for the report, where text was added to the cover photo.

Design Firm: AERIAL
Art Director: Tracy Moon
Designer: Tracy Moon
Photographers: R.J. Muna, R.J. Pictures, Inc.
Computer Manipulation: Clay Kilgore
Client: Datascope Corporation
Programs: Adobe Photoshop, Adobe Illustrator, QuarkXPress

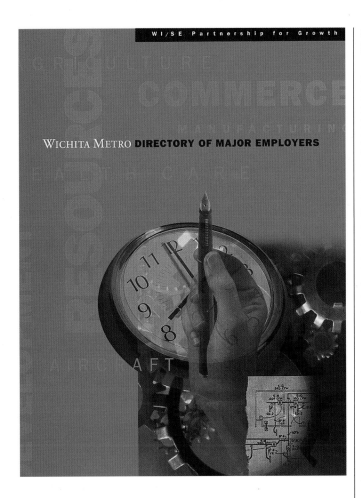

Simpson Estate Label Stock Swatch Book

Concept: To promote Simpson Paper's premium label stock and the printing capabilities of Blake Printery, Rick Tharp of Tharp Did It designed this collage of wine-related images. Tharp captured the essence of a premium wine by combining different visual elements that are involved in making wine in California's Napa Valley region. He chose images of fog, grapes, a bottle and a note inscribed with "wine is bottled poetry." It was particularly appropriate for Tharp Did It to produce this wine-oriented image—the design firm is well known for its award-winning wine labels.

Production: Tharp started by giving photographer Tom Landecker a pencil sketch of his composition to work from. Landecker in turn shot each of the collage elements: clouds, a sheet of paper, grapes, a bottle and a glass of wine. "The project was delayed eight months while we waited for the grapes and their leaves to come into season," explains Tharp. The hand-written message was produced on a separate sheet of paper by calligrapher Georgia Deaver.

Landecker brought the components into Photoshop, where elements were isolated from their backgrounds and arranged into the final composition. To assure the best reproduction, Landecker gave Tharp a transparency of the final image, which was professionally scanned by the printer. The layout for the swatch book was produced in QuarkXPress, while the poster layout was produced from a traditional mechanical.

Design Firm: Tharp Did It
Art Director: Rick Tharp
Designer: Rick Tharp
Computer Manipulation: Tom Landecker
Photographer: Tom Landecker
Calligrapher: Georgia Deaver
Clients: Simpson Paper Company, Blake Printery
Programs: Adobe Photoshop, QuarkXPress

Wichita Employment Directory

Concept: Wise Partnership for Growth, Inc. is a group of Wichita, Kansas–based businesses involved in city development. The group issues an annual directory of employers which goes to area job hunters as well as out-of-town businesses thinking of relocating. Wichita-based Greteman Group designed the cover for this directory. Firm principal Sonia Greteman saw the idea of jobs in Wichita as the synthesis of many things and sought to combine them all into a composite cover image.

Production: Designer Craig Tomson started by working with images of a clock, hand and pen that were furnished on a Photo CD clip file. All were brought into Photoshop and converted from color to grayscale images. Tomson used the Selection tools to outline each image and isolate it. The image of the hand originally held a wrench.

Tomson replaced the wrench with the pen by using the Layers feature and the Rubber Stamp tool.

Tomson combined the images of the gears and the portion of the Wichita street map with the others using Layers, varying the degree of translucency of each layer.

The image was converted into a duotone and brought into Macromedia FreeHand, where cover type was added.

Design Firm: Greteman Group
Art Director: Sonia Greteman
Designers: Sonia Greteman, Craig Tomson
Illustrators: Sonia Greteman, Craig Tomson
Computer Manipulation: Craig Tomson
Client: Wise Partnership for Growth, Inc.
Programs: Adobe Photoshop, Macromedia FreeHand

Other Applications

Color Conference Slides

Concept: San Diego–based B-LIN used Photoshop to create these attention-grabbing title slides for the Color Marketing Group's 1995 Spring and Summer International Color Conference. B-LIN designed backdrops for each slide's title that harmoniously blend imagery and color into rich textural effects. The slides were used to let conference attendees know the topic or theme of the next program segment.

Production: Designers started by bringing a variety of color and black-and-white images into Photoshop. Adjusting the Opacity control under the Layers palette blended images to the point where subjects lost their identity and became textures or patterns. The wavy background effect on the International Color Link slide was made by blending a photo of a flag with a layer of colored squares created by the rectangular Selection tool and the Fill command. Images of a manhole cover, daisy, sneaker, feather and venetian blinds were blended for the Design and Influences slide.

The designers applied Invert to some images and did selective cropping on others to achieve abstract effects. Hue and Saturation were adjusted on all images for harmonious color.

When each slide's background image was complete, type was added with the Type tool. In some cases, type was placed on individual layers to create overlapping messages.

When the title slides were completed, B-LIN forwarded the Photoshop files to a service bureau for slide output.

Design Firm: B-LIN
Art Director: Brian J. Lovell
Designers: Vicki Wyatt, Cecilia Sasaki
Illustrators: Vicki Wyatt, Cecilia Sasaki
Computer Manipulation: Vicki Wyatt, Cecilia Sasaki
Client: Color Marketing Group
Program: Adobe Photoshop

Environmental Graphics for the Olympic Games

Concept: As one of the firms involved in designing and implementing the look of the Games for the 1996 Centennial Olympic Games, Atlanta-based Copeland Hirthler design + communications was responsible for dressing up local facilities with Olympic-related environmental graphics. The design firm used Photoshop to create realistic comps, which were used to present their design concepts to the Atlanta Committee for the Olympic Games and Hartsfield International Airport.
Production: Color photos were taken of each of the sites where graphics would appear and then scanned on the firm's studio scanner so they could be brought into Photoshop.

Copeland Hirthler's designers produced art for the window design and airport graphics in Adobe Illustrator and then imported the Illustrator paths into Photoshop. The designers used Layers to position the art over the location photos. To achieve realistic positioning, portions of the art were selected and individually sized and skewed by selecting Distort under the Image/Effects menus. Blend If, under the Layers menu, was used to create a sense of transparency on the window application. To create the effect of shadows on the airport beams, portions were selected and color was desaturated under the Hue and Saturation menu. These areas were also darkened by adjusting the brightness control.

When Copeland Hirthler's ideas were approved, the

Airport concourse as it appeared before the Games. *Photoshop comp as it was presented to the client.*

Illustrator files and written specifications were given to sign fabricators for production.

Design Firm: Copeland Hirthler design + communications
Art Directors: Brad Copeland, George Hirthler
Designers: Erik Brown, Jeff Haack, David Crawford, David Park
Computer Manipulation: David Crawford, David Park
Photographers: Erik Brown, William Snyder
Clients: Atlanta Committee for the Olympic Games; Department of Aviation, Atlanta, Georgia
Programs: Adobe Photoshop, Adobe Illustrator

Final application of environmental graphics.

Windows at the Georgia Dome as they appeared before the Games.

Photoshop comp as it was presented to the client.

Final application of environmental graphics.

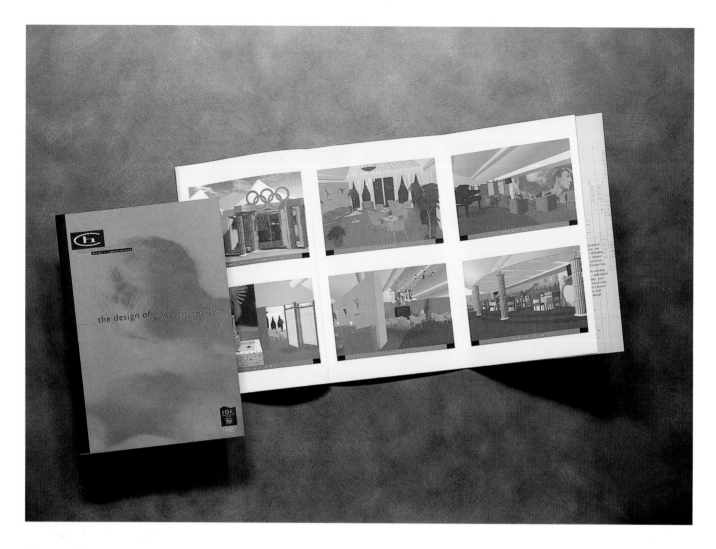

Olympic Games Environmental Graphics Brochure

Concept: Copeland Hirthler design + communications was intensively involved in the 1996 Centennial Olympic Games in Atlanta, including creating environmental graphics and designing facilities for the Olympics' hospitality club, where heads of state, corporate executives and Olympic officials went to relax during the games. This brochure was designed for those who visited the hospitality club to take with them. It tells how the design firm, and others involved in the club's interior design, created its regal ambiance inside an ordinary tent.

Production: At the time the brochure was produced, the club's interior was still in the conceptual stage—none of the items that constituted its interior would come together and be realized until shortly before the games began. Copeland Hirthler's design team worked with virtual images of the club's interior, which were generated on an SGI system. The images' lack of realistic definition required a subtle treatment within the brochure that involved bringing the SGI-generated images into Photoshop to convert them into duotones. From

there, they were imported into a QuarkXPress file for the brochure.

The brochure's cover image is treated in a similar manner. To suggest the Olympics' roots and ancient Greece, Copeland Hirthler's designers chose a photograph of a statue furnished to them as a color transparency. The transparency was scanned on the firm's studio scanner, brought into Photoshop and converted to a grayscale image. From there it was converted to a duotone of black and tan to give it a look in keeping with the brochure's interior visuals.

Design Firm: Copeland Hirthler design + communications
Creative Directors: Brad Copeland, George Hirthler
Art Directors: Melanie Bass Pollard, Sarah Huie
Account Executive: Sarah Huie, Ward Copeland
Designers: Melanie Bass Pollard, Sarah Huie, Sean Goss
Computer Manipulation: Melanie Bass Pollard, Sean Goss, Davidson and Company
Photographer: Don Freeman
Client: International Olympic Committee
Programs: Adobe Photoshop, QuarkXPress

Primo Angeli Inc. Web Site

Concept: Primo Angeli, of Primo Angeli Inc., was so pleased with the image used to represent his firm on the cover of *Making People Respond* (page 55) that he chose to use it on the home page of the firm's Web site.

Production: Taking an image originally created for print and adapting it to the Internet first required "flattening" the multi-layered image, which was originally produced in Photoshop. Staff member Ryan Medeiros took the many layers of the image and combined them all into a one-layered Photoshop image.

To decrease the file size, Medeiros reduced the resolution of the image under Image Size to 72 dpi—a resolution suitable for on-screen viewing. Because computers rely on RGB color, the image's print color mode of CMYK was converted to RGB. Under Indexed Color, Medeiros reduced the image's original 24-bit color palette of 16 million colors to 8-bit color—a palette of 256 colors. These changes ensured that the image would render rapidly on screen.

When Medeiros was done, he saved the Photoshop image as a GIF file—an image file format developed by Compuserve which can be read by a wide variety of Web browsers.

Design Firm: Primo Angeli Inc.
Creative Director: Primo Angeli
Art Director: Brody Hartman
Designers: Primo Angeli, Brody Hartman
Computer Manipulation: Ryan Medeiros
Client: Primo Angeli Inc.
Programs: Adobe Photoshop, Adobe Illustrator

Power Rangers Pop-up Cards

Concept: Mike Armijo of Armijo Design Office has found an industry niche producing Photoshop images and designs that are used on trading cards. The pop-up cards he designed for *Power Rangers: The Movie* demonstrate how elaborate trading card design can be. The series comprises twelve cards, each of a different Power Ranger character. Children collect the cards to complete sets of three, which together form a triptych, unified by a consistent background treatment. In addition to creating three different card designs that work together as a whole, Armijo also had to

take into account the pop-up aspect of the cards' design. He generated countless prints and pasted them together to form working models before he settled on a final design for each card.

Production: Armijo was given twelve color transparencies to work from, one for each of the characters, as well as digital art for the Power Rangers and Coca-Cola logos that appear on the cards. He scanned each of the transparencies on his studio scanner and brought them into Photoshop. Each image was color-enhanced by adjusting Hue and Saturation as well as

Contrast and Brightness controls.

The background for the cards was created by combining four different copyright-free images provided on CD-ROM. The ground, moon, sky and stars were each different images, brought into Photoshop and created as a separate layer. After adjusting color and contrast on each of the images and selecting the portions he wanted to use, Armijo used Blend If options and Feathering to realistically blend the four images into a final composite.

The Photoshop images were brought into QuarkXPress files

for each card so that type and logos could be added.

Design Firm: Armijo Design Office
Art Director Mike Armijo
Designer: Mike Armijo
Computer Manipulation: Mike Armijo
Client: Equity Marketing
Programs: Adobe Photoshop, QuarkXPress

XXX Snowboard
Promotional Campaign

Concept: XXX Snowboards devised this spinning board spec sheet to be distributed at sporting goods stores that sell their products. It helps snowboard users select the snowboard that suits them best by giving them specifications on each model's size, weight and edge. Designed by SEGURA INC., the spec boards use a cutout of a XXX snowboard design as a spinner. The front of each card also incorporates a background motif created in Photoshop.

Production: Computer imaging specialist Tony Klassen started with an original 35mm slide. He had a high-resolution scan made of the image and brought it into Photoshop, where he selected a wedge-shaped portion of the sky. Klassen made a duplicate of the wedge and flipped it to form a bilaterally symmetrical image. This image was duplicated and flipped again to form the uniformly symmetrical format of the final background image.

The flame-colored motif

behind each board was first drawn in Adobe Illustrator by art director Carlos Segura. Klassen brought the Illustrator drawing into Photoshop and used Kai's Power Tools, a Photoshop extension, to fill the shape with a swirly pattern.

The fronts of the cards were printed in four-color process from Klassen's Photoshop file. The back of each card was created in Illustrator.

Design Firm: SEGURA INC.
Art Director: Carlos Segura
Designers: Carlos Segura, Laura Alberts
Illustrators: Tony Klassen, Carlos Segura, Laura Alberts
Computer Manipulation: Tony Klassen, Carlos Segura
Client: XXX Snowboards
Programs: Adobe Photoshop, Adobe Illustrator, Kai's Power Tools

Nickelodeon's "Blue's Clues" Television Show

Concept: "Blue's Clues" is a television show that builds preschoolers' self-esteem by having them help the show's host and his animated puppy, "Blue," solve everyday problems. The show's look originates with designer and animator Traci Paige Johnson, whose sketches are brought to life by a team of designers and animators familiar with her style. "Blue's Clues" is the first and only cutout animated show produced entirely on Macintosh computers.

Production: Design and production teams maintain an organic look by starting with handcrafted characters and background elements made out of construction paper, clay, felt, pipe cleaners and a variety of textured materials. These elements are digitized on a flatbed scanner or through single frames captured with a video camera directly connected to the computer, and brought into Photoshop, where they can be combined with a library of organic textures within the computer. The "Blue's Clues" design team uses the Selection and Image Adjust tools to cut out, assemble, color correct and composite these raw elements into background scenes, characters and other items for the show. Each moveable part or position of each element is placed on a separate Photoshop layer so it can be animated in a sequence of movements in Adobe After Effects.

Designers: Traci Paige Johnson, Christian Hali
Art Director: Traci Paige Johnson
Computer Manipulation: Yo-Lynn Haggod, Soo Kim, Adam Osterfeld, Danial Nord, Jane Howell
Client: Nickelodeon
Programs: Adobe Photoshop, Adobe After Effects

MRSA Architects
Mousepad

Concept: MRSA, a firm specializing in architecture and planning, commissioned SEGURA INC. to design this mousepad to use as a holiday gift. The mousepad ensures that MRSA's name will always be in front of current and prospective clients.

Production: Using Adobe Illustrator, art director and firm principal Carlos Segura and illustrator Tony Klassen set the words, "growth," "progress," "foresight," "material" and "plan" in Mata, a font available through Segura's [T-26] foundry.

So that different kinds of imaging effects could be achieved with each word, each one was brought into Photoshop and assigned to its own layer. Klassen colored the words by adjusting Hue and Saturation. In some cases, he made copies of words and applied the Motion Blur and Offset filters. To create abstractions, other words were scaled and blurred to the point of illegibility. Different levels of transparency and blending were achieved by feathering and adjusting opacity on the Layers palette as layers were blended.

The Photoshop image was brought into a QuarkXPress file, where the border and type at the bottom of the pad were added. The manufacturer printed the mousepad from Segura's QuarkXPress file.

Design Firm: SEGURA INC.
Art Director: Carlos Segura
Designer: Carlos Segura
Illustrator: Tony Klassen
Computer Manipulation:
Tony Klassen
Client: MRSA Architects
Programs: Adobe Photoshop, Adobe Illustrator, QuarkXPress

Fine Arts

1

Jim Carroll

Jim Carroll's background includes a Bachelor of Fine Arts degree in painting, photography and printmaking as well as experience working with mural painter Anton Refrigier. Given his well-honed skills in varied traditional media, it should come as no surprise that Carroll's ethereal imagery is the result of using the computer to combine paintings and sketches with original photography.

Carroll often starts by photographing his subjects in his studio in rural Chatham, New York. Although Carroll often shoots them with 35mm color film, he always converts his images to grayscale when he scans them in order to impose his own color ideas on his subject matter. He digitizes his photos and other elements he brings into his images on his studio's flatbed scanner. Occasionally Carroll adds painterly effects in Fractal Design Painter, but he does most of his work in Photoshop, where images are composited, layered with brush strokes, scratched and given other degenerated finishes. His original renderings produce haunting scenes that hover somewhere in the realm between fantasy and reality.

Carroll's studio is a reflection of the multidisciplinary approach he takes to his work. Cameras and lighting equipment are in one corner. Another area, devoted to painting, is equipped with easels, brushes and tablets. Another corner contains a flatbed scanner, a Macintosh Quadra 840 and a dye sublimation printer.

Much of Carroll's award-winning work is used for editorial and advertising illustration as well as compact disc packaging. Carroll's studio is located about three hours outside of Manhattan and he sends his city-based clients dye sublimation prints of his work for their approval. In spite of the commercial success of his work, Carroll has increasingly sought to create a market for images he creates independently. His work has recently been recognized and exhibited by a number of New York City galleries.

1 Untitled

This CD cover for folk singer Meg Hutchinson started with five different black-and-white photos of the recording artist—one each for her head, guitar, torso and each hand. Carroll dabbed paint onto glass to achieve the mottled effect of the image's background and knifed scratches onto a piece of chipboard for added texture. He scanned each of these elements as well as lyrics from one of Hutchinson's songs, and brought them all into Photoshop. Carroll distorted the lyrics by applying the Twirl and Motion Blur filters. Then he used Layers and played with the Opacity controls to blend all of the scanned elements. He guesses that as many as twelve different layers went into the final composite.

2 "Anxiety"

This self portrait, created when Carroll was going through a stressful period in his life, depicts the artist being chased by demons. Carroll started by bringing several photos into Photoshop—three head shots of himself and three to four body poses—all photographed in his studio with a timed shutter release on his camera. He combined all photos into a single image of himself using Photoshop's Layers. The image of the demon is a composite of three original photos—a female nude, a circus horse and a bird

2

in flight. Carroll isolated the portions of each photo that he needed with Photoshop's Selection tools and used Layers to blend them into a single image. Both images were blended with a background of scanned handwriting, painted glass, scratched surfaces and type before the final composite was completed.

3 Untitled

Carroll created this portrait as a tribute to his mentor, Michael Martin, who introduced him to the computer and Photoshop in 1991. The composite depicts Martin in front of an easel and a fanciful figure representing inspiration. Carroll's original scans included two photos of Martin and photos of an easel, floor, rug, lighting umbrella, sneakers and a window, plus pencil drawings of "inspiration" and a figure. He combined all of these elements using Layers and

3

added texture with a scan of random marks made with pencil on chipboard. Carroll adjusted Curves and Levels to create more contrast in his pencil drawings and achieve tonal balance in his composition.

4 Untitled

Artist Gustav Klimt inspired the intricate patterning on this portrait. Carroll created the Klimt-like effects by bringing scans of penciled patterns and background renderings into Photoshop and colorizing them with the Fill command. He then adjusted Curves to exaggerate the color and lighting effects. Carroll used Layers to blend the background and painted effects he created in Photoshop with his photo of a woman. The Lasso tool was used to isolate portions of the woman's face and apply strategic color by adjusting Hue and Saturation. Before he completed the image, Carroll used the Brush and Smudge tools to render his model's hair. Created as a fine-art piece, this image was also used on a calendar promoting a paper manufacturer.

5 Untitled

Carroll created this image to promote Lunawork's sponsorship of a series of herbal therapy workshops. The composite employs a photo of a female nude, several photos of flowers and painted glass. Carroll scanned these items and brought them into Photoshop, where they were blended with the Layers palette. He created the moon in Photoshop by drawing a circular shape with the Airbrush tool. Carroll duplicated the circle, inverted it and placed it over the original to form a crescent.

Alan Brown, Photonics

Alan Brown started his career as a photographer specializing in people and special effects. In his pre-computer days, he relied on airbrush artists and photo labs to produce composites and other unusual effects he wanted to achieve. But Brown's reliance on other service providers proved to be frustrating—his lack of control over the process often yielded less-than-satisfying results. When the Macintosh started to become recognized as a design and graphic arts production tool, Brown bought into the technology, working on an early imaging program called PhotoMac. By 1989, Brown learned that two brothers by the name of Knoll had developed an image editing program which had just been sold to Adobe. Brown convinced Adobe to let him serve as a Beta site for what at that time was known as "Merlin," and eventually was released as Photoshop 1.0.

Brown has relied on Photoshop ever since as a primary application in his production of digital images, although he draws from many other programs as well, including several 3-D modeling programs, multimedia software and other imaging applications.

Brown established Photonics in 1988, at about the time he expanded from traditional photography into computer imaging. He still retains an in-house photography studio, where he shoots many of the photos that serve as the basis for his computer images, but wonders if its days are numbered. His ever-evolving business seems to increasingly encompass multimedia and graphic design, as well as computer imaging.

1 "Rising"
Brown started by drawing a keyboard in Adobe Illustrator. When he was done, he imported the keyboard paths into Vidi Presenter, a 3-D modeling program, where dimension was added. The keyboard was then

imported into Meta Tools Bryce, where Brown added a textured surface. Brown then brought the keyboard into Photoshop, where he adjusted Curves to heighten its textured surface. He used Fractal Design Poser, a 3-D figure-modeling program, to create the flying figure. The figure and the keyboard were composited in Live Picture, where the sky and other background elements were created. But before Brown could import these images into the program, he had to bring each image into Photoshop, where they were converted to IVUE images—a file format which is compatible with Live Picture. When Brown was done, he brought the composition back into Photoshop to convert the image to an EPS file. The image

was used on an album cover for musician Billy Larkin.

2 "Genie"
Brown created this image with many of the programs and techniques he'd used in "Rising." Figures were created in Fractal Design Poser. The bottle was created in Stratavision 3D and imported into Meta Tools Bryce, where texture was added. When Brown completed each of the elements that constitute the piece, he imported them into Photoshop, where they were converted to IVUE images. Live Picture was used to composite the visual elements in the piece and create the background landscape. When the image was completed, Brown imported it into Photoshop to convert to an EPS file.

3 Untitled
This image started with two 35mm slides—one of a single pyramid and another of three pyramids—all stock images of the Pyramids of Giza. Brown had high-resolution scans made of the slides and brought them into Photoshop. Brown first did some retouching on the slides, removing people and other items by replacing them with cloned sand he picked up with the Rubber Stamp tool. Brown then combined the two slides in Photoshop by creating masks and channels. He created the effect of a sunset by drawing a circle in the sky with the Ellipse tool. He colored and softened the sky and the sun by adjusting Hue and Saturation and applying the Gaussian Blur filter. Because Steel Lox's logo is a

triangle with two lines in it, he carved two linear areas out of the foreground pyramid by using the Rubber Stamp tool to replace those portions of the pyramid with cloned segments of the background. Steel Lox used the image in a series of magazine ads.

4 Untitled

Brown created this image to promote the Cincinnati Ballet. He started with two images: high-resolution scans of original transparencies of a ballerina's leg and a swan. He brought both images into Photoshop and used masks and alpha channels to combine them with a watery background, which he created in Specular Infini-D, a 3-D rendering program. The reflection of the swan was made by duplicating the image, flopping it and adjusting Opacity controls to achieve a realistic blending with the water. When he was done, Brown applied an overall watery effect to the image by applying the Adobe Gallery Effects Plastic Wrap filter. The image was used on posters, bus boards and the Cincinnati Ballet's season program.

5 Untitled

This identity for a manufacturer of aerospace industry software started with airbrushed art of a tire and a turbine blade. Brown acquired other images for the collage, which included stock transparencies of a jet engine, the earth, a satellite dish, and an original slide of a gear. Brown had high-resolution scans made of the images and brought them into Photoshop, where each was isolated from its background with the Selection tools. Brown used alpha channels and masks to composite the images. He achieved various levels of translucency by using the Gradient tool and adjusting Opacity levels. Hue and Saturation were adjusted to achieve the image's cool palette. The image was used on packaging and promotional materials.

Joyce Neimanas

Joyce Neimanas got her start in computer-aided imagery in 1992, when Apple, Inc. selected her, along with several other nationally recognized artists, to receive a free computer. Prior to that, Neimanas was producing large-scale, black-and-white collages created in the darkroom entirely by hand. But a three-day workshop, which included training in Photoshop, quickly transformed her collage process into one which involved the computer.

Neimanas works with found images from every conceivable source, including coloring and comic books, magazines, catalogs and books of ancient and nostalgic imagery she has acquired from rare-book dealers. She scans them on her studio's flatbed scanner and uses Photoshop to composite them into insightful collages that reflect her perception of their commonality. Taken out of context, the seemingly unrelated components blend harmoniously, and sometimes humorously, into a single vision.

Neimanas works on a large scale—her collages can measure up to 35" x 47" (89cm x 119cm). Chicago-based Neimanas ships her work to Nash Editions, which outputs her images as large-scale Iris prints on Arches paper. Each piece is a one-of-a-kind print.

Neimanas exhibits her work in galleries as well as museums. Her digital collages have appeared in the Museum of Contemporary Art in Chicago, the San Francisco Museum of Modern Art and the California Museum of Photography.

1 "Building"

With this piece, Neimanas sought to blend images from a 1920s medical book on healing with elements from a medieval manuscript that portray the building of a home. She started with flatbed scans of the manuscript as well as pages from the medical book and brought them

into Photoshop. Neimanas outlined each of the images she wanted to pull into her composite with Photoshop's Selection tools and used a Cut and Paste operation to properly position each component. Neimanas used Photoshop's Rubber Stamp tool in reverse and the Paint Brush tool to touch up edges and create a realistic blending of elements.

2 "Rebus"

A piece of ink-stained facial tissue served as the unlikely background for this piece. Neimanas

scanned the tissue on her flatbed scanner and brought it into Photoshop to be combined with a scan of a coloring book image of the Sphinx. The two images were composited using Layers. Neimanas also brought two images of women, clipped from fashion magazines, into the composition by scanning them and bringing them into Photoshop. After cropping each image, she blended them by adjusting Opacity controls on the Layers palette. Neimanas added a bee, scanned from a book, by outlining it with

Photoshop's Selection tools and using Layers to combine it with the other image elements.

3 "Dear Diary"

Neimanas started by scanning two snapshots of herself taken from her family photo album as well as a vintage postcard that serves as the background for the top portion of the composite. After the images were brought into Photoshop, Neimanas isolated herself from each photo's background using the Selection tools. She used Cut and Paste to superimpose her own face onto

4

⑤

⑥

the figures that appeared on the postcard. The backdrop for her composition is a medieval manuscript, scanned from an art history book Neimanas owns. Neimanas used Cut and Paste to place the postcard composite at the top portion of the composition. The bottom half was filled with comic-book images, including a vacuum cleaner, which she scanned and brought into Photoshop. These elements were scaled, cropped or outlined to fit each area. To finalize the collage, Neimanas used the Paint Brush and Rubber Stamp tools to touch up portions of the images that constitute the composite.

4 "Licks"

For images of people licking, Neimanas looked to pornographic magazines, where she found a wealth of material to choose from. Neimanas brought each magazine image into Photoshop, where she used the program's Cropping and Selection tools to isolate each face from its background. The other figures Neimanas pulled into her composition included various images she found in magazines and books. Neimanas brought scans of these images into Photoshop and cropped and scaled them to the desired size. She used the Rubber Stamp tool to obliterate the features on their faces, and adjusted Curves and Hue and Saturation to achieve the coloring she wanted. The mosquito border was achieved by placing a dead insect directly on the scanning bed, bringing it into Photoshop, and duplicating it many times. Neimanas used Cut and Paste to assemble all of the elements into a single composition.

5 "Seconds"

A magazine photo of a bald man in profile served as the starting point for this composite about time. Neimanas scanned the image as grayscale and brought it into Photoshop, where she used the Selection tools to isolate the head from its back-

ground. She also scanned a Japanese wood engraving, a photo of a foot from a book on medical healing, an illustration of a stopwatch and a photo of the side of a dictionary. All of these elements were brought into Photoshop, where they were cropped and composited using Layers. Neimanas filled the background with black.

6 "Sky"

The figure in the center of this collage came from an ancient painting Neimanas found in an art history textbook. Neimanas scanned the image directly from the book and brought it into Photoshop. The four Egyptian line drawings came from a coloring book. Neimanas scanned these and brought them into Photoshop, where she applied Invert to achieve white images against a black background. Neimanas also made a line drawing of each of the coloring book illustrations using white pastel on black paper. She scanned these four drawings and merged each with its corresponding reversed original. The two versions of each image were blended in Photoshop by adjusting Opacity on the Layers palette. Other images in the piece include diagrams from an airline in-flight safety brochure, scanned and outlined in Photoshop with the Selection tools, and placed into position using Layers.

Annie Higbee/ Imagewright

Rockport, Maine–based illustrator and fine artist Annie Higbee initially embarked on a career in the arts with her camera in hand, working as a freelance photographer and experimenting with photography as a fine arts medium. Her career and methodology took a dramatic turn in the early 1990s, when she hooked up with Kodak's Center for Creative Imaging. As an instructor at the Center, Higbee became familiar with the Macintosh and all of the major imaging and animation programs available on this platform.

Higbee has since incorporated two imaging programs into her work, using a combination of her own photography, Photoshop and Fractal Design Painter to achieve images that have a dreamy, evocative quality. She prints her images on her own dye sublimation printer or uses Jonathan Singer, a Boston-based output service, to produce Iris prints on archival paper.

Higbee has had considerable artistic recognition—several of her pieces have appeared in juried shows. Other work has been published, appearing on journal covers, holiday cards and as editorial illustration.

1 "Sleeper's Awake"
Higbee started with three original photographs—organ pipes, a window and sheet music— which she brought into Photoshop. For a flowing effect, Higbee first applied Photoshop's Wave filter to the image of the sheet music. She added a reddish tint to the organ pipes by adjusting Hue and Saturation. To blend all three images, Higbee used the Channels feature and adjusted the opacity levels until she achieved the desired effect.

2 "As Cool as Water, as Sharp as Ice"
Higbee started with three photos: standing feet, skater's feet and a breaking wave. She combined these in Photoshop with a drawing of cracks which she created in Fractal Design Painter. Higbee blended the three photos by creating a different channel for each in Photoshop. By adjusting the opacity level of each image as she combined channels, she was able to blend all three images into a composition. The photo composite was brought into Painter, where Higbee blended it with her drawing of cracks.

3 "Breakwater in Rockland"
Photos of a jetty and a Christmas tree were combined in Photoshop to compose this image. Working on an older version of the program, Higbee isolated the tree from its background with the Lasso tool, and did a simple Cut and Paste to position it at the end of the jetty. She adjusted Opacity settings before pasting the tree to achieve a degree of translucency that would help the tree blend in with the background of the jetty photo. Higbee created the glowing star on the top of the tree with Photoshop's Airbrush tool.

4 "Horse Dreams"
Higbee started with a photo of a tepee, which she scanned and brought into Painter to achieve the look of color applied with a brush. Although she relied primarily on Painter's tools to draw and paint the items in her composition, at one point Higbee brought the image of a horse she had drawn in Painter into Photoshop so she could make copies of it with the Rubber Stamp tool. She then brought the horse images back into Painter, scaling them as she imported them, to paint additional details as well as the background portion of her composition.

Robert Bowen

Robert Bowen's career began in photography and video. His background encompasses computer programming, movie special effects, computer animation and editing a book about art and geometry. While working on that book, Bowen met a number of computer artists and realized the possibilities that exist in computer imaging. Bowen has been on the edge of the technology ever since, producing visual effects for advertising, stock photography and editorial applications.

At Robert Bowen Studio, established in 1994, Bowen works on Macintosh and Silicon Graphics Indy (SGI) computers. He does most of his work in Photoshop and supplements this imaging with Barco Creator and other 2-D and 3-D rendering programs on the SGI. Bowen outputs images as Cibachrome photographic prints, Iris prints, gelatin silver black-and-white prints and Cactus prints.

Bowen's work has appeared in ads for Bacardi, Johnny Walker Black, IBM and Coca-Cola to name a few. He teaches at the School of Visual Arts and conducts imaging seminars. He exhibits his work in a number of New York City galleries.

1 "Oriental Faces"
Bowen relied on the Calculate menu for his imaging effects; however, he started by producing much smaller spheres in Alias. He used one of the color channels in Lab Color to color the spheres with a reddish tint. Like a Rorschach test, the bilateral symmetry of the image causes the viewer to read faces in various segments. Bowen created mirror images by flipping images during the calculating process.

2 "Montanas"

Four photographs were composited to create this landscape, currently available as a stock image through The Stock Market. The grassy foreground, green mountains, gray mountains and sky were each separate color transparencies merged in Photoshop. Spherize was used to achieve a slight curve to the sky image. The jarring peaks of the green mountains were achieved by rotating the mountains 90° and applying the Shear filter. Bowen used the Smudge tool to push portions of the peaks into exaggerated shapes. He rotated the mountains back to a horizontal plane and used Layers to combine the images.

3 "Sconces"

Bowen started by modeling simple spherical shapes in SGI Alias. Bringing the black-and-white shapes into Photoshop, he made a mask for each image and used Airbrush to create a foggy, circular shape. A different layer was created for each image, its mask and the airbrushing, and these were composited with Calculate. He took the images through a variety of Calculate blending options. Layers was used to composite the images.

4 "Dream"

Bowen started with transparencies of a lake, water pouring from a tray (by photographer Ryszand Horowitz), sandy mountains, clouds and a landscape. Each image was placed on its own layer, including a duplicate of one of the cloud images, and blended together using Layers. After completing the composite, Bowen brought in a transparency of a waterfall and layered it onto the corner of the tray of water to complete the surrealistic landscape.

5 "The World"

Bowen started by modeling cylinders in SGI Alias. The cylinders were brought into Photoshop, made into Grayscale images, duplicated and rotated at different angles. A hand-painted map Bowen created was added to the composition. Calculate, then Multiply were used to combine the cylinders with the map. Bowen did a bit of retouching with Airbrush to complete the composition.

6 "Sine Wave City 3D"

The incredible sense of depth created in this anaglyph can be truly appreciated with red and blue glasses. The strategy going into production is that stereoscopic vision is based on the distance between the left and right eyes. Bowen increased stereoscopic perception of this image by positioning the camera views of the two images three feet apart. Bowen created red and blue counterparts by shooting two slides and bringing them into Photoshop. He converted each view of the image into Grayscale and then made each into an Alpha Channel. Bowen Inverted them and converted one to magenta, the other to cyan. The images were merged by using Calculate, Multiply. The Shear Filter was used to create the sine wave.

Scott Bruno

Scott Bruno is a Cincinnati-based graphic designer who, in addition to design and imaging for print, produces animations he creates in Photoshop.

Bruno starts with original photographs and other images he scans and brings into Photoshop. He frequently creates composite images by taking one photo and combining it with others, adjusting color and lighting to achieve a particular mood or effect, and drawing directly on an image with Photoshop's painting and drawing tools. When Bruno is finished with an image, he creates copies of it (thirty frames constitute a second in an animated sequence) and uses Photoshop's filters and other special effects to create changes from one image frame to the next. When the frames are completed, Bruno brings them into a scripting program, where they are arranged in sequence and sound is added.

Bruno holds a B.S. in computer science and an M.F.A. in graphic design. In addition to working as a freelance designer and imaging specialist, Bruno teaches graphic design and computer imaging at the University of Cincinnati and the Art Academy of Cincinnati.

1, 2, 3 "This World, Then the Fireworks"

This animated video is a historical narrative of the life of crime novelist James Thompson, created primarily in Photoshop and Macromedia Director. Bruno researched Thompson's life at the public library in Fort Worth, Texas, where Thompson spent his adolescence. Bruno had the library send photos, such as this one of Thompson's high school yearbook page, which he incor-

porated into the video. In this sequence, the narrative tells how Thompson suffered a nervous breakdown at the end of his senior year, as his yearbook write-up blurs and fades into oblivion. Bruno achieved this sequence by applying Photoshop's Wave and Gaussian Blur filters over approximately forty-five frames of the yearbook write-up.

4

At the start of this sequence, smoke actually drifts from the burning cigarette. Bruno created the smoke by first drawing it in Photoshop with the Airbrush tool. He animated the smoke by bringing paths drawn in Adobe Illustrator into Macromedia Director. The paths, acting as masks against the rectangle of smoke, were scripted to move side-to-side, giving the illusion of smoke rising.

5, 6, 7, 8

In the portion of the video which describes Thompson's lonely existence as an alcoholic, Bruno composited four photos using Layers to depict Thompson sitting on a bed in a hotel room. The sequence starts by showing a figure with a burning cigarette and ends with a figure viewed from the rear in a bureau mirror. Bruno applied the Gaussian Blur filter in successive stages to add a haze to portions of the scene that needed to be played down, directing the viewer's attention to areas of the scene that remain in sharp focus. In the sixty-second sequence, the focus shifts from the figure sitting on the bed with the cigarette in his hand to the bottles on the bureau.

Olivia Parker

Olivia Parker graduated from Wellesley College in 1963 with a degree in art history. She began her career as a painter, but ventured into photography about twenty-five years ago. A self-taught photographer, she rapidly developed a reputation for creating photographic still lifes with unusual lighting effects.

Parker was introduced to Photoshop during a five-day workshop in 1993. Although she became familiar with the program, she didn't really delve into it as a means of producing her images until 1995, when a broken leg she received in a ski accident limited her mobility. With the Macintosh as her only means of production, Parker started using Photoshop as a tool for combining her photographic images.

Parker's background in still life photography prepared her well for combining images in unusual ways. For her source images, she draws from her own photographs, both black-and-white and color in formats ranging from 35mm slides to Polaroid 20" x 24" (51cm x 61cm) types. Parker scans 35mm slides on her studio's Kodak scanner and uses a friend's Leaf scanner for digitizing larger transparencies and negatives. She relies on Photoshop for her compositing. Parker's finished images are produced in limited editions of around thirty. Nash Editions, based in Southern California, archives her digital files for each image and outputs prints on 100 percent cotton rag paper when Parker requests them.

Parker's work has been widely recognized, appearing in major private, corporate and museum collections, including the Art Institute of Chicago, the Museum of Modern Art in New York, the Museum of Fine Arts in Boston and the International Museum of Photography at George Eastman House in Rochester, New York.

1 "A Book of Broken Rules"

Parker started with a black-and-white 4" x 5" (10cm x 13cm) negative of the book, and 35mm color slides of seagulls from her own photograph collection. After scanning these images as grayscale, Parker brought them into Photoshop, where each was isolated from its background with the Selection tools. She used Cut and Paste to position each of the gulls onto the book, saving different stages of development as she worked so that she could revert to the most recent version if a particular combination didn't satisfy her. Parker applied the Rubber Stamp tool to the wing of the gull within the book to achieve a blend. The background was filled with black to complete the image.

2 "Mr. Johnston's Pulltoy"

This composite started with three 35mm slides—a camel, a TV set and a bronze pulltoy of a bull on wheels from India. Because she wanted the lighting to be consistent on all components, Parker shot the pulltoy with lighting that duplicated the direction of light on the camel. She scanned each of the slides on her studio scanner and brought them into Photoshop, where each image was isolated from its background with the Selection tools. Parker used Cut and Paste to position the head of the camel over the head of the bull, and used the Rubber Stamp tool to position the camel's hump on the bull's back. Parker pasted the TV set onto the body of the bull and created a black background with the Fill command.

3 "Herbivore-Carnivore"

Parker was able to use Photoshop's Layers feature in assembling this composite, more recently created than some of her other pieces. She started with a 35mm slide of a carnivorous plant, and a 35mm slide of a bronze Indian toy which she shot in her studio. Parker scanned the slides on her studio

③

④

scanner, used Photoshop's Selection tools to isolate each image from its background and assembled them using the Layers palette. The head of the deer is another 35mm slide from Parker's collection. She reproduced it on the bronze toy using the Rubber Stamp tool.

4 "Missing Piece—Anhinga"
A slide of an anhinga, taken in Florida, served as the starting point for this image. Parker blended it with a bone game chip from the nineteenth century which she shot in her studio. Both slides were scanned and brought into Photoshop. After using the Selection tools to isolate the game chip from its background, Parker worked painstakingly with the Rubber Stamp tool, cloning pixels from the anhinga and the game chip, to achieve the realistic blend in the final composite. She filled the background with black.

5 "Action Attraction"
Parker was inspired to create this piece when she noticed that today's toy action figures tend to merge the human figure with somewhat monstrous elements. She found images in a sixteenth century medical book purchased from a rare-book dealer, which documents what the book refers to as "monstrous births," or birth deformities. Parker created a border by scanning pages of the book and coloring them in Photoshop by converting the black-and-white images to CMYK and adjusting Curves. She cropped and sized each image and used Cut and Paste to assemble them into the border. She brought the action figure into her composition by shooting a 35mm slide of the figure and scanning it. After bringing it into Photoshop, Parker isolated the figure from its background with the Selection tools, and created a gradated background with the Gradient tool. She created a blend of the figures with the Paint Brush. The figure was combined with its border with the Layers palette.

⑤

Permissions

p. 7 © Viva Dolan Communications + Design

pp. 8-9 © 1996 Bean Street Studios

p. 10 © 1996 Rickabaugh Graphics; Photos: Larry Hamill

p. 11 © Primo Angeli Inc.; Photos: Jaime Pandolfo

pp. 12–13 © SEGURA INC.

p. 14 © 1995 David Plunkert

p. 15 © 1994 David Plunkert

p. 16 (left) © Stoltze Design

p. 16 (right) © Copeland Hirthler design + communications

p. 17 © Rock and Roll Hall of Fame and Museum

p. 18 © 1994 Ludlow Garage Reunion Committee; Photo: Tony Arrasmith

p. 19 © Boyden & Youngblutt

p. 20 © 1996 Spur Design LLC

p. 21 © Copeland Hirthler design + communications

p. 22 © Viva Dolan Communications + Design

p. 23 (left) © 1996 DBD International, Ltd.

p. 23 (right) © 1995 Frank Petronio

p. 24 © 1994 Cincinnati Museum Center

p. 25 © 1995 AERIAL; Photos: R.J. Muna Pictures, Inc.

p. 26 © 1996 Bruce Plank

p. 27 © 1994 Paula J. Curran

p. 28 (left): © Mark Oldach Design, Ltd.

p. 28 © Mark Oldach Design, Ltd.; Photos: Educational Foundation of the National Restaurant Association

p. 29 © 1996 MTV Networks

p. 30 © PandaMonium Designs; Photos: Steven Lee

p. 31 © 1995 Color Marketing Group

p. 32 © 1995 Spur Design LLC

p. 33 © 1996 Townsend Design

p. 35 © AERIAL; Photos: R.J. Muna Pictures, Inc.

p. 36 © Microsoft Corporation; Photos: Tom McMackin

p. 37 © SEGURA INC.

p. 38 (left) © AERIAL; Photos: R.J. Muna Pictures, Inc.

p. 38 (right) © Courtney & Company

p. 39 (top) © Lebowitz/Gould/ Design, Inc.

p. 39 (bottom) © SEGURA INC.

p. 40 © Corbis Corporation; Photo: Tom McMackin

p. 41 © Stoltze Design

p. 42 © REY International

p. 43 © AERIAL; Photos: Jerry Stoll, R.J. Muna Pictures, Inc.

pp. 44–45 © NEXTLINK Corporation; Photo: Tom McMackin

p. 46 © 1994 Frank Petronio

p. 47 © REY International

p. 48 © Equifax; Photos: Jerry Burns

p. 49 © Grafik Communications, Ltd.

p. 51 © Brainstorm Inc.

p. 52 © Acme Design Company; Photos: Elektra Entertainment/ Asylum Records

p. 53 © Acme Design Company

p. 54 © Greteman Group; Photos: Paul Bowen

p. 55 (left) © Primo Angeli Inc.

p. 55 (right) © 1996 Grove Atlantic; © 1996 David Plunkert

p. 56 © 1996 Bay Networks

p. 57 © 1996 *Computerworld* Magazine

p. 59 © Parham Santana, Inc.

p. 60 © Pam Shapiro; Photos: R.J. Muna Pictures, Inc.

p. 61 © Primo Angeli Inc.; Photos: June Fouché

pp. 62–63 © SEGURA INC.

p. 64 © 1996 Paula J. Curran; Photos: Greg Scheideman

p. 65 © 1996 A. Buhler/K. Crooker/M. Kaplan

p. 66 © Pisarkiewicz & Company, Inc.

p. 67 © SEGURA INC.

p. 68 © OXO, International; Photo: Tom McMackin

p. 69 © Rhino Chasers; Photo: Tom McMackin

pp. 70–71 © REY International

p. 72 © Primo Angeli Inc.; Photo: Ernie Friedlander

p. 73 © Primo Angeli Inc.; Photo: June Fouché

p. 75 © Courtney & Company

p. 76 © SEGURA INC.

p. 77 © Copeland Hirthler design + communications; Photos: Jerry Burns

p. 78 © Microsoft Corporation

p. 79 © Steppenwolf Theatre Company, Chicago

pp. 80–81 © SEGURA INC.

p. 82 © Boyden & Youngblutt

p. 83 © 1996 InfoWorld Impact Marketing

p. 85 © AERIAL; Photos: R.J. Muna Pictures, Inc.

p. 86 © SEGURA INC.

p. 87 © Rock and Roll Hall of Fame and Museum

p. 88 © 1995 AERIAL; Photos: R.J. Muna Pictures, Inc.

p. 89 © 1996 Boelts Bros. Associates

p. 91 © Primo Angeli Inc.; Photos: June Fouché

pp. 92–93 © Starbucks Coffee Company; Photo: Tom McMackin

p. 94 © SEGURA INC.

p. 95 © AERIAL; Photos: Jerry Stoll, R.J. Muna Pictures, Inc.

p. 96 © 1996 Inso Providence Corporation, Stewart Monderer Design, Inc.

p. 97 © Grafik Communications, LTD.; Photos: Taran Z, Markus Nikot

p. 98 © The Frank Russell Company; Photo: Tom McMackin

p. 99 © PandaMonium Designs

p. 100 © Copeland Hirthler design + communications; Photos: Jerry Burns, Mark Shelton

p. 101 © Equifax

p. 102 © Grafik Communications, Ltd.; Photos: John Vitorovich, Publishers Depot

p. 103 © Parham Santana, Inc.

p. 104 © 1997 Boyden & Youngblutt

p. 105 © AERIAL; Photos: R.J. Muna Pictures, Inc.

p. 106 © B-LIN

p. 107 © Parham Santana, Inc.

p. 108 © NEXTLINK Corporation; Photo: Tom McMackin

p. 109 © Novell, Inc.; Photo: Tom McMackin

p. 110–111 © SEGURA INC.

pp. 112 © 1995 DataScope; Photos: R.J. Muna Pictures, Inc.

p. 113 (right) © 1994 Tom Landecker

p. 113 (left) © Greteman Group

p. 115 © B-LIN

pp. 116–117 © Copeland Hirthler design + communications

p. 118 © Copeland Hirthler design + communications; Photos: Don Freeman, William Snyder, Sean Goss

p. 119 © Primo Angeli Inc.

p. 120 © 1995 Twentieth Century Fox Film Corporation, © 1995 Saban Entertainment, Inc. & Saban International N.V. All Rights Reserved.

p. 121 © SEGURA INC.

p. 122 © 1997 Viacom International Inc. All Rights Reserved. © Nickelodeon, "Blue's Clues" and all related titles, logos and characters are trademarks of Viacom International Inc. and are used herein by permission. Photos courtesy of Nickelodeon.

p. 123 © SEGURA INC.

pp. 125–127 © Jim Carroll

pp. 128–129 © Alan Brown/ Photonics

pp. 130–131 © 1996 Joyce Neimanas

pp. 132–133 © Annie Higbee/Imagewright

pp. 134–135 © Robert Bowen; "Dream": © Robert Bowen and Ryszand Horowitz

pp. 136–137 © Scott Bruno

pp. 138–139 © Olivia Parker

Directory of Creative Professionals

Acme Design Company
215 N. St. Francis, Suite 4
Wichita, KS 67202
(316) 267-ACME

AERIAL
58 Federal
San Francisco, CA 94107-1422
(415) 957-9761

Armijo Design Office
17707 Crenshaw Blvd., Suite 210
Torrance, CA 90504
(310) 329-8547

Arrasmith McHale & Associates
342 Gest St.
Cincinnati, OH 45203
(513) 241-3102

Barnhurst/Spatafore
50 S. 600 E.
Salt Lake City, UT 84102
(801) 364-8759
or
701 Minnesota St., Suite 106
San Francisco, CA 94107
(415) 206-9384

B-LIN
4918 N. Harbor Dr.
San Diego, CA 92106
(619) 223-0080

Boelts Bros. Associates
345 E. University Blvd.
Tucson, AZ 85705-7848
(520) 792-1026

Bowen, Robert
7 W. 22nd St., 10th Floor
New York, NY 10010
(212) 206-0848

Boyden & Youngblutt
120 W. Superior
Fort Wayne, IN 46802
(219) 422-4499

Brain Sells
230 Hyde Park Dr.
Hamilton, OH 45013
(513) 896-5350

Brainstorm, Inc.
3347 Halifax
Dallas, TX 75247
(214) 951-7791

Brown, Alan
700 W. Pete Rose Way, Suite 360
Cincinnati, OH 45203
(513) 723-4440

Bruce Plank Design Office
221 N. Main St.
Wichita, KS 67202
(316) 269-2736

Bruno, Scott
955 Kirbert Ave.
Cincinnati, OH 45205
(513) 921-5688

Carroll, Jim
2160 Rt. 9
East Chatham, NY 12060
(518) 392-5234

Copeland Hirthler design +
communications
40 Inwood Circle
Atlanta, GA 30309
(404) 892-3472

Courtney & Company, Inc.
636 Avenue of the Americas
New York, NY 10011
(212) 627-2540

Curran, Paula J.
158 Art & Design, Iowa St. Univ.
Ames, IA 50011-3092
(515) 294-9942

DBD International, Ltd.
406 Technology Dr. W., Suite B
Menomonie, WI 54751
(715) 235-9040

Frank Petronio > commercial artist
248 East Ave.
Rochester, NY 14604
(716) 262-4230

Grafik Communications, Ltd.
1199 N. Fairfax St., #700
Alexandria, VA 22314
(703) 683-4686

Greteman Group
142 North Mosley, 3rd Floor
Wichita, KS 67202
(316) 263-1004

Higbee, Annie/Imagewright
P.O. Box 914
Rockport, ME 04856
(207) 236-2615

Hornall Anderson Design Works
1008 Western Ave., Suite 600
Seattle, WA 98104
(206) 467-5800

Lebowitz/Gould/Design, Inc.
7 W. 22nd St., 7th Floor
New York, NY 10010
(212) 645-0550

Mad Macs
5965 Belmont Ave.
Cincinnati, OH 45224
(513) 542-8778

Mark Oldach Design
3316 N. Lincoln Ave.
Chicago, IL 60657
(773) 477-6477

MTV Networks
1515 Broadway
New York, NY 10036

Neimanas, Joyce
1801 W. Wabansia Ave.
Chicago, IL 60622
(773) 276-4293

Nesnadny + Schwartz
10803 Magnolia Dr.
Cleveland, OH 44106
(216) 791-7721

PandaMonium Designs
14 Mt. Hood Rd., Suite 3
Boston, MA 02135
(617) 731-8458

Parham Santana
7 W. 18th St.
New York, NY 10011
(212) 645-7501

Parker, Olivia
229 Summer St.
Manchester, MA 01944
(508) 526-7344

Photonics
700 W. Pete Rose Way, Suite 360
Cincinnati, OH 45203
(513) 723-4440

Pisarkiewicz & Company, Inc.
34 W. 22nd St., 6th Floor
New York, NY 10010
(212) 645-6265

Primo Angeli Inc.
590 Folsom St.
San Francisco, CA 94105
(415) 974-6100

REY International
4120 Michael Ave.
Los Angeles, CA 90066
(310) 305-9393

Rickabaugh Graphics
384 W. Johnstown Rd.
Gahanna, OH 43230
(614) 337-2229

SEGURA INC.
1110 N. Milwaukee Ave.
Chicago, IL 60622
(773) 862-5667

Spur Design
3647 Falls Rd.
Baltimore, MD 21211
(410) 235-7803

Stewart Monderer Design, Inc.
10 Thacher St., #112
Boston, MA 02113
(617) 720-5555

Stoltze Design
49 Melcher St., 4th Floor
Boston, MA 02210
(617) 350-7109

Tharp Did It
50 University Ave., Suite 21
Los Gatos, CA 95030
(408) 354-6726

Townsend Design
2541 Marling Dr.
Columbia, SC 29204
(803) 779-4633

Viva Dolan Communications +
Design
1216 Yonge St., Suite 203
Toronto, Canada M4T 1W1
(416) 923-6355

Zerogravity
1110 N. Milwaukee Ave.
Chicago, IL 60622
(773) 862-5667

Index

More Great Books for Knock-Out Graphic Design!

1998 Artist's & Graphic Designer's Market—This marketing tool for fine artists and graphic designers includes listings of 2,500 buyers across the country and helpful advice on selling and showing your work from top art and design professionals. *#10514/$24.99/786 pages*

WWW Design: Web Pages from Around the World—Use the most innovative designs and graphics on the Web today to inspire your own Website design. Includes interactive CD-ROM (Mac/PC). *#30960/$49.99/160 pages/300 color images*

Graphic Design America—Peek into the portfolios of 38 of the best up-and-coming U.S. designers and design firms. Discover what's new and innovative and how your work can rise above the rest. *#30962/$49.99/256 pages/400 color illus.*

Graphic Design: New York 2—Take a look at 38 stand-out portfolios from the city that put graphic design on the map. Studios like Louise Fili, Desgrippes Gobe and Carin Goldberg are represented. *#30948/$49.99/256 pages/400 color illus.*

The Complete Guide to Eco-Friendly Design—59 real-world case studies reveal both the technical information AND the creative inspiration you'll need to produce earth-friendly printed pieces. *#30847/$29.99/144 pages/118 color illus.*

Digital Type—Type becomes essential design elements in more than 100 examples of cutting-edge type from leading design firms. Use for magazines, brochures, ads, posters, many others. *#30956/$34.99/144 pages/200 color images*

Great T-shirt Graphics 3—Showcases the latest trends in more than 350 silk-screened, airbrushed, and printed T-shirts from top international designers. Includes interactive CD-ROM (Mac/PC) with 500 designs from vols. 1-3. *#30958/$44.99/160 pages/350 color images*

Package & Label Design—More than 300 of the best new, innovative packaging and label designs from top international designers. Includes interactive CD-ROM (Mac/PC) with 700 archive images. *#30989/$44.99/160 pages/300 color images*

Using Design Basics to Get Creative Results—60 real-world, full-color projects show you how to create powerful designs built on foundations of basic principles. Each section ends with helpful exercises and self-test questions. *#30828/$29.99/144 pages/125 illus.*

Getting Started in Multimedia Design—Here's creative advice, business tips and other secrets to success from accomplished media designer Gary Olsen. *#30886/$29.99/144 pages/176 color illus./paperback*

Clip Art Smart: How to Choose and Use Digital Clip Art—Shows you how to effectively use clip art to improve design and save time and money. Includes interactive CD-ROM (Mac/PC) with 500 copyright-free images. *#30994/$39.99/144 pages/200 color images*

Graphic Design: Inspiration and Innovations 2—When circumstances conspire against you, get inspired by these case studies of the best of design done under the worst of circumstances.

Helps you see how creative thinking can turn near-disaster into triumph. *#30930/$29.99/144 pages/177 color illus.*

Even More Great Design Using 1, 2 & 3 Colors—When budgets are tight, reach for this book. 170 innovative designs using limited colors on posters, stationery, packaging, annual reports, and more. *#30955/$39.95/192 pages/300 color illus.*

Graphic Design Basics: Pricing, Estimating & Budgeting—Make money with confidence using simple steps to boost the profitability of your design company and make things run a lot smoother. You'll learn money-managing essentials that every self-employed designer needs to succeed—from writing estimates to sticking to budgets. *#30744/$27.99/128 pages/ 47 color, 49 b&w illus.*

The Graphic Designer's Sourcebook—Find everything you need to run your business and to pull off your most innovative concepts. With names and phone numbers for more than 1,000 suppliers of unusual and everyday services and materials, this reference will save you hours of rooting for information. Listings include type, packaging, studio equipment, illustration, photography and much more! *#30760/$24.99/160 pages/18 b&w illus./paperback*

Fresh Ideas in Brochure Design—Make your design memorable with inspiration from this collection of cutting-edge sampling of today's best brochure design from 69 top studios around the country. *#30929/$31.99/160 pages/298 color illus.*

Graphic Design Basics: Creating Logos & Letterheads—Using 14 creativity-sparking, step-by-step demonstrations, Jennifer Place shows you how to make logos, letterheads and business cards that speak out about a client and pack a visual punch. *#30616/$27.99/128 pages/ 110 color, 125 b&w illus.*

Best Small Budget Self-Promotions—Get an inside look at the best of low-budget promotion with this showcase of more than 150 pieces that make clients stop and take notice. Included are examples of distinctive identity systems, unconventional self-promotions, pro bono work and more! Plus, you'll find costs and quantities, cost-cutting tricks and the story behind the designs. *#30747/$28.99/136 pages/195 illus.*

Creativity for Graphic Designers—If you're burned-out or just plain stuck for ideas, this book will help you spark your creativity and find the best idea for any project. *#30659/$29.99/144 pages/169 color illus.*

Designer's Guide to Marketing—Good design by itself isn't enough! Discover the key steps you must make to achieve the success your work deserves. Easy-to-understand marketing know-how to help you win clients and keep them. *#30932/$29.99/144 pages/112 color illus.*

Graphic Design Tricks & Techniques—Your quick reference to over 300 expert time- and cost-saving ideas from top studios. Get fantastic results in design, production, printing and more. *#30919/$27.99/144 pages/19 b&w, 99 color illus.*

The Best Seasonal Promotions—Get inspired with this exceptional collection of more than 150 fully illustrated promotions for every holiday and season of the year. Includes info on concept, cost, print run and production specs. *#30931/$29.99/144 pages/196 color illus.*

Graphic Artists Guild Handbook of Pricing & Ethical Guidelines, 9th Edition—You'll get practical advice on how to negotiate fees, the ins and outs of trade practices, the latest tax advice and more. *#30896/$29.95/328 pages/paperback*

Graphic Design Basics: Creating Brochures and Booklets—Detailed demonstrations show you precisely how to plan, design and produce everything from a church bulletin to a four-color brochure. Plus, a full-color gallery of 20 well-designed brochures and booklets will give you loads of inspiration. *#30568/$26.99/128 pages/ 60 color, 145 b&w illus.*

Fresh Ideas in Letterhead & Business Card Design 3—A great idea-sparker for your letterhead, envelope and business card designs. 120 sets shown large, in color, and with notes on concepts, production and costs. *#30885/$29.99/144 pages/325 color illus.*

Fresh Ideas in Promotion 2—Volume 2 in this inspiring series of the best new work in promotion. Includes captions with concept, cost, print run and production specs. *#30829/$29.99/144 pages/160 color illus.*